THE GOLDEN AGE
of AMERICAN
IMPRESSIONISM

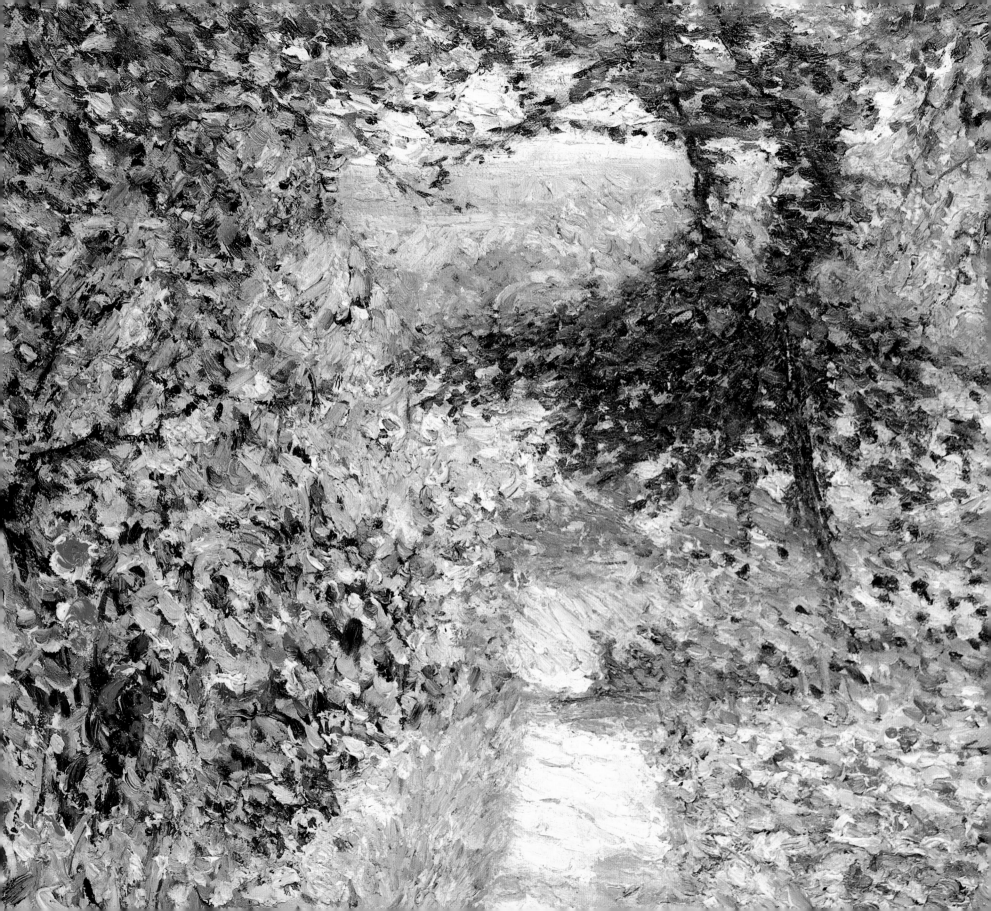

THE GOLDEN AGE
of AMERICAN
IMPRESSIONISM

by WILLIAM H. GERDTS

with Essays by CAROL LOWREY

WATSON-GUPTILL PUBLICATIONS / NEW YORK

PAGE 2
Joseph Raphael (1869–1950)
The Garden, detail of plate 54, 1913
Oil on canvas, 28 x 30 inches
Garzoli Gallery, San Rafael, California

Senior Acquisitions Editor: Candace Raney
Edited by Anne McNamara
Designed by Eric Baker Design, Associates, Cindy Goldstein
Graphic Production: Ellen Greene
Text set in Mrs. Eaves

First published in 2003 by Watson-Guptill Publications,
a division of VNU Business Media, Inc.,
770 Broadway, New York, N.Y. 10003
www.watsonguptill.com

Library of Congress Cataloging-in-Publication Data

Gerdts, William H.
 The golden age of American impressionism / by William H. Gerdts; with
essays by Carol Lowrey.
 p. cm.
"The genesis of this publication lies in an extraordinary exhibition, The golden
age of American impressionism, on view at the Heckscher Museum of Art, in
Huntington, Long Island from 22 November 2003 through 1 February 2004."
Includes bibliographical references and index.

ISBN 0-8230-2093-2 (HC : alk. paper)

1. Impressionism (Art)—United States—Exhibitions. 2. Painting,
American—19th century—Exhibitions. 3. Painting, American—20th
century—Exhibitions. I. Heckscher Museum of Art. II. Title.

ND210.5.I4G4745 2003

759.13'09'03407474725—dc21

2003010907

Manufactured in China

FIRST PRINTING, 2003

2 3 4 5 6 7 8 / 09 08 07 06 05 04

DEDICATED TO

RONALD G. PISANO,

A FINE ART HISTORIAN AND A GOOD FRIEND.

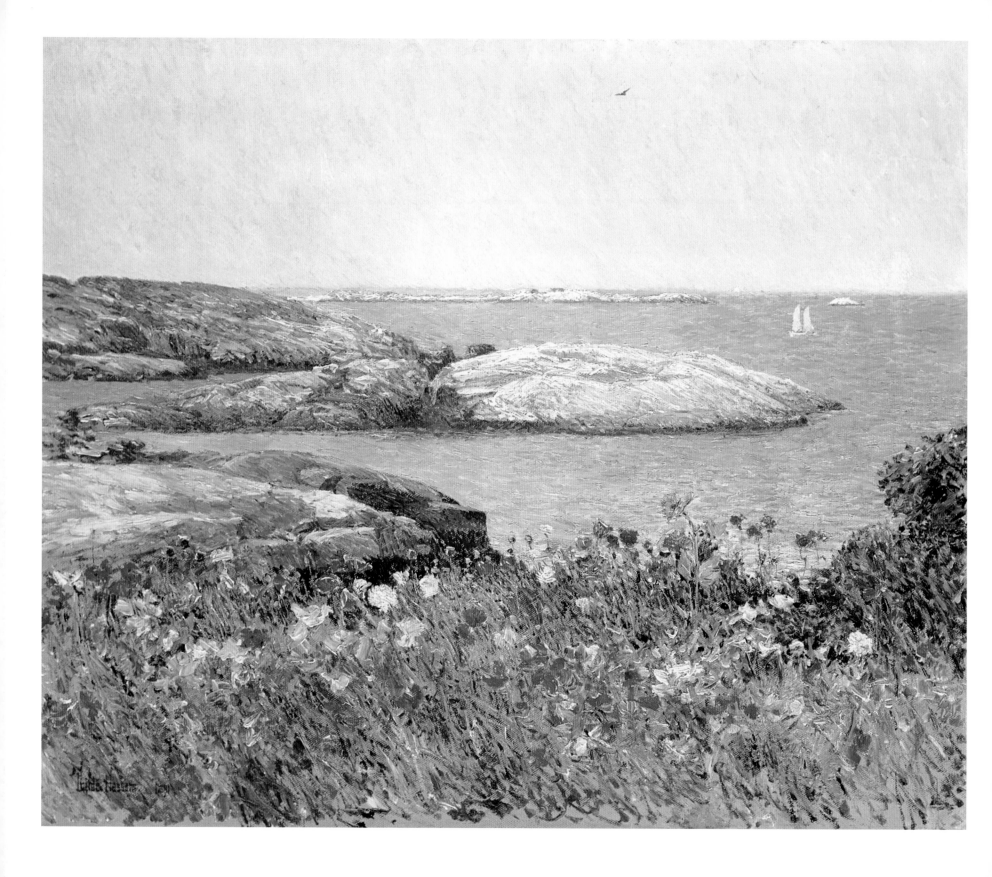

CONTENTS

PLATE 1
(Frederick) Childe Hassam
(1859–1935)
Poppies, Isles of Shoals, 1891
Oil on canvas, 19 ¾ x 24 inches
National Gallery of Art, Washington DC.
Gift (Partial and Promised) of Margaret
and Raymond Horowitz, 1997.135.1.
Photograph © 2003
Board of Trustees, National Gallery
of Art, Washington

FOREWORD

The genesis of this publication lies in an extraordinary exhibition, *The Golden Age of American Impressionism*, on view at the Heckscher Museum of Art in Huntington, Long Island, New York, from 22 November 2003 through 1 February 2004. Comprised of some of the most exquisite American Impressionist masterpieces ever created, this remarkable show could have been assembled by only one individual, Dr. William H. Gerdts, for many years revered as the dean of American painting.

Nearly three years ago, Bill enthusiastically accepted our invitation to undertake this project, one intended to attract an extensive public audience at a moment when the Heckscher is poised to embark upon an ambitious expansion project. The owners—both private and public—of the cherished works included both in our show and in this publication have parted with them in homage to Bill, who has declared this to be his final guest-curated exhibition. We are honored that he has chosen *The Golden Age of American Impressionism* as the coda to an important aspect of what has indubitably been an exceptional career in American art.

Long Island has played a noteworthy role in the evolution of American art, a history that is admirably reflected in the collections of the Heckscher Museum of Art. The transcendent light and scenic waterways of the island called Paumanok by the poet Walt Whitman—a native son of Huntington, which celebrates its 350th anniversary in 2003—have long drawn American painters. The allure of the region for American artists was the lifelong interest of another native son and an extraordinary scholar as well as benefactor of the Heckscher, the late Ronald G. Pisano, to whom Bill has dedicated this publication.

Artists may first have been lured to remote regions of the Island by Tile Club expeditions, but a resident colony of artists began to reach critical mass on the east end, in Suffolk County, in the later years of the nineteenth century. Drawn to its picturesque colonial-era villages and the expansive beaches that made the area a summer destination for city-dwellers, they found seaside subjects not unlike those that attracted French Impressionist painters to the coast of Normandy.

William Merritt Chase and Childe Hassam are the most cele-brated American Impressionist painters to have made their homes on Long Island—Chase in the Shinnecock Hills of Southampton and Hassam in East Hampton. Their luminous canvases offer abundant testimony to the region's allure and beauty. Chase's Shinnecock School of Art—the preeminent school of outdoor landscape painting in America—drew more than one hundred students, many of whom remained in the area, working in an impressionistic manner. Over time, Ernest Lawson, John Twachtman, and J. Alden Weir all painted Long Island subjects. (Extending our geographic scope slightly, the Long Island Sound, with its scenic shoreline and inlets, was the greatest magnet in the United States for American Impressionism, luring Robert Vonnoh, Theodore Robinson, Edward Rook, and Willard Metcalf to Connecticut.) In addition, Long Island was the home of many other American Impressionists of lesser renown, including Gaines Ruger Dunoho and William de Leftwich Dodge, and the American Impressionist style was reflected in the work of accomplished regional painters well into the twentieth century.

In consequence, it is especially appropriate for the Heckscher Museum of Art to mount an exhibition of American Impressionism, a movement whose masters have undeniably found inspiration and sustenance in our region. And there could be no more appropriate guest curator than Dr. William H. Gerdts, who has brought new insight into this fascinating and alluring movement through the magnificent works of art on our walls and in these pages. We are truly indebted to him and to our generous lenders for making such a breathtaking project possible.

Finally, we are delighted to be partnering with Watson-Guptill to bring this splendid publication to art-lovers across America. In doing so, it has been our great pleasure to work with Candace Raney, Senior Acquisitions Editor, and Anne McNamara, Project Editor.

Beth E. Levinthal
EXECUTIVE DIRECTOR

Anne Cohen DePietro
CHIEF CURATOR
HECKSCHER MUSEUM OF ART

AUTHOR'S ACKNOWLEDGEMENTS

First and foremost, I would like to express my appreciation to Beth E. Levinthal and Anne Cohen DePietro at the Heckscher Museum of Art, for inviting me to guest-curate this exhibition and author this book. They, as well as Jane White, have all been a joy to work with, from conception to completion. No scholar could ask for more. I would also like to thank my good friend and frequent collaborator, Carole Lowrey, for her contributions. The late Ronald G. Pisano, to whom this book is dedicated, was a fine scholar and a great good friend who, rightly, might have held the role which I have here attempted to fill. I would like this book to be seen as my tribute to him.

All of us involved in this project wish to offer our gratitude to the lenders, personal and institutional, who have so generously parted temporarily with these great works of American Impressionist art. They are listed elsewhere in this book, but I must single out especially Jan and Warren Adelson and Meredith and Cornelia Long for their invaluable assistance in representing our request for many of the loans in the exhibition. This all would not have come to pass without their help.

In addition, I would like to offer especial thanks to Dr. H. Barbara Weinberg, who offered me the opportunity of choosing from the superb holdings of The Metropolitan Museum of Art, resulting in the appearance here of Julian Alden Weir's *The Red Bridge*, that painter's acknowledged masterpiece. A very special note of thanks, too, to Alan Mirken for lending one of the finest and most beautiful of Mary Cassatt's pastels to this show. This was, I believe, the favorite work of his late wife, Barbara, among all the pieces in their splendid collection. I look upon this generosity as a tribute to Bobby.

William H. Gerdts
PROFESSOR EMERITUS OF ART HISTORY
GRADUATE SCHOOL OF THE CITY UNIVERSITY OF NEW YORK

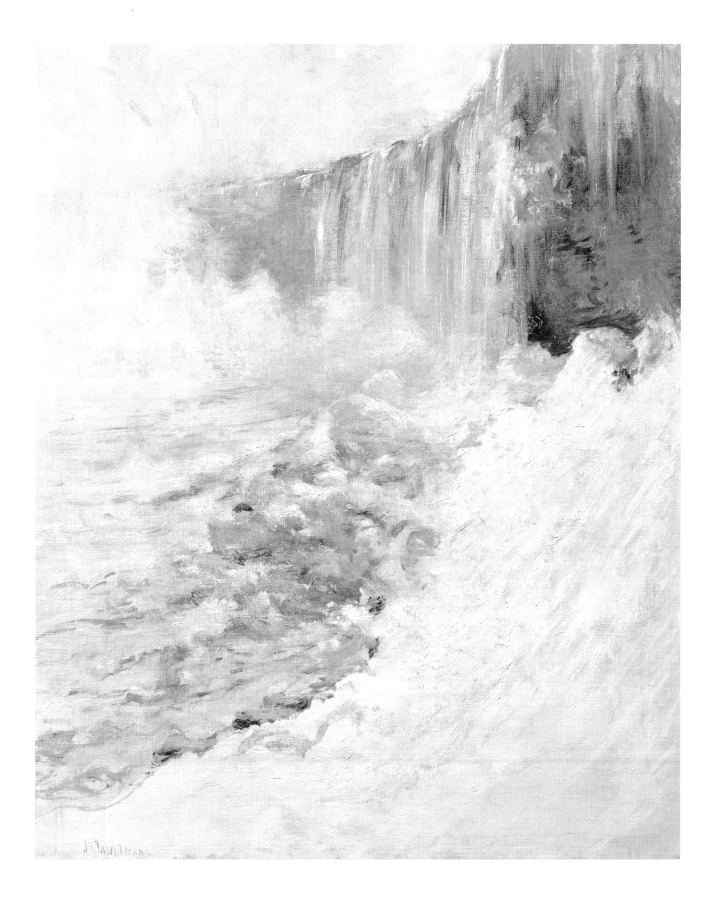

LIST OF
COLOR PLATES

INTRODUCTION

The tremendous popularity of American Impressionism is manifested in the enthusiasm of collectors, the escalating prices, the wealth of literature—surveys, monographs, scholarly and popular articles on the subject—and the explosion of exhibitions devoted to it, not only in the United States, but abroad, where shows of American Impressionism have taken place from Japan to Austria and Switzerland, and even as I write this there is an exhibition devoted solely to California Impressionism traveling from Paris to Krakow, and then to Madrid. With all this approbation for the movement, it is difficult to recall that there was a long stretch of time when American Impressionism elicited only contempt and derision from almost all facets of the art establishment. American Impressionism was disdained on the one hand as a weak derivative of French Impressionism, at best imitative and at worst a timid reflection of the achievements of Claude Monet, Pierre Renoir, and the other French masters of the Impressionist movement. On the other hand, though thoroughly contradictory to that evaluation, American Impressionism was seen as not Impressionist at all, but rather a superficial overlay of bright color and loose pigment on what was considered the basic and "natural" aesthetic of American art, which had come to be defined as sincere, vigorous, virile, and above all "realist," a realism which American critics did not recognize as underlying the achievements of the Impressionists—French or American.

That was then, this is now, and the paintings of Mary Cassatt, Childe Hassam, William Merritt Chase, and their colleagues are valued as among the greatest achievements of American art. The work of these artists and their confreres have been subject to intense analysis and interpretation, much of which has expanded our appreciation of their accomplishments and some of which has perverted or warped their motivations and exploits. Some of the best and most telling of recent scholarship has been devoted to placing these artists within the context of the society in which their art was produced—the economic, political, and social structure of the late nineteenth and early twentieth centuries—as well as distinguishing their accomplishments from those of other artists contemporary with them, who either chose more conservative aesthetic paths or made forays into visual territory which the Impressionists eschewed.

The art presented here is a deliberately traditional, if you will, "old-fashioned" collection. My purpose has been to gather the finest examples of the work of those painters whom I believe to be the preeminent and most original of the American Impressionists, and to tell the story of the movement through those examples; if there is any distinguishing aspect of the present selection, it is my conviction that some of the finest of American Impressionist painting was accomplished by artists working outside the context of the New York and New England heritage, and I have therefore included a number of outstanding examples of work by artists often relegated to the status of "regional" painters. Other than these regional examples, a good many of the paintings in this book are familiar to audiences who have long admired American Impressionism. My aim has been to bring the familiar and unfamiliar together, to celebrate the American aesthetic, and incidentally, to provide the growing art-loving audience with a full experience of this golden moment in the history of American art.

William H. Gerdts
PROFESSOR EMERITUS OF ART HISTORY
GRADUATE SCHOOL OF THE CITY UNIVERSITY OF NEW YORK

THE GOLDEN AGE
of AMERICAN
IMPRESSIONISM

by William Gerdts

The Civil War brought more than a drastic change in the social, economic, and political makeup of the United States; the cultural complexion of the nation was radically altered also, nowhere more so than in the fine arts. Previously, American artists and their patrons exalted in achievement sometimes recognized as even superior to that which dominated Europe at the mid-century, viewing the New World as a second Eden and vaunting the magnificent attractions of the American continent. Such an idealized version of our art rang increasingly hollow following the fratricidal struggle of the early 1860s, and immediately thereafter, literally thousands of American art students began to travel abroad to study in the great academies in Europe, in Paris and Munich particularly, to learn, as one critic noted, to "paint as other people paint."

These young tyros, men and women alike, entered the schools and private ateliers open to them, mixing with artists of other Western nations to learn to master the human figure in traditional, academic terms. Shortly after they began to arrive, a group of French painters reacted against the strictures of academic teaching and began to work in that aesthetic which we now deem "Impressionist," while discarding the more traditional themes of classical, religious, and allegorical subjects, or the popular motifs of peasant and Orientalist themes (the latter, reconstructions of North African and Near Eastern exotic life). No American painter traveled to Europe to join the Impressionist movement, but many of them were seduced into experimenting with this more Modernist aesthetic, particularly during the summer months when the academies were closed and the artists were on their own, free to experiment with out-of-doors subjects which had little place in the academies in the first place.

The earliest American reaction to French Impressionism was uniformly negative, as reported back in columns and newspapers in American magazines beginning in 1874, the year of the first Impressionist exhibition held in Paris. Beginning in 1878, sporadic examples of French Impressionism began to appear in exhibitions on this side of the Atlantic, increasingly generating critical controversy. The first significant showing of French Impressionism in the United States appeared in the Foreign Exhibition, held in Boston in 1883, when the French dealer, Paul Durand-Ruel, sent over a group of eighteen Impressionist pictures by Claude Monet, Camille Pissarro, Alfred Sisley, and Pierre Auguste Renoir. Though this was only a small fraction of the total show, it was this group of works which drew critical fireworks from writers not only from Boston but also from New York. This showing, however, was as nothing compared to the exhibition of almost 250 Impressionist works out of the 300 Durand-Ruel showed in New York City in April of 1886, with over forty works each by Monet and Degas, along with somewhat fewer examples by their contemporaries, and even several paintings by the Pointillist painter, Georges Seurat.

No exhibition held in the United States ever generated such critical controversy, ranging from total condemnation to tempered enthusiasm. There are a number of approaches to the analysis of that criticism, but one division among the critics that remained fairly consistent was the approval of the landscapes—primarily those of Monet—and the execration of the figural works of Degas and Renoir. A good many writers admired the tenderness and grace of the landscapes, their loveliness and the felicitous purity of their local tints, the joyous self-abandonment to the charms of sunshine overcoming their inadequacy of drawing. The artists of the figure paintings on the other side were seen as wallowing in ugliness, projecting pessimism, and choosing the vile and the deformed as their ideal. No wonder, then, that Monet's work began to be collected in large numbers by American collectors, nor that, when American painters, first in Europe and then back in the United States, began working in an Impressionist manner, they chose to emulate the landscapes of Monet, or, when they chose to paint the figure, they opted for a lovely young woman, usually in virginal white, or tousled, golden-haired children, forsaking the awkward ballet dancers that had figured in Degas's paintings, and the flabby nudes that had generated such objections in Renoir's contributions. Nor should we view these American Impressionists as crassly succumbing to critical preferences and objections, but rather recognize that, for the most part, they themselves derived from a moral and cultural background similar to that of the American critics who had offered their judgments in 1886.

WILLIAM MERRITT CHASE

In May of 1886, the Durand-Ruel Impressionist exhibition moved from the American Art Association to the galleries of the National Academy of Design, otherwise a bastion of conservatism in American art, where an expanded catalogue listed twenty-one more French Impressionist paintings lent by American collectors. The most immediate result of the Impressionist exhibition upon American art would seem to be the series of park pictures that William Merritt Chase began to paint the following month, first in the parks in Brooklyn, where his parents had moved and where he and his growing family lived for a while, and then later in Central Park. These urban landscapes, such as *Boat House, Prospect Park*, ca. 1887 (plate 11), reflected the modern world of middle-class leisure to which Chase's colorful, flickering brushwork was well attuned. The pleasure craft, available for group sailings on the lake, sport colorful canopies, while the flat, orange-beige horizontal of the boat house rooftop, silhouetted against the dense green foliage behind, becomes a flickering mass of broken brushstrokes when reflected in the rippling waters of the lake.

Though Chase had begun his European studies at the Royal Academy in Munich, Germany, in 1872, and was associated with the vigorous brushwork and strong tonal contrasts of Munich Modernism, as exemplified by the work of the German radical painter Wilhelm Leibl, he had begun to abandon the Munich manner by the early 1880s. By 1881, Chase was involved with the acquisition by the New York collector Erwin Davis of several important figure works by Edouard Manet. He spent the summers of 1881 and 1882 producing street and village scenes in and around Madrid and Toledo that depart radically from the dark tones and broad brushwork of Munich, substituting instead flat areas of bright sunlight that partake of the then-popular "glare" aesthetic.

In regard to the aesthetics of Impressionism, however, Chase's adoption of a combination of high-keyed colorism and flickering patterns of light and shade, which characterize his Brooklyn park scenes, were prefigured in the pictures painted in Holland in the summers of 1883 and 1884, such as the pastel, *Reflections, Holland*, 1883 (plate 12). Pastel

painting, in fact, was important in preparing the way for Americans to accept the innovations of Impressionism, inherently characterized as the medium was with the sketchy application of brightly colored chalks, broken linearism, and often the lack of smooth surfaces. Indeed, Chase was a vital force behind the formation of the Society of Painters in Pastel, which though founded in New York in 1882, did not hold its first of four exhibitions until March of 1884, where Chase predominated with seventeen works, including two Dutch canal scenes, one of which is the present example.

While the 1880s witnessed Chase's expanding investigation of Impressionist strategies, it was the pictures he painted out in Shinnecock, near Southampton, Long Island, from 1891 on, that constituted his fullest emergence into that aesthetic. Urged to form an out-of-doors art school there, he abandoned his park pictures and concentrated on paintings in oils, plus a relatively few pastels. In these, he explored and exploited the low-level countryside, covered with dunes and bayberry bushes. At the same time he taught classes of both amateur and professional artists, while living a comfortable life in a rustic home designed for him and his family by the renowned architect, Stanford White. In many of these pictures his family provided models, their white gowns and hats adorned with colored ribbons, acting as a foil for the rich greens of the foliage. These appear in *Beach Scene-Morning at Canoe Place* of ca. 1896 (plate 13), set in Canoe Place, the narrowest passage between the Shinnecock and Great Peconic Bays, painted before the building of a canal in 1897 that connected the two. Shinnecock provided a paradise for Chase, as well as an arena where he could work with the bright, sparkling, crisp brushwork that mark his distinctly American interpretation of Impressionism.

MARY CASSATT

Chase was actually not the earliest American artist to become associated with the Impressionist movement; that distinction belongs rather to Mary Cassatt, who, though born in Pittsburgh and having initially studied at the Pennsylvania Academy of the Fine Arts in Philadelphia, spent most of her professional career abroad. After creating her first really mature works in Italy and Spain, Cassatt settled in Paris in 1873, where she had earlier studied. Over the next several years she became acquainted with the work of the French Impressionists who began to exhibit together in 1874, and was especially drawn to the paintings of Edgar Degas, who became her friend and mentor, and who had admired her work in the Paris Salon of 1874. In the years immediately following, the impact of Impressionist color and loose brushwork can already be seen in several small oils Cassatt painted of modern women in intimate surroundings such as her *Woman on a Striped Sofa with a Dog (Young Woman on a Striped Sofa with Her Dog)* of ca. 1875 (plate 14), where she has already adopted her primary subject of the lives of upper-class, often quite confident women. By 1877, she had persuaded her friend Louisine Elder to purchase Degas's *Rehearsal of the Ballet*, a gouache and pastel over monotype of ca. 1876 (Nelson-Atkins Museum of Art, Kansas City), and Degas in turn that year invited Cassatt to join the Impressionist group. Cassatt's own Impressionist paintings were seldom seen in the United States until the 1890s. Her impact here centered more on her encouragement of the patronage of the work of her French Impressionist colleagues among American collectors.

Though Cassatt did not exhibit with the Impressionists in 1877, she soon acknowledged her association with them, and participated in the 1879 show with eleven works. Almost surely influenced by Degas's subject-matter, among Cassatt's most advanced paintings, some of which appeared in the Impressionist shows of 1879 and 1880, were a group of theatre and/or opera pictures, images of attractive young

PLATE 3
Mary Cassatt (1844–1926)
Lady with a Fan
(Anne Charlotte Gaillard), ca. 1880–81
Oil on canvas, 32 x 25 ½ inches
Adelson Galleries, Inc.,
New York

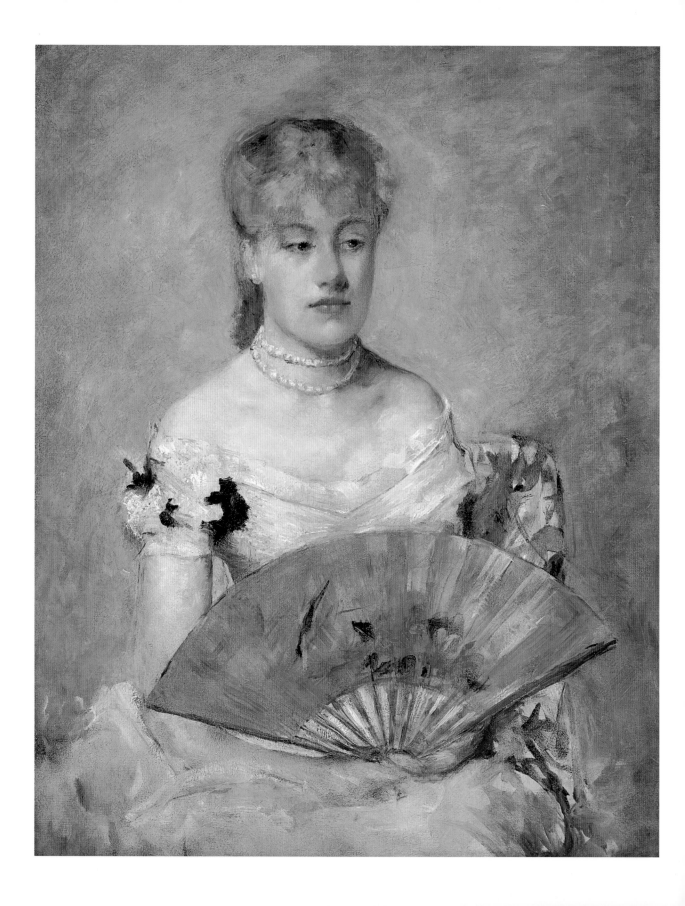

women in stylish evening garb, often holding fans. While not a theatre subject as such, her more portrait-like *Lady with a Fan (Anne Charlotte Gaillard)* of ca. 1880-81 (plate 3) partakes of many of the same conventions found in the theatre paintings, a picture of stylish young womanhood, brightly illuminated in soft but vigorous brushwork, suggesting the subject's attendance at either a private or public festivity. Indeed, Cassatt had met Mlle. Gaillard through a family member of the composer Auguste Vaucorbeil, who was named director of the Paris Opera in 1881. Cassatt's palette is a daring one, a symphony in pinks, suggesting perhaps a reflection of the work of her fellow expatriate, James Whistler. Daring, too, is the décolletage, though the artist balances the sensuousness of bright colors and bare flesh with the very erect pose and the open, and thus shielding fan. This work may, in fact, have been shown in the Impressionist exhibition of 1880, under the title of *Portrait of Mlle. G.*

This group of pictures, as so many of Degas's, were necessarily indoor scenes, but Cassatt began increasingly to join many of her other Impressionist colleagues in placing her subjects in the out-of-doors. Many of these outdoor scenes depicted solitary women in garden settings, but at the same time, during the 1880s, she increasingly chose the theme of modern motherhood, one with which she would ultimately be especially identified. In a work such as *In the Park* (plate 15), usually dated to ca. 1893-94, but painted perhaps even a decade earlier at the height of her association with the Impressionist movement, she has constructed a touching but restrained duet between the self-assured child and the watchful young guardian, either nurse or mother. The group is vigorously restrained in composition by the diagonal rail of the bench on which they sit, and placed within an impressionistically painted formal garden setting of brightly colored flowers, possibly the garden of one of the houses the Cassatt family rented during the 1880s and early 1890s. Also like

Degas, Cassatt chose as a serious alternative to the oil medium the exploitation of pastel, and perhaps no more tender expression of motherhood can be found in her entire oeuvre than her superb *The Young Mother* (plate 16) of ca. 1900. Here, despite the opposite directions of the gaze of each figure, the integration of the nude, clinging, and dependent child and the gentle, but firmly supportive and adoring parent, creates a classic triangle of an unyielding bond.

JOHN SINGER SARGENT

Another American expatriate, John Singer Sargent, met Claude Monet in Paris about 1876, just about the same time that Cassatt and Degas established a friendship; the relationship really blossomed around 1885 when the two artists spent a good deal of time together in France, both in Paris and in Giverny where Monet was living. Sargent had trained with Carolus-Duran in Paris, and attained even greater fame than Carolus as a portraitist of international society. But in addition, Sargent devoted his summer months to "holiday" paintings, relieving himself of the burden of catering to the demands of the rich and famous while at the same time investigating more contemporary aesthetic modes. His major painting of the summers and early autumns of 1885-86, after he had moved his base of operation from Paris to London, was *Carnation, Lily, Lily, Rose* (Tate Gallery, London), painted at the artists' and writers' colony at Broadway in the West of England. The picture of two young girls in a garden lighting Japanese lanterns at twilight was modeled by the daughters of Frederick Barnard, one of his English colleagues, and constituted a great triumph when finally exhibited at the Royal Academy in London in 1887. Though the decorative aestheticism of the picture may seem relatively tame to us today, the lack of specific narrative, absence of perspective, and bright colors were revolutionary in English art, and identified Sargent with modern

French tendencies which had heretofore gained little headway in England. Sargent worked on the painting out-of-doors for only a short while each late afternoon—thus accounting for the need to stretch its creation over several years. Even more freely painted, more intensely colored, and more spontaneous are the oil studies that Sargent painted of the Barnard children, both singly and together, such as his *Study for Carnation, Lily, Lily, Rose* (plate 17), probably done early in the evolution of his masterpiece.

DENNIS MILLER BUNKER

Sargent did not summer again in Broadway after 1886, but he continued to work in an Impressionist manner when not engaged in formal portraiture, creating pictures of leisure among friends and family, at Henley in 1887, Calcot in 1888, and Fladbury in 1889. Sargent returned to America and experienced great success with portrait commissions in Newport, Boston, and New York during the winter of 1887-88. In Boston, Sargent met the ingratiating young artist Dennis Miller Bunker (1861-1890), a painter who had trained in the atelier of the great French academician, Jean-Léôn Gérome, and who had been "taken up" by Boston society. The two became friends, and Sargent invited Bunker to join him and his family in Calcot in 1888. There, Sargent's Impressionist manner impacted sufficiently on Bunker that he abandoned the close tonal harmonies of his landscape work for the brilliant colorism and seemingly unstructured compositions he observed in Sargent's work. Bunker brought this new, Impressionist manner back to Boston with him in the fall of 1888, and while his figural pieces continued to reflect his academic training, his summer paintings created in nearby Medfield in 1889 and 1890, such as *Meadow Lands* (plate 18) of 1890, demonstrate Sargent's influence. Whether Bunker would have remained a confirmed Impressionist is open to question; even the 1890 fields of bright greenery such as *Meadow Lands*

utilize a softer, velvety, and less broken brushwork and somewhat more restricted chromatics than his paintings of the previous year. Still, critics were aware of Bunker's conversion to the modernist strategies of Impressionism, and when some of Sargent's summer paintings were exhibited in the United States in 1890, they were grouped with Bunker's and compared with them.

AMERICANS IN FRANCE

If Americans at home began to become significantly aware of French Impressionism in 1886, American artists working abroad became dramatically involved with the movement the following year, when a group of seven painters—six Americans and one Canadian—chose to spend their summer in Giverny, where Claude Monet lived. It should be stressed that no Americans went abroad to become Impressionists; they traveled to Paris to gain the technical accomplishments of their European peers, but some of them at least were attracted and excited by the newer aesthetic developments they discovered abroad. Beginning in 1887, Giverny became the most significant Impressionist art colony in Europe. Americans were hardly the only artists to paint there; others came from everywhere from Russia to Argentina, but Americans were the most numerous. Some came for a single visit, some for many; some stayed a few days, some accumulated years of residence there. Actually, very few became really friendly with Monet; they might have seen him painting in the fields or greeted him on the small peasant town's roadways, but they had a better chance of seeing his art in galleries in Paris or even in New York. Nevertheless, his presence in Giverny, as well the proximity of the village to the Seine River, and its position halfway between Paris and Rouen, made it an ideal community for an art colony that existed for over thirty years.

PLATE 4
Theodore Robinson (1852-96)
On The Canal (of Port Ben Series), 1893
Oil on canvas, 19 x 23 inches
Private Collection, Seattle, Washington

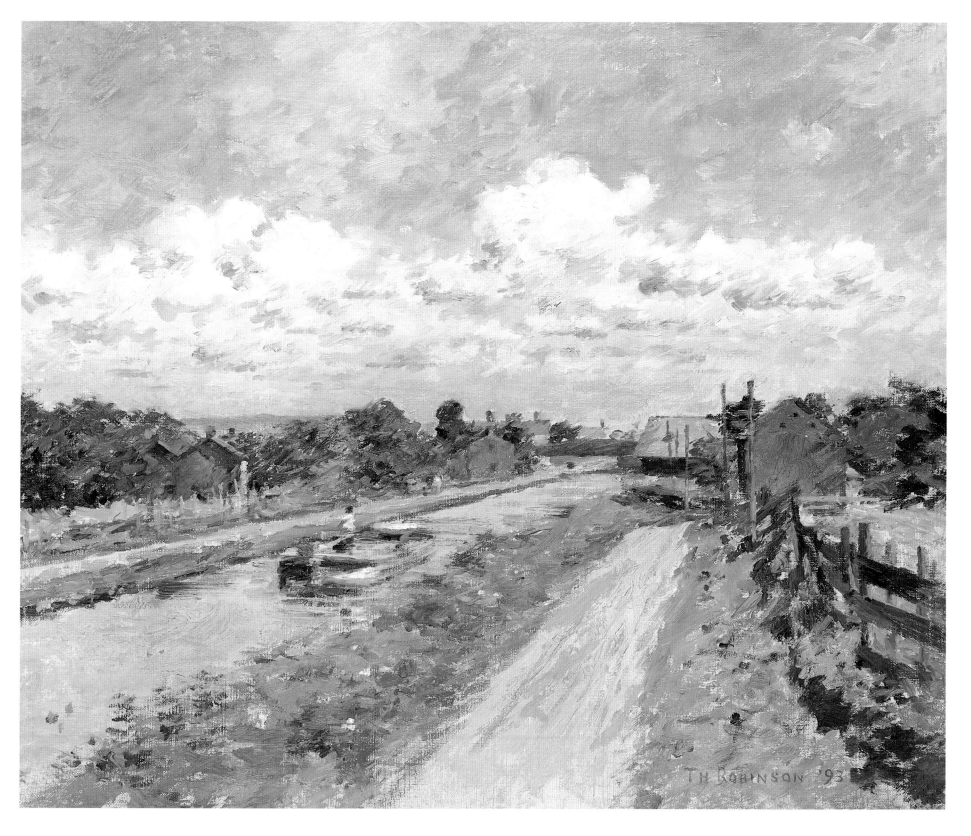

THEODORE ROBINSON

Of the half dozen or so Americans who did become close to Monet, Theodore Robinson has become the most celebrated. Robinson spent the greater part of the years 1887 through 1892 in Giverny, and most of the paintings he created in this period were done there, including his *Road by the Mill* (plate 19), which, in its broken brushwork, high colorism, and concern for bright sunlight, reflects the influence of Monet and Impressionism. Similar to Monet's investigations of the changing conditions of weather and times of day in depicting haystacks in Giverny or the facade of Rouen Cathedral, *Road by the Mill* is one of a series of paintings that Robinson painted in 1892, his last season in Giverny. There exists also an overcast version of the scene, without the young peasant woman and cow, and night views as well. But for all their modernity, Robinson's Giverny paintings, as well as those of most of his colleagues of the first generation of colonists, were involved with the lives and situation of the village itself. Unlike Monet, who seldom painted the town and never its inhabitants, Robinson here, and in many of his works, concentrates on Giverny as a community. His subjects are generally the peasant men and especially young women of the village, involved in their work of growing grain, caring for orchards and vegetable gardens, or tending farm animals. And as here, the structures in the village upon which the colonists most concentrated were the mills in which grain was ground and apples were pressed into cider.

Not all of Robinson's Giverny figural subjects were local, however; in particular, there was Marie, a woman from Paris with whom he was involved, and with whom he may have fathered a child. Marie is probably the subject of *Le Débâcle* (plate 20) of 1892, a depiction of an elegantly dressed figure in violet, a favored color of the Impressionists, holding a book by the edge of a bridge crossing over one of the two tributaries of the Seine that passed through Giverny. The title of the picture might seem confusing today, since the scene is a peaceful one, with no threatening "debacle" in the offing, until one realizes that *Le Débâcle* was the latest novel of the great French realist author Emile Zola, and thus adds a further note of contemporaneity to the scene.

In early December, 1892, Robinson returned to the United States; he never again returned to France before his early death in 1896. In the summer of 1893, financial pressure led him to teach a group of students from the Brooklyn Art School at Napanoch, New York, on the Delaware and Hudson Canals. Some of his finest paintings created that summer were a series of scenes in the village along the canal, where again, as in Giverny the year before, and emulating Monet, he created variations of the same scene, of which *On The Canal (of Port Ben Series)* (plate 4), is the most colorful, brilliant, and "active" among them. It should be noted, too, that, as in so many of his Giverny paintings, Robinson's scene here is a *working* landscape, with barges and tow paths, and the homes of the canal workers making up the village itself. The following year, though Robinson painted a series of brilliant pictures when visiting his friend and colleague John Twachtman in Greenwich, Connecticut, his summer teaching for the art school in Princeton, New Jersey, was far less productive. But earlier in March of 1894, he began to paint two views of the great international exposition held in Chicago the previous year. The *World's Columbian Exposition* (plate 21) as well as its companion, *North Lagoon, World's Columbian Exposition* (Chicago Historical Society), were painted on commission for a publishing venture that was never completed. Robinson himself was dissatisfied with the results, perhaps because it had been necessary to base his pictures in part on a photograph that was not of his own taking. Even so, Robinson successfully captures the grandeur of the Fair in the high domed United States Government Building, and the extensive Manufactures and Liberal Arts Building

behind, illuminated in crisp sunlight and brilliant and glowing color, and while he necessarily allows strong structural masses to be clearly defined, the fore- and middle-ground foliage is rendered in his typical Impressionist brushwork.

ROBERT VONNOH

Giverny was the principal art colony in France in which artists explored the Impressionist aesthetic, but it was not the only one. An interesting alternative developed in the village of Grèz, situated at the southeastern corner of the Forest of Fontainebleau. In 1875 a group of British and American painters, like Sargent students of Carolus-Duran, who had been painting at Barbizon on the opposite corner of the Forest, sought out Grèz which, situated on the Loing River, offered the pleasures of swimming and boating lacking at Barbizon. Attracted by the locale, they transferred their activities there and continued to work in the Naturalist vein they had been practicing in Barbizon, often including in their painting not only the river but also other structures such as the stone bridge over the Loing, the local church, and some castle ruins. But soon after, spurred on initially by a group of Scandinavian painters who began to make their base in Grèz in 1882, and then by the arrival of the Irish painter Roderic O'Conor in 1886, the strategies of Impressionism began to dominate the work of the Grèz artists, above all the American, Robert Vonnoh, who had begun to paint there in 1887. *Beside the River (Grèz)* (plate 22) of 1890 is a splendid example of the heightened colorism and bright sunlight Vonnoh practiced in numerous renditions of the village itself, effectively contrasting the solid, light-colored building structures with their shimmering reflections on the surface of the Loing River and the purple shadows of the bridge at the right.

JULIAN ALDEN WEIR

In 1889, several of the earliest Giverny colonists returned to Boston and held one-artist exhibitions of their work. Others, including Robinson, exhibited their Impressionist paintings in New York City at much the same time. In 1890, Bunker and Sargent's Impressionist work was on exhibition in a number of American cities, and Vonnoh had a one-artist show in Boston in 1891. Thus, by the early 1890s, Americans were becoming familiar not only with French Impressionism but also with their American counterparts and more and more of the younger leaders of American art were beginning to subscribe to the movement. Thus, Julian Alden Weir, who had studied with Gérôme in the 1870s, and in 1877 viewed the third Impressionist exhibition in Paris as "worse than the Chamber of Horrors," gradually abandoned the dark, tonal figure and still-life paintings he created after returning to New York that year, and by 1890 had adopted many of the tenets of Impressionism. This is especially true of the paintings he created at his two Connecticut homes, one in Branchville in Western Connecticut, and the other at Windham in the northeastern part of the state, where his wife's family had a summer home. In *The Laundry, Branchville* (plate 23) of ca. 1894, Weir introduces thick, vibrating brushwork and a steep rising composition to contrast the green lawn and foliage with the brick red buildings in the rear and the abstract pattern of the wash hung before them. The flattening of the picture plane, with its high horizon line and the introduction of almost detached elements such as the saplings in the lower left, suggest the influence of Japanese prints, which Weir, Robinson, and other American Impressionists not only admired but also collected at this time. The impact of Japanese art is even more clear in what is often considered Weir's masterpiece, *The Red Bridge* (plate 24) of 1895, with the brilliant vermilion of the unadorned, functional iron structure, reflected in the Shetucket River below, contrasting with the earth tones of the landscape. Here again, a high horizon combined with the dominant diagonals of the composition and the

cut off forms of the trees at the right and the looping branch at the left, flatten the composition in a manner recalling Japanese prints.

While much has been made of Weir's regret that this modern, functional structure replaced a venerable covered bridge, it was to this new edifice that Weir was attracted, not the older, picturesque bridge. Just as the first generation of Giverny painters concerned themselves with aspects of work and toil among the French peasantry, so many of the Impressionists working in America also chose subjects pertaining to labor and industry; after all, *The Laundry, Branchville,* for all its decorative patterning, focuses upon household work. Similarly, Weir's *The Building of the Dam* (plate 25) of 1908, one of the finest and most Impressionist of his later paintings, is an industrial subject, though Weir has successfully absorbed the dark, mechanical equipment within the sunlit, tree-filled Connecticut hills near his Windham home.

JOHN TWACHTMAN

Among the leading American Impressionists of the 1890s, John Twachtman was the artist closest to Weir, though he came from a very different background. Born in Cincinnati, he, like Chase and so many other Midwesterners, initially sought artistic training in Munich rather than Paris. He accompanied his teacher and friend Frank Duveneck to Munich in 1875, and practiced the vigorously painted tonal contrasts of Munich Modernism in the period that ensued. After a few years in Cincinnati and New York, he returned to Europe, this time to Paris, enrolling at the Académie Julian in the early 1880s. By 1889 Twachtman had settled in Greenwich, Connecticut, not too far from Weir's Branchville home. There, he developed his very individual interpretation of Impressionism, usually based on a very limited range of colors, and devoted, for the most part, to depicting his house and property on Round Hill Road. The trees and foliage, the brook, pool, and small waterfall appear over and over again in his pictures, paintings created at different times of the year that exude the comfort of his intimate knowledge and enjoyment of his rural home. Twachtman was especially celebrated as an interpreter of winter, as seen in his painting of the mid 1890s, *Snowbound* (plate 26), a tonal synthesis of blue and white, in which his house is snugly enframed by the leafless trees, and embraced in its landscape setting. Likewise, while seldom a painter of formal still lifes, he reveled in depicting the blooms he planted, and even more the wildflowers he found on his property, such as *Meadow Flowers (Golden Rod and Wild Aster)* (plate 27), painted in the early 1890s, a thematic interest he had previously explored in pastel. In soft, shimmering brushwork, the viewer is plunged in amongst the golds, lavenders, and greens of the goldenrod and Joe-Pye weed wildflowers, the artist omitting any setting or horizon, becoming one with intimate nature, stirred by a breeze. When Twachtman was not painting on his own property, he was often in the Cos Cob section of Greenwich, Connecticut, where, in the summers of the 1890s he taught, in some years joined by Weir, using the old Holley House, an inn where students and fellow artist-visitors often stayed. Twachtman did not paint the Holley House often, but a number of his finest works are views from the porches of the house, including his autumn view, *October* (plate 28), where the richly painted landscape in the foreground, with a magnificent spreading elm at the left, opens up to reveal the neighboring Brush House, a building of the later 1700s and a sister building to the Holley House itself. *From the Holley House, Cos Cob, Connecticut* (plate 29) of ca. 1901, a view along River Road toward the Lower Landing at Cos Cob, was painted after the Cos Cob grist mills, which would have blocked the view, were destroyed by fire in January of 1899. Here, before the soft, pastel-like harmonies of water, roadway, and small structures, new growths in the foreground not only suggest a springtime scene, but also infuse the painting with calligraphic patterns that attest to Twachtman's interest in Japanese aesthetics, shared with his colleague, Julian Alden Weir.

PLATE 5
(Frederick) Childe Hassam (1859–1935)
A Favorite Corner, 1892
Watercolor on paper,
14½ x 9½ inches
Private Collection

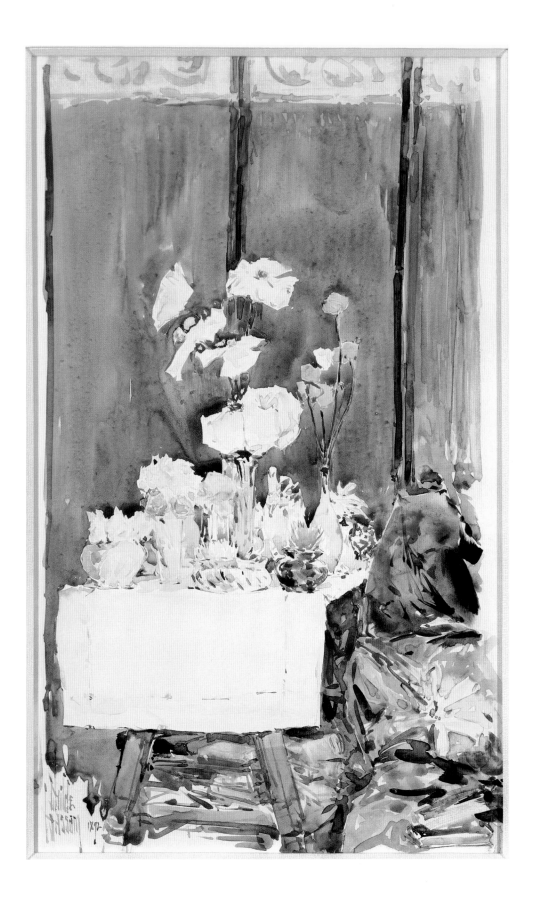

While the majority of Twachtman's Impressionist pictures were painted in Greenwich, he traveled in the last decade of the nineteenth century to Niagara Falls, to Yellowstone, and to Gloucester. In the winter of 1893-94, Twachtman resided in Buffalo, New York, with Dr. Charles W. Cary, a member of an important Buffalo family, among whom were leading members of the local art community. During that time, Twachtman made a series of paintings of Niagara Falls, most likely drawn to the subject for its intrinsic fame, rather than on commission; among these, *Niagara in Winter* (plate 2) is one of the most painterly and sensuously beautiful. He chose a low vantage point from which grandeur emanates from height, rather than breadth, and which at the same time allowed the artist to indulge in compelling colorist effects, countering the blues and greens of the waters with the white foam and frozen ice. Nor are Japanese elements missing here, with the picture divided diagonally into two unequal segments, the almost flat, close-up white mass in the lower right contrasting with the distant plunge of the Falls.

CHILDE HASSAM

One of the most outstanding, and certainly the most celebrated of the leaders of American Impressionism was Childe Hassam. Hassam was born in Dorchester, Massachusetts, and studied in Boston before making his first trip touring abroad in 1883, where any impact of the French Impressionists appears to have been minimal. On his return, Hassam gained renown for a series of powerful tonal scenes of contemporary urban street life. In 1886 he returned to Europe, this time studying in Paris and spending his summers with his wife at the suburban home of friends outside of the capital in Villiers-le-Bel. It was here that Hassam painted *After Breakfast* (plate 30) of 1887, one of his earliest fully Impressionist works, in which the gorgeous hues of the red geranium plants and the contemporary,

informal scene of casual, intimate pleasure enjoyed by his wife and her companion, are the two contrasting focuses amidst the rich green abundance of potted plants and the natural foliage wall.

When Hassam returned to the United States at the end of 1889, he settled not in Boston but in New York, which remained his home base for the rest of his career. Still, he was an inveterate traveler, during the summers especially, and in the succeeding years he focused on the island of Appledore, amidst the Isles of Shoals off the coast of New Hampshire and Maine. There, the poet, writer, and painter Celia Thaxter, ran a hotel, Appledore House, which served as an informal salon for artists, musicians, and writers, a group amongst which Hassam became the most celebrated. It was there that Hassam painted a series of pictures, including his 1891 *Poppies, Isles of Shoals* (plate 1). Here the extensive garden cultivated by Thaxter, who emphasized a natural, informal disposition of blooms, dominated by the poppy, is contrasted with the low-slung rocky outcropping of the Isles, all depicted in bright sunlight. Indeed, Thaxter aimed for the intentional wildness that dominated American garden aesthetics at the end of the nineteenth century that celebrated the joyous exuberance of nature. The rock formations and waters of the Atlantic Ocean are painted in relatively even brushwork, contrasted with the vigorous, thickly painted poppies, which call to mind the poppy paintings of Claude Monet, several of which had been critically highlighted in the 1886 French Impressionist exhibition in New York, which Hassam had attended. But unlike Monet's pictures, Hassam assures the viewer of a sense of place, defining the characteristics of Appledore and its surrounding islands.

Hassam had gone to Paris to study at the Académie Julian, and to master the painting of the human figure, and while the majority of his works are landscapes, the figure, as in *After Breakfast*, is often integral to the scene. It can even be a dominant motif, as in *The Sonata* (plate 31) of 1893, a haunting image of a woman in white at the piano in Appledore

House, where a single yellow rose both mirrors the beauty of the principal subject and suggests the flower garden seen through the window at the left. The environs of Appledore are further suggested in the moonlit "sonata" painting, a corner of which appears cut off in the upper right, surely a work by Hassam himself. An evocative work, this is one of a number of paintings by Hassam pairing young women with music and pianos; the subject holds sheet music, identified as Beethoven's *Apassionata,* which she may have played or been planning to play, though the image may also be meant simply to project quiet meditation. Hassam's association with Thaxter climaxed in her final book, *An Island Garden,* published in 1894, the year of her death, and illustrated with watercolors by Hassam. *A Favorite Corner* (plate 5), painted in 1892, is one of several illustrations not of the garden itself, but of the flower arrangements that Thaxter created inside the parlor of her cottage, where her guests crowded amidst the welter of furniture, books, and pictures. Hassam's vigorous watercolor technique creates a work independent of the text, in which Thaxter described the flowers picked daily and placed in vases on a small table covered with a white linen cloth embroidered in silk.

Hassam continued to visit Appledore for many years after Thaxter's death, but he concentrated more on the rocky coastline and the sea, rather than her garden. He also began to give more and more attention to other New England towns that represented for him the traditions of the area as well as the nation, communities such as Newport, Provincetown, and Gloucester. Gloucester, especially, was becoming a major attraction for artists by the turn of the century, and Hassam was there a number of times, painting *Gloucester* (plate 32) in 1899. In very gritty, broken brushwork, he emphasized the still thriving port, with the harbor, teeming with pleasure vessels, creating a counterpoint to the vertical pilings in the left foreground; the tall masts of the boats and the distant church tower at the left constitute the highest points in the composition, breaking the horizon as they rise to the sky. Like his

colleagues Robinson and Weir, Hassam painted a good many pictures of physical labor, particularly paintings of the shipbuilding trade that continued in communities such as Provincetown and Gloucester, works such as *The Sparyard, Inner Harbor, Gloucester* (plate 33). If *Gloucester* featured pleasure vessels, this work concentrates on the local working class continuing a trade that had flourished in the town over many decades. The vessels in the distant background, sketchily laid in, appear to be docked at warehouses and other commercial structures. Likewise, the scumbled paint is laid on thickly, a pictorial suggestion of the vigor associated with the occupation depicted.

OLD LYME

In 1903, Hassam first visited Old Lyme, Connecticut. Old Lyme had developed as an artist's community in 1899, where painters worked primarily in a Barbizon and Tonalist mode, but with Hassam's arrival the artistic identification of Old Lyme turned to Impressionism, and Old Lyme became the "American Giverny." Churches figure importantly in Hassam's work in both urban and rural imagery, but none so affected him as the old Congregational Church in Old Lyme, which he depicted beginning in 1903, and continuing to 1906, when he painted *Church at Old Lyme* (plate 34). The artist's respect for both tradition and religion fuse in these images, as the church rises up in stark, white grandeur, framed by autumnal elm trees. Though the church was reconstructed after fire destroyed the structure early in the morning of July 3, 1907, Hassam declared that it could never be rebuilt and ceased recording its image.

Hassam continued to visit Old Lyme, and many other artists painted in the "American Giverny," which developed into the most important Impressionist art colony in America. Some visited during the summer, and some came to reside there permanently, such as Edward Rook, who settled there in 1903, and whose *Laurel* (plate 36) enshrines the state flower, which grew there abundantly. Rook brought an especially

PLATE 6
(Frederick) Childe Hassam
(1859–1935)
St. Patrick's Day, 1919
Oil on canvas, 24 x 20⅛ inches
Mr. and Mrs. Meredith J. Long

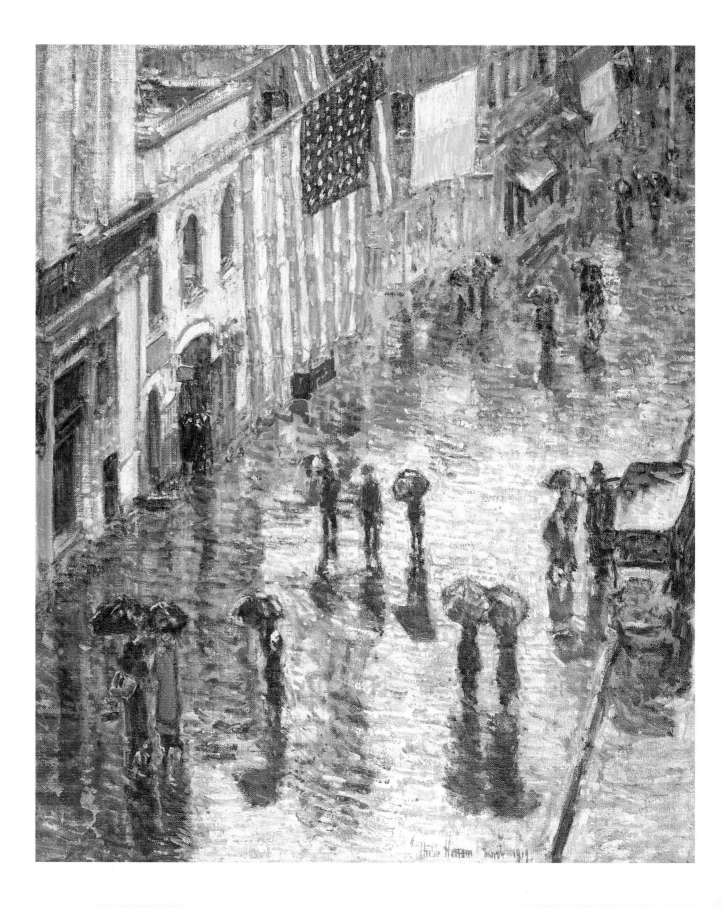

expressive vitality to his rendering of the local landscape, endowing the flowering laurel with a sense of growth.

NEW YORK

Hassam's respect for American traditions and his nationalistic impulses found their most celebrated expression in his "Flag" series, painted during and immediately after World War I, when the colorful aesthetic of Impressionism merged with the flags and banners celebrating the Allied cause. While many of the series identified the parades along Fifth Avenue, in *Flags on 57th Street, Winter 1918* (plate 35) Hassam interjected his patriotic concerns embodied in the American flag in a more intimate commercial environ and, in this case, one especially meaningful to the artist. This view is taken from Hassam's studio at 130 West Fifty-seventh Street, looking east toward the intersection of Sixth Avenue; the Milch Brothers Gallery at the northwest corner, with its glowing windows indicative of the oncoming evening, dealt in American art and was to exhibit the "Flag" series the following year. The contemporaneity of his artistic strategies is echoed in the elevated railroad that forms a backdrop for the scene. Hassam's fascination with all aspects of weather in the city finds expression in the inclement winter conditions, unique among the "Flag" series, while the white layers of snow provide a strong foil for the colorful flags and banners overhead. *St. Patrick's Day* (plate 6) is another of the "Flag" series, a view from above where the American banner dominates the row of flags overhanging the glistening wet sidewalk, in which the flags' colors are reflected, while ideographic figures with umbrellas stroll below. Again, Hassam's patriotic concerns are joined with the pictorial examination of weather conditions, which had dominated his urban scenes from the beginning of his career. The "Flag" series garnered Hassam tremendous acclaim, and it was in these works that he was able to give the modern cityscape true national resonance.

It was the Impressionists, beginning with Chase's urban park scenes, who gave rise to the interpretation of the modern city as a viable artistic subject. Hassam was the leader of this direction, first in Boston, then back in New York, and in the early twentieth century, as the interpreter of "The New New York," the skyscraper city. But in the first two decades of the century he shared that distinction with Colin Campbell Cooper, less renown today, who celebrated the great structures arising out of the "canyons of New York," such as the Woolworth Building. Cooper's masterpiece, acknowledged as such in its own time, was *Broad Street Cañon, New York* (plate 37) of 1904; the painting depicts the newly erected Stock Exchange at the left, erected only the previous year, brightly illuminated by sunlight, surrounded by the twenty-one-story Commercial Cable Building (1897), and the ornate Gillender Building (1901). These are contrasted with the older Subtreasury Building at the rear, and the Mills Building of 1883 in the shadows at the right. Here is a paean to the modern city at its grandest, one that the printmaker Joseph Pennell also depicted in 1904, and Hassam would undertake three years later (Herbert F. Johnson Museum of Art, Cornell University, Ithaca, New York).

THE TEN

At the end of 1897, a group of artists, made up primarily of painters working in an Impressionist mode, and led by Hassam, Weir, and Twachtman, seceded from the Society of American Artists and set up their own organization to hold annual exhibitions which would be smaller and more homogeneous than those of the Society or the older National Academy of Design. The Society itself had been founded twenty years earlier, primarily to exhibit the work of the younger painters who had sought training in Paris and Munich, and had found their work often refused or poorly hung at the annual shows of the Academy. But by the mid-1890s, these artists found the two organizations almost indistinguishable, and, in

fact, the leading Impressionists were exhibiting their work about equally with the Society and the Academy. Disturbed not only by the heterogeneity of the Society's shows, but also by their increasing size and mediocrity, they formed their own organization, called simply "The Ten," though dubbed by critics "The Ten American Painters." The group included artists Frank W. Benson, Joseph DeCamp, Thomas W. Dewing, Childe Hassam, Willard Metcalf, Robert Reid, Edward Simmons, Edmund Tarbell, John H. Twachtman, and J. Alden Weir; William Merritt Chase joined the group a few years after Twachtman's death in 1902. Not all of its members strictly subscribed to the Impressionist aesthetic. Edward Simmons, for instance, was in some ways a "part-time" easel painter, devoting most of his career to mural decoration after returning to the United States from his European training and subsequent activity in the artists' colonies in Concarneau in France and then in St. Ives in England. And Thomas Dewing has been viewed primarily as a Tonalist, probably the leading Tonalist figure painter, creating haunting images of well-bred but rather remote, elegant female figures, either together or in concert, many at the artists' colony in Cornish, New Hampshire. Dewing created easel paintings, screens (inspired by the vogue for Japanese arts and crafts), and increasingly toward the latter part of his career, following an exhibition of James Whistler's pastels at New York's Wunderlich Gallery in 1889, beautiful pastels. In a somewhat Whistlerian manner, the figures of his lovely if enigmatic women sometimes barely emerge from the brown toned paper on which they are drawn, as seen in his seated *Lady in Blue* (plate 7) of ca. 1910, in which the figure appears almost to float across the neutral surface. Similar, but far more vibrantly drawn and colored, is the typically attenuated *Lady in Blue, Portrait of Annie Lazarus* (plate 38) of ca. 1890. A long-time friend of Dewing and his wife, Lazarus began an affair with Dewing around the mid-1890s, which ended only when Lazarus left Cornish in 1901. With her brilliant green dress and open yellow fan

glistening against the neutral background, this is one of the most vivid and assertive of Dewing's images. Despite the aesthetic variations of its members, The Ten were nevertheless often looked upon as the vanguard of American Impressionism.

WILLARD METCALF

A member of the The Ten was Willard Metcalf, who had also been one of the original Giverny colonists back in 1887. Much of Metcalf's career after he returned to the United States from France in late December of 1888 was given over to commercial work, but in July, 1895, he visited Gloucester, Massachusetts, with Hassam, and painted a series of pictures there, which are among the most ravishing Impressionist paintings of the late nineteenth century and among his finest, most coloristic achievements. *Gloucester Harbor* (plate 39) is one of these, a work he showed with the Society the following year, winning him the Webb Prize. This was his first American landscape for over a decade, and he captures the activities of the harbor, the variegated structures in the distance, and the foliage covered hillside in the foreground in the pure colorism of Impressionism.

Despite his achievements in Gloucester, and even with his participation with The Ten, most of the next decade was not a successful one for the artist, who produced relatively little work outside of some murals and decorative panels. It was only after 1904 when he went to Clark's Cove, Maine, to live with his parents that he began to address himself strenuously to his deteriorating personal and professional state, and began to seriously resume his landscape work. On the basis of his Maine paintings,

PLATE 7
Thomas Wilmer Dewing (1851–1938)
Lady in Blue, ca. 1910
Pastel on fine medium
dark brown paper, 10⅜ x 6⅞ inches
Private Collection

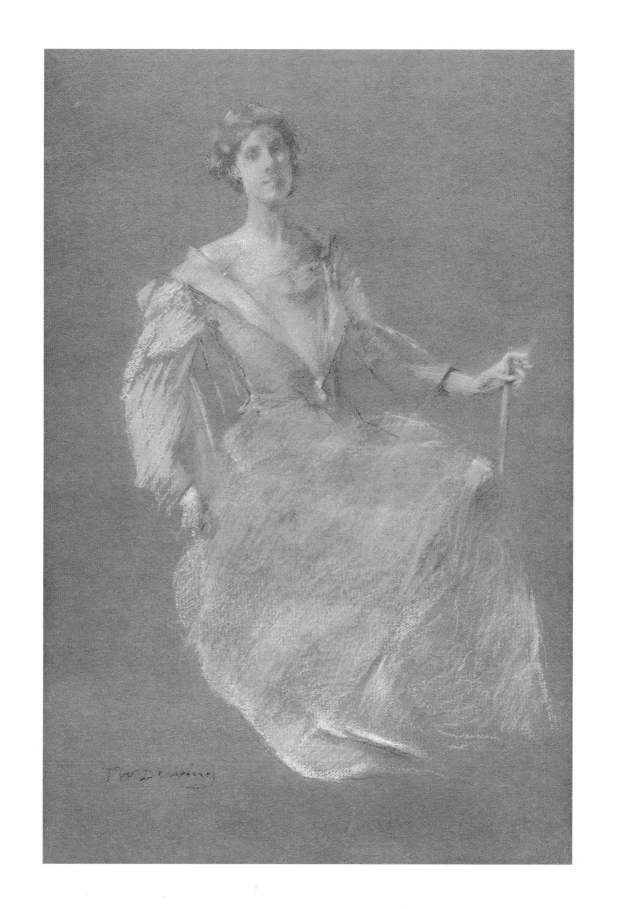

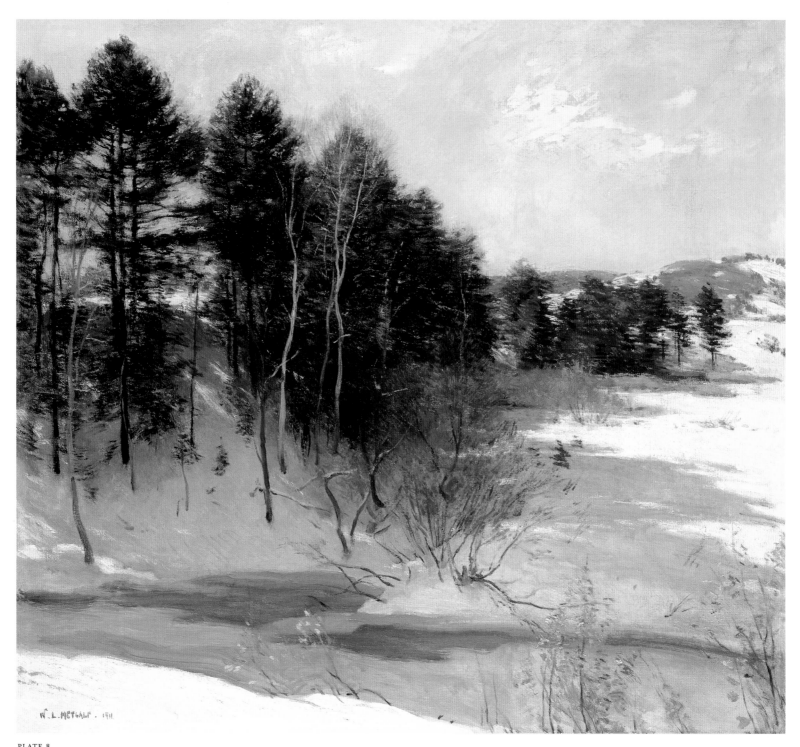

PLATE 8
Willard Leroy Metcalf (1858–1925)
Thawing Brook (Winter Shadows), 1911
Oil on canvas, 28 ⅛ x 29 ⅜ inches
Florence Griswold Museum;
Gift of the Hartford Steam
Boiler Inspection and Insurance Company 2002.1.93

he held his first one-artist show in New York the following year, and that summer joined Hassam at the Old Lyme art colony, which he had briefly visited two years earlier, staying at the Florence Griswold House, the center of art activities in the "American Giverny." It was that summer that he painted *Poppy Garden* (plate 40), a brilliant rendering of a field of poppies, reminiscent of both Monet and Hassam's earlier treatments of the same subject, a wildflower mass of blooms with the flat blue of the Lieutenant River in the background.

But while Metcalf's presence certainly confirmed the dominant Impressionist mode practiced in Old Lyme, the artist himself went on to earn himself the identification of the Poet- or Painter-Laureate of New England. He painted along the Connecticut coast and further into the state's northern hills; he continued to visit and paint in Maine; and many of his finest works were painted in and around Cornish, New Hampshire, and later in his career in Chester and Springfield, Vermont. He also became celebrated as a painter who understood and rendered superbly the variety of seasonal change; he was particularly renowned for his paintings of winter, and was acclaimed by some critics as a successor to the deceased Twachtman. Among his finest winter paintings are those he created in and around Cornish, beginning in 1909, a village and artists' community that he visited frequently during the next decade. Though not all, most of these are winter scenes, such as his beautiful rendering of *Thawing Brook* (plate 8), painted in 1911 during his delayed honeymoon with his second wife. Metcalf's Cornish snow scenes vary from softer, tonal renderings of landscapes visible through falling snow, to sharply observed forms, seen in the clear, crisp weather conditions noted here. These latter works are more dramatic, utilizing stronger contrasts of light and dark, with here the heavy row of white pines casting their purple shadows upon the white snow as they recede toward the distant hill-side. Metcalf is concerned here, too, with the actual changes of the seasons, as winter will eventually give way to spring, and as the snow will melt to enlarge the thawing brook of the title.

ROBERT REID

The majority of The Ten who worked in New York or are associated with that metropolitan area were active as much or more in landscape work as figurative compositions; the exception here is Robert Reid. Reid was almost entirely a figure painter, working in an Impressionist manner of high colorism and broken brushwork, often combining his images of lovely, healthy young American womanhood in the out-of-doors with flowers—garlands, bouquets, pots of flowers, even a wall of flowers—the age old alliance of human loveliness with the most beautiful harvest of nature. Many of these pictures even bore titular identifications with the blooms that were featured, so that an unknowing reader might expect a floral still life, rather than a figurative work. This is not true of Reid's *The White Parasol* (plate 41), painted in the summer of 1907 in Medfield, Massachusetts, where the young woman carries a bouquet of lilies, surely picked from the massive arrangements behind her and juxtaposed to the goldenrod in the lower right. The work shares with most of his painting of this period a flattening of space and a lack of shadow that increases the picture's decorativeness at the expense of volumetric reality. It is not certain when Reid developed this specialty, but he appears to have begun this series as early as 1896, while a whole book was published featuring these women-and-flower paintings in 1900. The parasol, too, was a frequent device among American Impressionist painters of female imagery. By the very nature of its function as a sun shield, the parasol introduces the suggestion of luminosity, though Reid here utilizes the solid sunburst form as a nearly flat foil for the intricate patterning surrounding his figure.

THE BOSTON SCHOOL

Edmund Tarbell, Frank Benson, his friend and colleague at the School of Boston's Museum of Fine Arts, and their associate, Joseph DeCamp, were the three Boston members of The Ten. Although they all painted landscapes, the three artists were celebrated above all for their figural work, which tended to concentrate upon familial images infused with gracious demeanor—no workmen or street figures marred the perception of Boston figurative Impressionism. After his academic studies in Paris in the 1880s, Tarbell was the earliest of the trio to turn to Impressionist strategies in 1890, especially under the impact of Sargent and Bunker. These strategies, in turn, were emulated by his colleagues, notably by Benson, painting images of his family in the out-of-doors first in New Castle, New Hampshire, and then on the island of North Haven, Maine. Benson's earliest, fully realized Impressionist work of this nature was *The Sisters* (plate 42) of 1899, depicting his children, Elizabeth and Sylvia, in the clear fresh air and glowing sunlight. The alertness of the children is mirrored in the active brushwork defining the hill on which they are placed, while the unbroken stretch of water beyond lends the blue component to the primary colors, along with white, defining Benson's chromatic mastery. Benson has caught the immediacy of the Impressionist aesthetic and molded it to his personal sympathy and affection for his children, while introducing a modernist note in the Japanese-inspired branches that decorate the upper edge of his canvas. While many factors were certainly at work here, it is not totally coincidental that Benson fully joined the Impressionist spirit with the formation of The Ten at the end of the century; *The Sisters* appeared in their annual exhibition in 1901. That same year, Benson began to summer on the island of North Haven in Maine's Penobscot Bay, first renting, and then purchasing Wooster Farm in 1906. This became the setting for many of his finest later outdoor

works, both coastal settings, continuing the format established by *The Sisters,* and interior wooded views, such as *Girls in the Garden* (plate 9), painted in 1906 where his three daughters, Eleanor, the oldest, Elisabeth, and Sylvia, the youngest, all in virginal white, relax in varied poses within the brilliantly sunlit setting, enjoying the diverse pleasures of gardening, which even more bespeaks the pleasures of family and home.

Joseph DeCamp's production of Impressionist work was far more variable. Much of his career was spent in portraiture, in which Impressionism played little or no part, and many of his other figural works were indoor scenes, quite dark and somber, cleaving to academic strategies. Perhaps no figural painting by him adopted the full range of Impressionist technique as his *June Sunshine* (plate 43), probably painted in 1902 in Gloucester, during the third of DeCamp's four successive summers painting in that artists' colony, where he reestablished his camaraderie with so many of his fellow Cincinnati-born colleagues who had studied in Munich. If the beauty and innocence of childhood was a major theme of the Boston Impressionists, as seen in Benson's *The Sisters,* maternal affection was another subject espoused by these artists, and interpreted here by DeCamp in brilliant color and sparkling light. His wife Edith, in softly elegant costume, reads to their daughter Sally, who is clothed in a white dress that absorbs colored shadows. They are silhouetted against a background of Gloucester's scintillating Wonson's Cove, with the pier from the Harbor View Hotel stretching out at the top, forming a distant horizontal enframement with the bench on which the figures comfortably sit.

It was Edmund Tarbell, earlier than Benson or DeCamp, who introduced Impressionist strategies into Boston figure painting in 1890, in some ways directly indebted both to Bunker who had returned from his summer with Sargent in 1888, and also from Sargent directly. Tarbell's

painting *My Wife, Emmeline, in a Garden* (1890; private collection) is directly indebted to Sargent's most Impressionist picture, *A Morning Walk* (1888; private collection), the painting of which Bunker would have witnessed in Calcot, and which was exhibited in Boston early in 1890. But over the years, Tarbell's artistic development and interests were more complex and varied than those of his colleagues. While he never abandoned the depiction of his growing family painted out-of-doors in bright sunlight, by the late 1890s, perhaps under the influence of the work of Edgar Degas, Tarbell began experimenting with more spatially complex indoor scenes, darker and more limited in tone, with a careful adjustment of much softer light, often penetrating the spaces either filtered through Venetian blinds or through veiled curtains. This allowed for a more careful control of the play of illumination, not only within the spatial configuration, but also over his figures, who are more calm and contemplative than his outdoor figures. By 1904, Tarbell had refined his technique by incorporating even more subtle light effects and greater elegance both in design and rarified subject matter in his iconic *A Girl Crocheting* (1904: Canajoharie Library and Art Gallery, Canajoharie, New York), which ushered in what has been termed the "Vermeer Revival." This work reflected a new appreciation for the previously ignored Dutch seventeenth-century master Jan Vermeer, an appreciation that had begun several decades earlier in Europe. All of these aesthetic elements coalesce in Tarbell's *Girls Reading* (plate 44) of 1907, where the carefully controlled light pours through the sheer curtains, distinguishing the elegant furniture and objets d'art, and defining, yet synthesizing the separate activities of the three lovely women of different ages. The emphasis here conforms to Tarbell's own stated belief in the purpose of art to render beauty—beauty both of light and space as well as the beauty of objects and figures, and of the latter's interrelationships.

PHILADELPHIA

The majority of the most renowned painters working in the Impressionist manner in America were based in Boston and New York. For reasons too complex to analyze here, Philadelphia, the third metropolis in the Northeast, was not as congenial to either the production or the patronage of Impressionism, certainly due, in part, to the continuing academic emphasis fostered there by her greatest artist-teacher, Thomas Eakins, and continued by his followers, such as Thomas Anshutz. Nevertheless, there was a thriving school of Pennsylvania Impressionism, centered at the artists' colony in New Hope on the Delaware River, founded in 1899. The Pennsylvania Impressionists, often viewed as obsessed with direct transcription and lacking poetic resonance, were in their own day contrasted with the elitist aestheticism of the Boston school, just described. These artists have usually, in the past, been characterized as creating large, dramatic, often snow-filled landscapes in which figures were rare and color was often minimalized.

NEW HOPE

Recent scholarship, however, has proven a far wider range of both aesthetic and thematic interest among the artists working in New Hope in the early twentieth century, with Daniel Garber and Robert Spencer both producing paintings often equal or even superior to those of their colleagues. After studying abroad, Garber, whose range of both subject matter and technical variety was greater than any of his colleagues, settled in Lumberville, Pennsylvania, just up the Delaware from New Hope. Garber was especially intrigued with views across the river, often focusing upon the quarries at Byram, New Jersey, and elsewhere. But in his 1912 prize-winning masterpiece, *Wilderness* (plate 45), the artist enframes the distant Jersey cliffs, softly rendered and dotted with private residences, with dark and dramatic vine-entwined trees in the foreground, painted as a fantasia

Frank Weston Benson (1862–1951)
Girls in the Garden, ca. 1906
Oil on canvas, 30 x 25 inches
Collection of Rhoda and David Chase

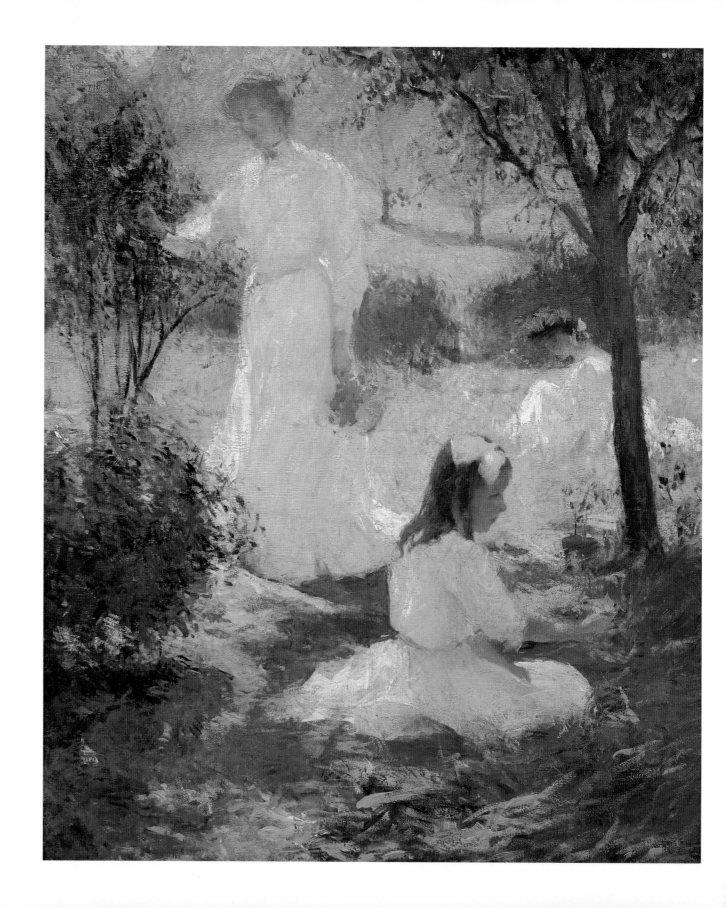

of the utmost detail, the two components separated by the broad blue stream of the Delaware River.

Garber was a superb figure painter as well as a landscapist. Indeed, a number of the leading Pennsylvania Impressionists devoted their talents primarily to the figure. Among the group, Robert Spencer, a pupil of Garber's, was the most original, shunning the verdant colorful landscapes and elegant women and children who populated most Impressionist work. In fact, though we have emphasized how often American Impressionists chose themes of labor, Spencer was the one major artist to devote most of his career to documenting the working class while utilizing the strategies of Impressionism. From 1906 to the early 1920s, Spencer worked among the various Delaware River towns from New Hope to Frenchtown, New Jersey, painting tenements and scenes of common folk going into or from the silk, cotton, and grist mills of the region. As with his impressive and typical *Five O'Clock, June* (plate 46) of 1913, depicting the women workers emerging from the mills, Spencer's palette was more muted than that of his teacher and most other Impressionists. In addition, in this work he utilized the sparse grandeur of the mill structures themselves to form the backdrop to his scene, contrasting them with the impressionistically painted foliage beside and behind them.

THE SOUTH

By the turn-of-the-century, Impressionist work had been on view in almost every city of any size in the United States, and artists utilizing Impressionist strategies could be found throughout the nation. Nevertheless, regional responses differed widely, with patrons and critics in some areas responding to Impressionism enthusiastically, while others maintained allegiance to more conservative aesthetics. The reasons for these discrepancies varied, including such factors as the strength of the academic traditions that dominated the local academies, to the migration of the more original talents in some communities to the more profitable artistic markets of the Northeast. While there were, for instance, Southern painters who examined contemporary life in terms of the color, light, and broken brushwork of Impressionism, they were relatively few, and one of the finest of these, Helen Turner from New Orleans, migrated in 1906 to the artists' colony in Cragsmoor, New York. At the time, Cragsmoor was a community of painters of diverse artistic sympathies, among whom Turner was the one most committed to Impressionism. This is to be seen especially in her outdoor scenes of lovely, demure young women situated in gardens or on porches, as in her 1904 masterpiece, *Girl with Lantern* (plate 47). As here, her subjects are sometimes accompanied by Japanese lanterns—which are, themselves, vehicles for light—constituting at least an indirect homage to Sargent's renown *Carnation, Lily, Lily, Rose*. But Turner infuses her pictures with her own broad spectrum of radiant color and scumbled brushwork, here centering upon the young woman dressed in a white dress dappled with reflections from the multi-colored lanterns and rich garden foliage surrounding her.

Probably the most significant Impressionist to reside and paint in the South was Gari Melchers. Originally from Detroit, Melchers had expatriated to The Netherlands in the late nineteenth century, where, during the first decade of the twentieth century, he had turned from native peasant genre and religious subject matter to Impressionist garden and domestic scenes. Melchers returned to the United States in 1915 and purchased a home in Fredericksburg, Virginia, in 1916, where the scintillating brushwork of bright colors and soft, tranquil sunlight documented the quiet pleasures of small-town life, such as in his view of the Presbyterian *St. George's Church* of about 1919-20 (plate 48).

THE MIDWEST

In the Midwest, most attention has been given to the Impressionist achievements of a group of Indiana painters—the "Hoosier School," as

they have been identified in literature—whose core members included artists William Forsyth, John Ottis Adams, and most notably Theodore Steele. The attention these artists have received is due both to the quality of their pictorial accomplishments and also to the fact that, unlike the celebrated Impressionists from other Midwestern centers—one thinks of John Twachtman and Joseph DeCamp, for instance, both from Cincinnati, who settled in their maturity in the Northeast—the Hoosiers chose to return to their native state after studying abroad. There, in the 1890s, they gradually abandoned the darker tones and peasant genre they had painted while studying in Munich, and instead celebrated in rich colorism the beauty of Indiana's small towns, streams, and valleys, and especially the hills of Brown County, which became the Midwest's leading art colony. The most renown of the Hoosier Group, Theodore Steele, built a home in Brown County, but painted in an increasingly Impressionist manner throughout the state. *November Morning* (plate 49) was painted in 1904 in the Whitewater Valley of Indiana, where since 1898 Steele had shared a home and studio with his fellow Hoosier, John Ottis Adams, in Brookville, close to the eastern boundary of the state. Devoted to the local landscape, the paintings of Steele and his associates were hailed by many cultural leaders in the Midwest as creating a distinctly native achievement, at once modern but clearly American.

CALIFORNIA

The one region of the United States that responded resoundingly to the strategies of Impressionism, though almost a generation after American artists in France began to utilize this mode in the 1880s, was California, Southern California especially; many Northern California artists remained enthralled to the more muted tones and poetic aspects of Tonalism. The reason for the impact of Impressionism in the south are many and have been much discussed, but the peculiar and intense nature of the light of Southern California has always been recognized as an important factor. Another is the relative freshness of the culture there, as opposed to the Bay Area in the north, and the ensuing receptivity of so many of the artists in the region, from Santa Barbara to San Diego, to a more modern aesthetic course. Still another, more simple and direct explanation lies in the community of painters who lived and worked together, often with homes in the Arroyo Seco area of Pasadena and especially in the artists' colony they established in Laguna Beach. This was the most important such colony in the West, where Impressionism flourished, and where the natural terrain of broad coastline and cliffs, the deep blue of the sea, the interior hills and mountain ranges, and the nearby desert, as well as the all-pervasive luminosity, inspired many painters to explore a rich range of color and light.

Still another meaningful factor here was the arrival and integration of American Impressionists who had been previously active in Giverny in France, artists such as Alson Clark and John Frost, as well as shorter-term stays of painters like Frederick Frieseke and Richard Miller, whose work attracted a good deal of positive critical notice as well as local patronage. Of all these painters, the most celebrated was Guy Rose, a California native who returned to his home state in 1914 and went on to achieve exceptional acclaim; he is the one California Impressionist whose work today enjoys national celebration. Rose had been an integral part of the later generation of Americans in Giverny, returning to the United States in 1912 and to California in 1914, where he immediately was recognized as a leading figure in the Southern California art colony, a position reinforced by his teaching at the Stickney Memorial School of Art in Pasadena, where he became director in 1918. He first gained recognition for his French subjects, exhibited in both group and one-artist shows, but by 1917 the majority of the pictures

he exhibited were California subjects, including some painted in the Sierra Mountains. One of the finest of these is entitled *Sunset Glow* (plate 50), also known earlier as *Sunset in the High Sierras*, probably the finest of a series of paintings he created in the Sierras. It is a marvelous work that captures the glory of California mountain scenery with flickering brushwork in the full chromatic spectrum and diffused light that appears unique to Southern California. Though the painting was first exhibited in 1923, Rose had suffered a debilitating stroke early in 1921, and therefore the picture must date from the late 1910s.

Rose painted locally in Pasadena and at the San Gabriel Mission, and he was also active further south, both at Laguna Beach and La Jolla. But from 1918-20 he spent his summers up at Carmel, on the Monterey Peninsula in Northern California, which was home to the state's other major art colony. There, he specialized in pictures of the Carmel dunes and of the rugged coastline, painting a number of renderings of *Point Lobos* (plate 10) of ca. 1918, which is at the southern end of Carmel Bay, on the Pacific Ocean. The color here is even more intense than Rose's work in the south, but the difference in the light between the north and south is telling, for instead of the warm diffusion of *Sunset Glow,* the light here is extremely clear and sharp, detailing the monumental and unusual rock formations which attracted so many painters to this spot on the California coast.

Impressionist and Tonalist painters, primarily landscape specialists, mixed freely in the Carmel-Monterey art colony, which had come into being as a refuge after the disastrous earthquake and fire in San Francisco in 1906. One of the finest, if least known, of the Impressionist specialists there was Ernest Bruce Nelson, who had established himself in the community of Pacific Grove on the Monterey Peninsula in 1913. Nelson's *Pacific Grove Shoreline* (plate 51) of ca. 1915 bears a good deal of similarity to Guy Rose's rendering of the shoreline a little to the south, though the more panoramic sweep and more simplified forms are typical of

Nelson's art, and the patchy brushwork may be allied to the aesthetic of his Southern California contemporary, William Wendt. Nelson's involvement with the California art scene was relatively brief, for after serving with the United States Army in World War I, he moved to Cooperstown, New York.

GIVERNY LUMINISTS

When Guy Rose returned to the United States in 1910, he had left Giverny, where he had become part of a new generation of art colonists, the art of which differed greatly from that of Theodore Robinson and the other early artist-visitors to the village. Beginning in the second half of the 1890s, the leading foreign artists in Giverny were Frederick and Mary MacMonnies, who acquired a large, abandoned walled monastery. Their home and estate became the center of the colony, though artists continued also to stay at the Hotel Baudy. The village and its inhabitants are rarely visible in these later Giverny paintings. The MacMonnies, their colleagues, and his students, tended to concentrate on views within the MacMonnies's property, and when figures were involved they were either the artists and their families or professional models from Paris.

While the MacMonnies's stayed in Giverny in the early years of the twentieth century, still another "generation" of artists appeared in the 1900s. Guy Rose and his wife were among the first, but the new leader of the colony was Frederick Frieseke, who had first visited in 1905, and then settled there for half the year from 1906 through 1919, renting a house next door to Monet's. It was Frieseke who introduced a new version of the Impressionist aesthetic by about 1908/09, one to which Rose among many other painters subscribed. These artists, too, like the MacMonnies, disengaged themselves and their art from village life, and concentrated on their immediate environment, both home life and especially the abundant floral garden on Frieseke's property, such as that artist's *Hollyhocks* (plate 52), painted by 1914. Perhaps using his wife as a

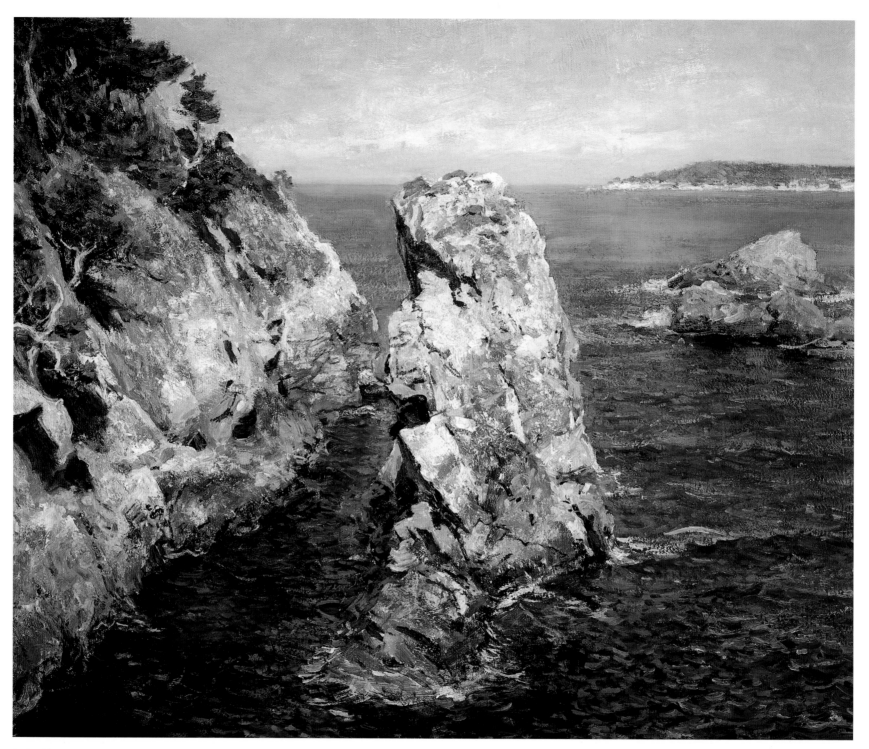

PLATE 10
Guy Rose (1867–1925)
Point Lobos, ca. 1918
Oil on canvas, 24 x 29 inches
Private Collection, Courtesy of
The Irvine Museum, Irvine, California

model, the figure stands among a pattern of growing hollyhocks of different hues in the bright sunshine. The painting confirms the artist's assertion that his inspiration derived rather from his love of sunlight and the sparkle of different colors, than an interest in flowers, per se. The sense of pattern and decoration here, characteristic of this later generation of Giverny colonists, allies the work also with some aspects of Post-Impressionism.

In December of 1912, Frieseke and three others of what has been called the "Giverny Group" or the "Giverny Luminists" held a highly acclaimed exhibition at New York's Madison Art Gallery. These included the aforementioned Guy Rose, Lawton Parker, and Richard Miller, who arrived in Giverny around 1907 and remained for the summers through 1911, active both as a painter and teacher. Miller was then and has remained the most celebrated of the group along with Frieseke; a close friend of Frieseke, the two artists exhibited together a number of times and adopted many of the same artistic strategies. It was probably about 1910 that Miller turned from specializing in depictions of elegant women in indoor settings to outdoor scenes. Indeed, Miller's *A Gray Day* (plate 53) of 1910-11, was probably painted in Frieseke's Giverny garden, and centers around a white pool there, while the green lawn furniture also appears in many of Frieseke's pictures. The bucolic setting, too, and the very feminine, domestic engagement at teatime characterizes many paintings by the Giverny Group. Particularly favored by Miller are rich and voluminous costumes, and the contrast between the very impressionistically painted setting and the more careful, even academic treatment of the face and hands of the model herself are typical of Miller's approach.

THE NETHERLANDS

Outside of France, American involvement in artists' colonies in Europe was particularly strong in The Netherlands; Gari Melchers had dominated the colony at Egmond before his return to the United States and it was in his last years there that he began to explore the Impressionist mode. Many small villages in Holland welcomed scores of artists, but probably the most renown of the artists' communities was Laren. One of the Americans to paint there during the first decade of the twentieth century was Joseph Raphael from San Francisco. Like Guy Rose, Raphael was California-born; however, unlike Rose, Raphael spent almost his whole creative life abroad, returning to his home town only at the beginning of World War II. During the 1900's, Raphael, who had married a Dutch woman, produced a number of monumental, dramatic figure paintings of local inhabitants of Laren, though he sent his work back to San Francisco where he had exhibitions and found patronage. Then, in 1912, he moved to Uccle, a suburb of Brussels, Belgium, and remained there until 1929 when he returned to Oegstgeest in The Netherlands. Just prior to his move to Belgium, Raphael's methodology had changed radically, and he began to paint colorful outdoor scenes, sometimes involving figures and often set in fields of flowers or in vividly rendered gardens, such as *The Garden* (plate 54) of 1913. Evolving a unique synthesis of Impressionist and Post-Impressionist strategies, Raphael applied his paint in large dabs, creating a decorative, Post-Impressionist tapestry, while flattening space and simplifying forms. At the same time, his tendencies involved broken and Pointillist-inspired brushwork, and he adopted the heightened colorism, simplification, and decorative patterning of Vincent Van Gogh, the Post-Impressionist with whom he shared the greatest affinity. The painting of Van Gogh, in fact, would seem to have been the deciding factor in Raphael's turn from the strong, dark naturalism of his Laren period to his involvement with Impressionist and Post-Impressionist strategies. Van Gogh's work began to be strongly appreciated in his native Netherlands in the first decade of the twentieth century, and the painters of the art colony in Laren were greatly impressed by his work. After about 1916-17, Raphael moved even further in a Modernist direction, abandoning his Impressionist methodology and charging his painting with Expressionist distortion.

THE NEXT GENERATION

By the time of the Panama-Pacific Exposition held in San Francisco in 1915, and certainly by the end of that decade, Impressionism, once a vital, modern force in American painting, had become both conventionalized and conservative in the light of newer developments in American art. Except for Childe Hassam, most of the leading artists of the movement were deceased or, like Mary Cassatt, incapacitated, and even Hassam, with his "Flag" series behind him, had completed his most original contributions to our art. "The Ten American Painters" had ceased their annual exhibitions and the Boston contingent of that group, still active and now regarded as the standard bearers of American Impressionism, were seen as an elitist clique, increasingly remote from the mainstream of American life. As a prevailing movement in the United States, Impressionism had been replaced, first in the 1900s by the urban realism of the "The Eight" or the Ashcan School (centered on artists Everett Shinn, John Sloan, George Luks, William Glackens, and Robert Henri), and then, with the Armory Show in New York City in 1913, by the impact of European modernism, as exemplified in the art of Picasso and Matisse.

Yet, among The Eight—the painters whose exhibition at New York's Macbeth Gallery in February of 1908 defined the growing concern for the rendering of the vitality of contemporary city life—there were several whose paintings still reflected the aesthetics of Impressionism. One of these was Boston's Maurice Prendergast, whose early pictures, his watercolors especially, such as his *Ladies with Parasols* (plate 55), in their projection of outdoor daily pleasure rendered in shimmering brushwork and bright colors, still fit well into the Impressionist format. This work was painted around 1896-97, most likely at Boston's Revere Beach or Nantasket, between the artist's first two trips abroad, and before he became increasingly imbued with the formal innovations of Cézanne and the French Modernists. The watercolor

demonstrates Prendergast's ability to handle large groups of figures, imbuing each with distinction in their poses, while concentrating his restless brushwork on the two ladies in the foreground, and contrasting the generally neutral tones of the beach setting with the brilliant red washes of their parasols.

Of the members of The Eight, it was Ernest Lawson who maintained the closest ties with mainstream American Impressionism, and, as a student of Twachtman's, remained throughout his career primarily a painter of the land- and cityscape, rather than the figure. Although he also painted in the countryside, Lawson's principal motifs were the upper reaches of Manhattan and the shore of the Harlem River, looking toward the Bronx and often incorporating the bridges linking the two boroughs, as in his *Harlem River* (plate 56) of ca. 1911, in which the High Bridge appears in the distance. Though ostensibly a painter of New York City, Lawson preferred the sparsely settled reaches of upper Manhattan, treating them, as here, more as pure rural landscapes, with greater settlement on the shore and atop the hillside across the river. His color range is varied and Impressionistic, though the paint is applied in broken, uneven strokes, and with the thick impasto that constitutes one of Lawson's most distinguishing features.

Painters did not, of course, abandon the Impressionist aesthetic with the advent of the Ashcan School and the inroads of European modernism; indeed, Impressionist pictures continue to be painted today. But the period from about 1885 to 1920 constitutes the years of its ascendancy and the achievements and innovations of the principal American masters of the movement, so many of whom we honor here with examples of some of their finest work.

Edmund Tarbell (1862–1938)
Girls Reading, detail of plate 44, 1907
Oil on canvas, 25 x 30 inches
Shein Collection

THE PLATES

William Merritt Chase (1849-1916)

Over a period of nearly five decades, William Merritt Chase produced a large and diverse body of work ranging from portraits, interiors, and still lifes executed in a dark Realist manner to landscapes and outdoor genre scenes done in a sparkling Impressionist mode. Charismatic, sophisticated, and blessed with an abundance of talent, he was extremely successful in New York art circles, both as an artist and a teacher.

Chase was born in Williamsburg (later Ninevah), Indiana. Although his father hoped his son would follow his example and enter the shoe business, Chase rejected the pursuit of this profession in favor of an artistic career. He began his formal training in Indianapolis in 1867, studying with the portraitist Barton S. Hays. He then went to New York, spending two years at the National Academy of Design, where he was taught by Lemuel E. Wilmarth. After painting portraits and still lifes in St. Louis during 1871, Chase went to Munich, resuming his education at the Royal Academy of Fine Arts under Karl von Piloty and Alexander von Wagner. Most importantly, he assimilated the dark palette and suggestive handling associated with Munich Realism, as exemplified in the work of the young German painter Wilhelm Liebl.

In 1878, after a sojourn in Venice, Chase returned to New York and moved into the legendary Tenth Street Studio Building, where he maintained a stylish and very opulent studio decorated with antiques, bric-a-brac, and his own collection of paintings. It was at this time that he embarked on his dual career as a teacher, joining the faculty of the Art Students League, where he taught intermittently until 1912. He went on to become one of the most influential art instructors of his day, holding teaching posts at the Pennsylvania Academy of the Fine Arts, the Brooklyn Art School, and elsewhere. He was also the founder of two art schools—the Shinnecock Summer School of Art, on Long Island, and the New York School of Art. His innumerable students included such notables as Rockwell Kent, Charles W. Hawthorne, and Georgia O'Keeffe.

A giant among his peers, Chase was a dynamic and popular figure on the New York art scene, participating in the activities of the city's leading art societies, including traditional institutions such as the National Academy of Design and the more the innovative and progressive Society of American Artists, organized by a group of young, foreign-trained painters in response to the Academy's conservatism. He was also a founding member of the Society of Painters in Pastel, established in New York in 1882 in response to the revival of interest in that long-neglected medium. Indeed, pastel's easy portability made it an ideal medium for recording on-the-spot impressions. Accordingly, Chase produced many pastels during his extensive travels abroad, among them *Reflections, Holland* (plate 12). Executed during a trip to The Netherlands, when he first began working en plein air, this work was among his contributions to the Society's 1884 annual exhibition.

Although Chase had the opportunity to see examples of French Impressionist painting abroad, he was no doubt deeply inspired by the exhibition of Impressionism held at the galleries of Durand-Ruel in New York in the spring of 1886. Stimulated by the Impressionists' emphasis on depicting modern life and middle-class leisure, as well as by their innovative technique, he produced a number of works depicting the parks in Brooklyn as well as New York's Central Park, capturing the brilliance of a summer's day and the joys of outdoor recreation in paintings such as *Boat House, Prospect Park* (plate 11).

Chase painted some of his finest outdoor subjects in Shinnecock, Long Island, where he taught plein air classes from 1891 to 1902. Like his Impressionist cohorts in Boston, he frequently used his family members as models, as is the case with *Beach Scene-Morning at Canoe Place* (plate 13). This dazzling work is a classic Chase, revealing his rapid technique and love of sunlight, as well as his desire to translate the more idyllic moments of life into paint.

PLATE 11
William Merritt Chase (1849–1916)
Boat House, Prospect Park, ca. 1887
Oil on panel, 10 ¼ x 16 inches
Private Collection

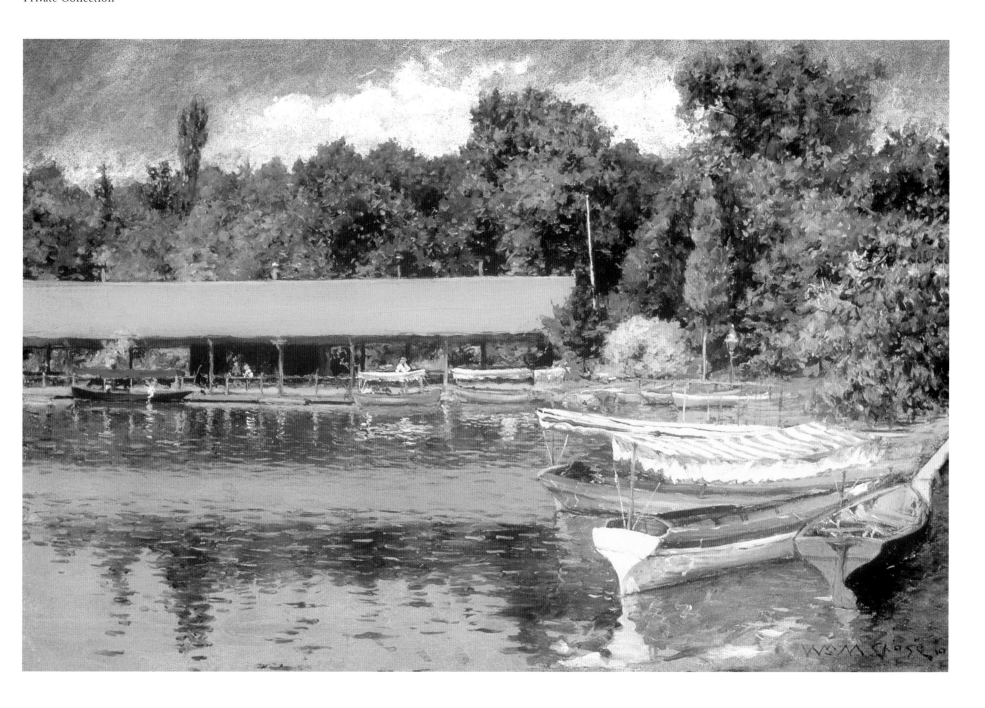

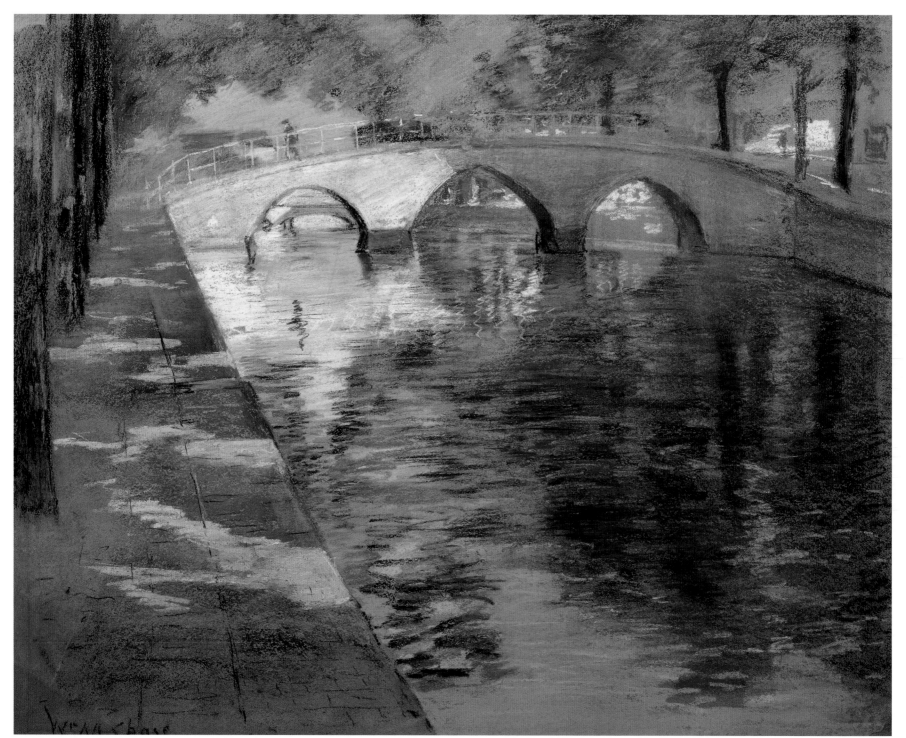

PLATE 12
William Merritt Chase (1849–1916)
Reflections, Holland, 1883
Pastel on paper, 24 x 30 inches
Private Collection, Courtesy of
Spanierman Gallery LLC, New York

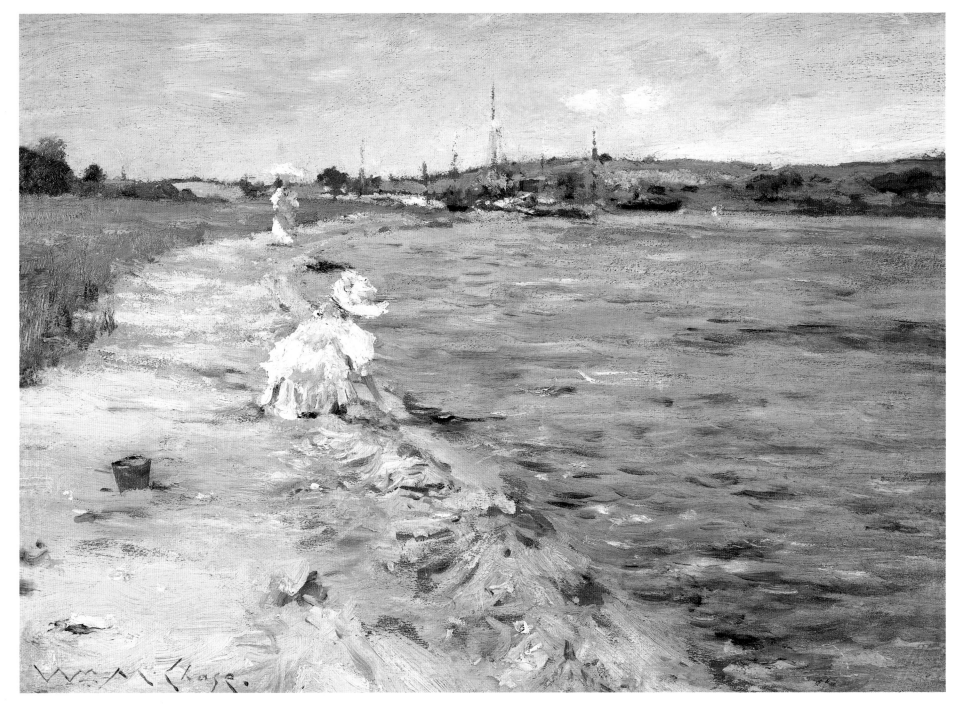

PLATE 13
William Merritt Chase (1849–1916)
Beach Scene — Morning at Canoe Place, ca. 1896
Oil on wood panel, 9 ¾ x 14 inches
Private Collection

Mary Cassatt (1844-1926)

The first American painter associated with the Impressionist movement, and the only one to exhibit with the French Impressionists, Mary Cassatt focused on the portrayal of contemporary life, especially in relation to the dual themes of modern motherhood and the leisure activities of upper-class Parisian women. A major figure in international art circles, she lived an expatriate lifestyle, but influenced the Impressionist tradition at home by encouraging well-to-do American collectors to acquire paintings by her French cohorts. Described as "one of the first of the moderns to attract serious attention in Europe," her extraordinary success set an example for many painters, especially a younger generation of women desirous of making their mark in the art world.[1]

The daughter of an affluent banker of French descent, Cassatt was born in Allegheny City (now a Pittsburgh suburb), Pennsylvania. She grew up in Philadelphia, but as a child spent five years in France and Germany. She enrolled in classes at the Pennsylvania Academy of the Fine Arts in 1860 and studied there intermittently for the next five years. In 1866 she went to Paris, where she received private instruction from several teachers—among them the revered academician Jean-Léon Gérôme as well as Charles Chaplin, known for his portraits of stylish women—and studied the work of Old Masters in the Louvre. She made her debut at the Paris Salon in 1868 and exhibited there fairly regularly until 1876.

Cassatt returned to Philadelphia for the duration of the Franco-Prussian War, but by 1871 she was back in Europe, touring the Continent before settling in the French capital around 1873. At this point in her career, she was moving away from conventional academic painting and, inspired by the new school of Impressionism, had developed a more fluid style and a gayer palette which she applied to depictions of domestic life featuring women enjoying a night at the opera, taking tea, or simply relaxing, as in her lovely *Woman on a Striped Sofa with a Dog (Young Woman on a Striped Sofa with Her Dog)* (plate 14), painted around 1875.

Cassatt's interest in progressive pictorial strategies went hand in hand with her growing familiarity with the French Impressionists themselves, especially the painter Edgar Degas, with whom she formed a close and lasting friendship. Indeed, in 1877, when the conservative-minded jury rejected her submissions to the annual Salon, Degas invited her to exhibit with the independent Impressionist group, which she did—in 1879, 1880, 1881, and 1886. In fact her *Lady with a Fan (Anne Charlotte Gaillard)* (plate 3), a vivid depiction of a stylish young Parisienne dressed for an outing at a ball or an opera, may have appeared in the Impressionist exhibition of 1880 under the title *Portrait of Mlle. G.*

Cassatt painted the figure not only in indoor settings, but in outdoor locales too, as revealed in her charming *In the Park* (plate 15), a tender portrayal of a self-possessed child and her vigilant guardian shown against a backdrop that includes a verdant flower garden. Taking her aesthetic cue from Degas, Cassatt also explored the aesthetic possibilities of pastel, a medium that enjoyed renewed interest among the Impressionists. Her thorough command of these dense chalky crayons is demonstrated in works such as *The Young Mother* (plate 16), executed around the turn of the century. This exquisite rendering of an infant cradled in its mother's arms reveals the precision and clarity of Cassatt's draftsmanship, her solid modeling of the human form, and her emphasis on simplified, closely cropped designs which allow the viewer to concentrate directly on the subjects without any distracting background elements.

In 1893, Cassatt purchased the Château de Beaufresne, in Mesnil-Théribus, on the outskirts of Paris, where she spent her later years. Throughout the early 1900s, she became an advocate for women's suffrage and continued to advise American art collectors in their purchases. Around 1914, failing eyesight due to cataracts put an end to Cassatt's activity as an artist. She died at her country house on June 14th, 1926, at the age of eighty-three.

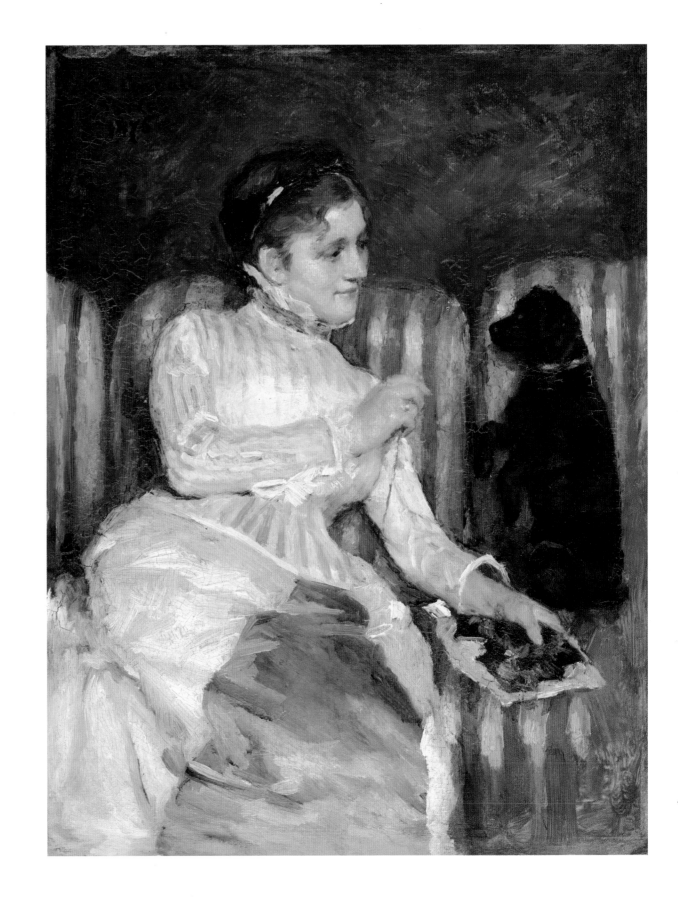

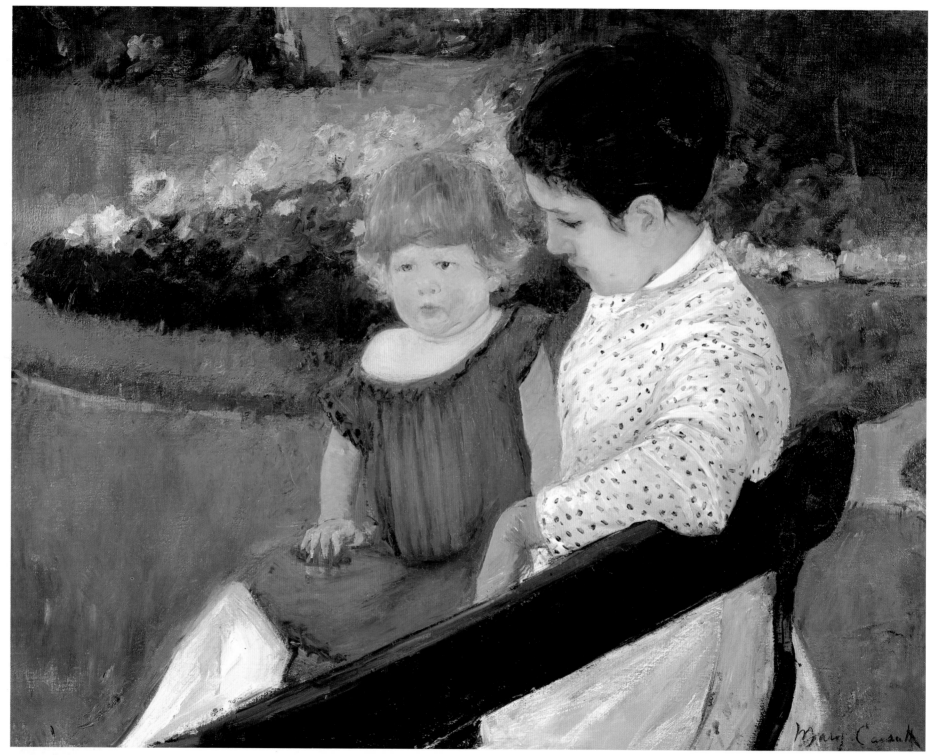

PLATE 15

Mary Cassatt (1844–1926)

In the Park, ca. 1893–94

Oil on canvas, 29 x 36 ½ inches

The Collection of Mr. Fayez Sarofim

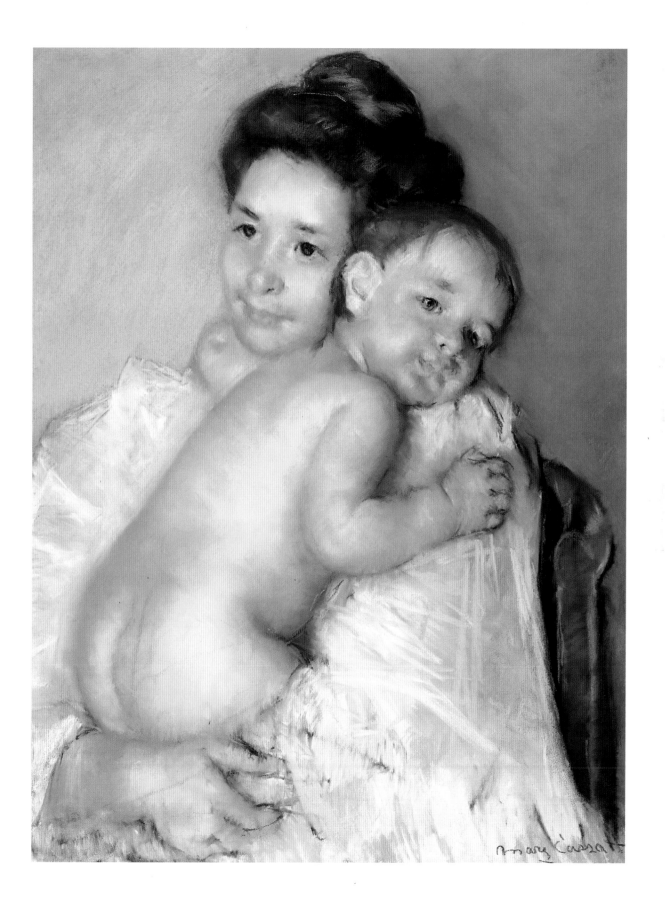

John Singer Sargent (1856-1925)

John Singer Sargent is best known for his outstanding achievements as a portraitist of international society. However, his extensive summer travels provided him with the opportunity to paint outdoors, during which time he applied the tenets of Impressionism to landscapes and figure subjects.

Born in Florence to American parents, Sargent began studying art in Rome in 1868. He received intermittent instruction at the Accademia delle Belle Arti in Florence between 1870 and 1873, and then went to Paris, where he trained in the atelier of the portrait painter Emile Auguste Carolus-Duran and studied drawing at the Ecole des Beaux-Arts. In subsequent years, his travels to locales such as Spain and Holland exposed him to the work of Old Masters such as Diego Velázquez and Frans Hals, which in turn influenced his own bravura portrait style.

By 1880 Sargent was well established as a portraitist of affluent members of European and American society. He was initially based in Paris, but when his controversial rendition of Madame Pierre Gautreau created a scandal at the Salon of 1884, he moved to London, where he lived for the remainder of his career.

During his years in Paris, Sargent had ample opportunity to familiarize himself with French Impressionist painting. He met Claude Monet in Paris in April of 1876 and around 1885 he began spending time with the revered master, both in Paris and in the village of Giverny, where Monet had settled in 1883. However, Sargent made some of his earliest forays into Impressionism not only in France, but also in the village of Broadway, located in the Worcestershire district of England, where he spent the summer and early autumns of 1885 and 1886. Experimenting with the vivid colors and spontaneous brushwork of the "New Painting," he created lively outdoor studies such as this portrayal of Dorothy Barnard (plate 17), a daughter of Frederick Barnard, one of Sargent's English friends. Painted in a fluid manner with intense colors, this painting served as a prelude to his masterwork *Carnation, Lily, Lily, Rose* (1885; Tate Gallery, London), which created a stir when exhibited at the Royal Academy in 1887 and is said to have marked the beginning of the Impressionist tradition in England.

Sargent painted his most fully Impressionist canvases during the late 1880s, setting an example that inspired other artists, including the young American painter Dennis Miller Bunker, who visited him at Calcot, England in 1888. Portraiture remained his primary artistic pursuit until around 1900, when he began to devote most of his time to dazzling, light-filled watercolors painted on holiday excursions to Italy, the Canadian Rockies, and Florida. Although he retained a cosmopolitan lifestyle, Sargent maintained close ties with America, especially the city of Boston, where he exhibited his work, executed portrait commissions, and produced mural decorations for the Boston Public Library (1890-1919), the Museum of Fine Arts (1916-25), and Harvard's Widener Library (1921-22).

PLATE 17
John Singer Sargent (1856-1925)
Dorothy Barnard
(Study for Carnation, Lily, Lily, Rose), 1885
Oil on canvas, 28½ x 19½ inches
Private Collection

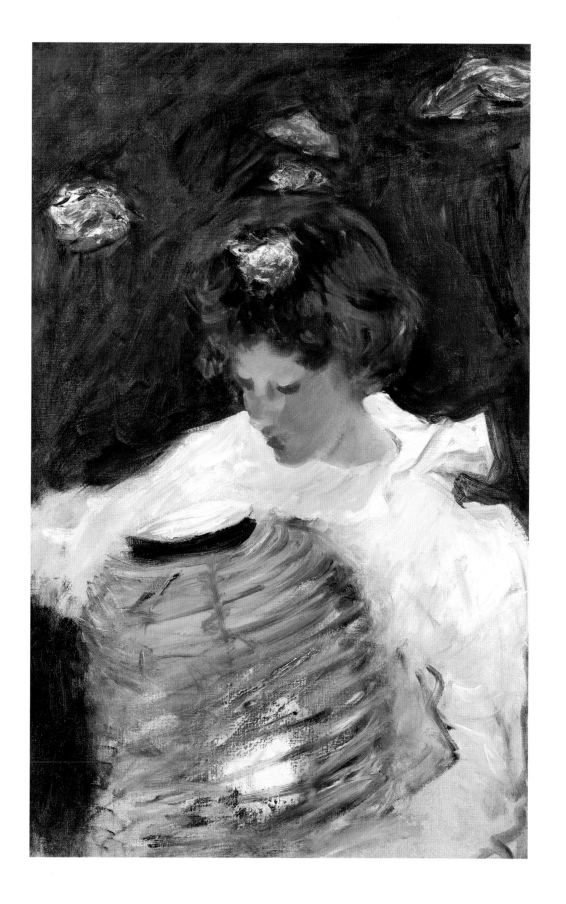

53

Dennis Miller Bunker (1861–1890)

Over the course of his all-too-brief career, Dennis Miller Bunker achieved recognition for his portraits and his Impressionist-inspired landscapes. The New York-born painter initiated his artistic training in his hometown, studying at the National Academy of Design and then at the Art Students League. In the autumn of 1882 he traveled to Paris for further instruction at the Académie Julian and the Ecole des Beaux-Arts, where he worked in the atelier of the much-admired figure painter Jean-Léon Gérôme. During his three years in France, Bunker painted in the countryside, working in a moody tonal manner influenced by the contemporary Barbizon School.

In 1885 Bunker settled in Boston, joining the faculty of the newly founded Cowles Art School and having a one-man show of his work at the Noyes & Blakeslee Gallery. He quickly won fame as a local society portraitist, attracting patrons such as Isabella Stewart Gardner and J. Montgomery Sears, among the city's leading tastemakers. It was probably through his connection with Mrs. Gardner that Bunker met the painter John Singer Sargent, who invited him to visit him in Calcot, in Berkshire, England, in 1888. Seeing Sargent's colorful and rapidly painted Impressionist landscapes had a direct impact on Bunker's own plein air work, causing him to adopt a brighter and more varied palette and abandon his tightly structured designs. He returned to America and resumed his activity as a portraitist, working in a dark painterly manner. However, he adhered to a more progressive, Impressionist approach in the intimate landscapes he painted during the summers of 1889 and 1890 in the town of Medfield, Massachusetts, about fifteen miles southwest of Boston. Notable for its soft, fluent brushwork and fresh hues, *Meadow Lands* (plate 18) is one such canvas—a testament to Bunker's astute observation of outdoor light and his desire to experiment with modern modes of expression.

Intent on establishing his reputation in the nation's art capital, Bunker moved back to New York City in 1889. Although portrait commissions were slow in coming, he was sustained by support and backing from several influential figures in the art world, including the painters William Merritt Chase, Thomas Dewing, and Charles Adams Platt. He was also friendly with architect Stanford White, who commissioned him to paint ceiling decorations for the Whitelaw Reid house in New York. Regrettably, Bunker's promising career was cut short when he died unexpectedly of pneumonia in December of 1890, only a few months after his marriage to Eleanor Hardy, a wealthy Bostonian.

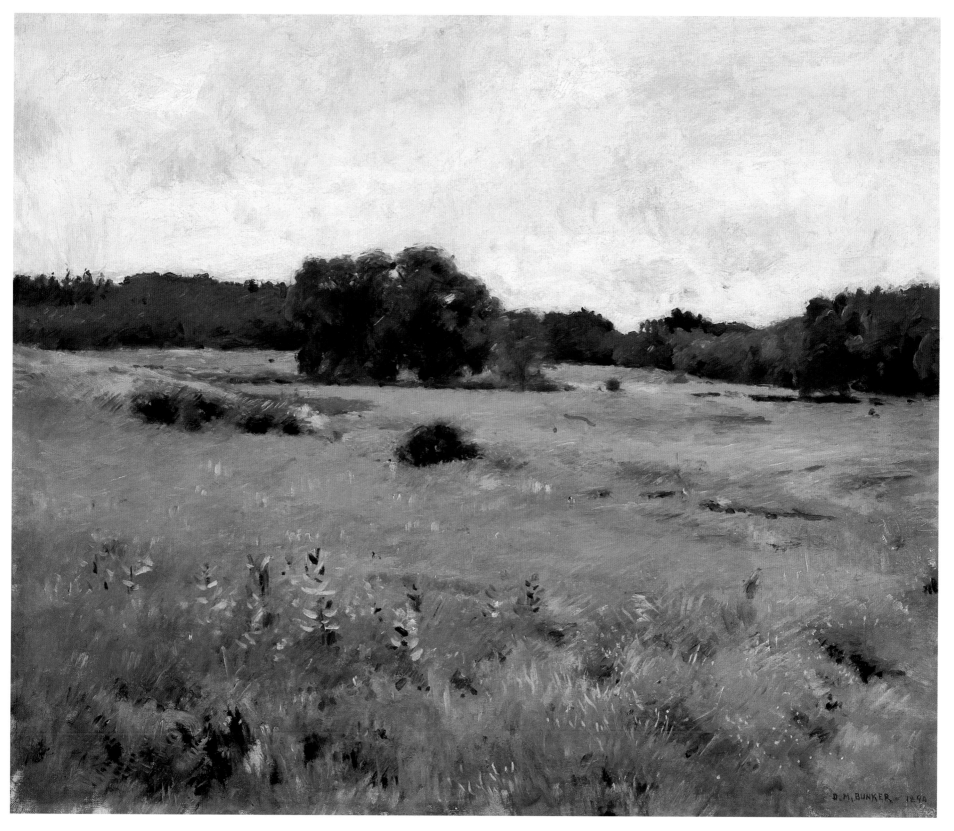

Theodore Robinson (1852–1896)

A painter of landscapes and figure subjects, Theodore Robinson played a vital role in the propagation of Impressionism in the United States. Born in Irasburg, Vermont, he grew up in Evansville, Wisconsin, where, as a child, he first became interested in art. He received a conventional academic training, studying in Chicago and New York before going to Paris in 1876, where he received instruction from Emile Auguste Carolus-Duran and attended Jean-Léon Gérôme's classes at the Ecole des Beaux-Arts. He came back to America in 1879 and divided his time between New York, Boston, and Nantucket until 1884, when he made an extended visit to France.

During this second trip abroad, Robinson was active in Paris, as well as in pastoral locales such as Barbizon, Cernay-la-ville, and Grèz-sur-Loing. In 1885 he visited the Normandy village and artist's colony of Giverny, which served as his primary residence from 1888 until 1892. A modest, industrious painter, Robinson was one of the few members of the American Givernois to become friendly with Claude Monet, the town's famous resident artist. Influenced by Monet's example, he abandoned his dark, Barbizon-inspired style in favor of Impressionism. Like his friend and mentor, Robinson took great delight in the varied colors of nature and sought to portray transitions of light and air at different times of day under varying climatic conditions. However, while the Frenchman took a very orthodox approach, using broken brushwork and high-keyed hues to disintegrate forms in space, Robinson developed a more tempered style in which he reconciled his interest in light, color, and a painterly technique with a lingering concern for solid draftsmanship, carefully articulated compositions, and representational realism. His approach, which he applied to peasant themes and views of the Seine Valley, is revealed to perfection in landscapes such as *Road by the Mill* (plate 19), one of a series of related canvases Robinson painted in 1892. His final year in Giverny also resulted in such lovely oils as *Le Débâcle* (plate 20), wherein his Parisian lover, Marie, reads Emile Zola's latest novel against a backdrop that includes the little stone bridge over the Ru River.

Robinson's work was greeted with approval by the American art world; to be sure, he enjoyed a successful exhibition at the Society of American Artists in New York in 1889, and went on to win that organization's Webb Prize in 1890 and its Shaw Fund Award in 1892. Not surprisingly, he was soon hailed as one of the foremost American exponents of the Impressionist style.

Robinson returned permanently to New York in December 1892. After years of depicting foreign subjects, he made a firm decision to "paint American," adapting his palette and forms in keeping with indigenous topography and atmospheric conditions.[2] He subsequently conducted outdoor classes and painted landscapes in Connecticut, New York, New Jersey, and Vermont. While teaching for the Brooklyn Art School at Napanoch, New York, on the Delaware and Hudson Canal, he continued his practice of creating serial images by producing several views of the local canal, among them the colorful *On the Canal (of Port Ben Series)* (plate 4). Robinson also applied his personal Impressionist style to a rare urban subject, capturing the splendor and magnificence of the 1893 Chicago World's Fair in his *World's Columbian Exposition* (plate 21), which shows the United States Government Building and the Liberal Arts Building bathed in an aura of warm, late afternoon sunlight.

Robinson's personal brand of Impressionism appealed to American critics and art aficionados, and helped pave the way for the acceptance of that aesthetic in the United States. Unfortunately, his influential career was cut short by his premature death in New York City, from asthma, in 1896.

PLATE 19
Theodore Robinson (1852–1896)
Road by the Mill, 1892
Oil on canvas, 20 x 25 inches
Cincinnati Art Museum,
Gift of Alfred T. and Eugenia I. Goshorn 1924.70

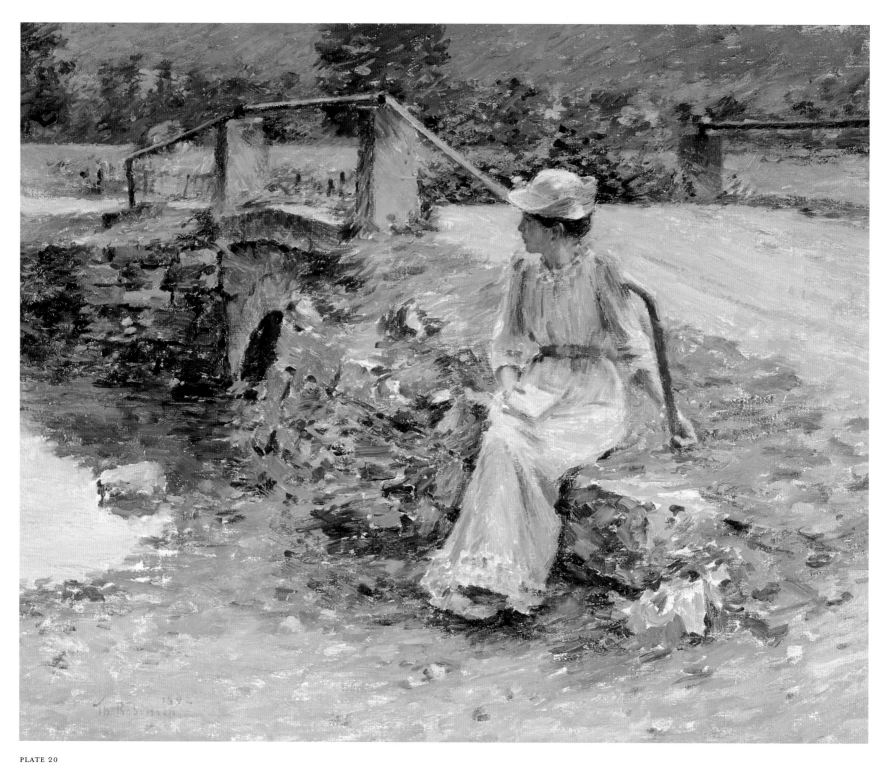

PLATE 20
Theodore Robinson (1852–1896)
Le Débâcle, 1892
Oil on canvas, 18 x 22 inches
Scripps College, Claremont, California
Gift of General and Mrs. Edward Clinton Young, 1946

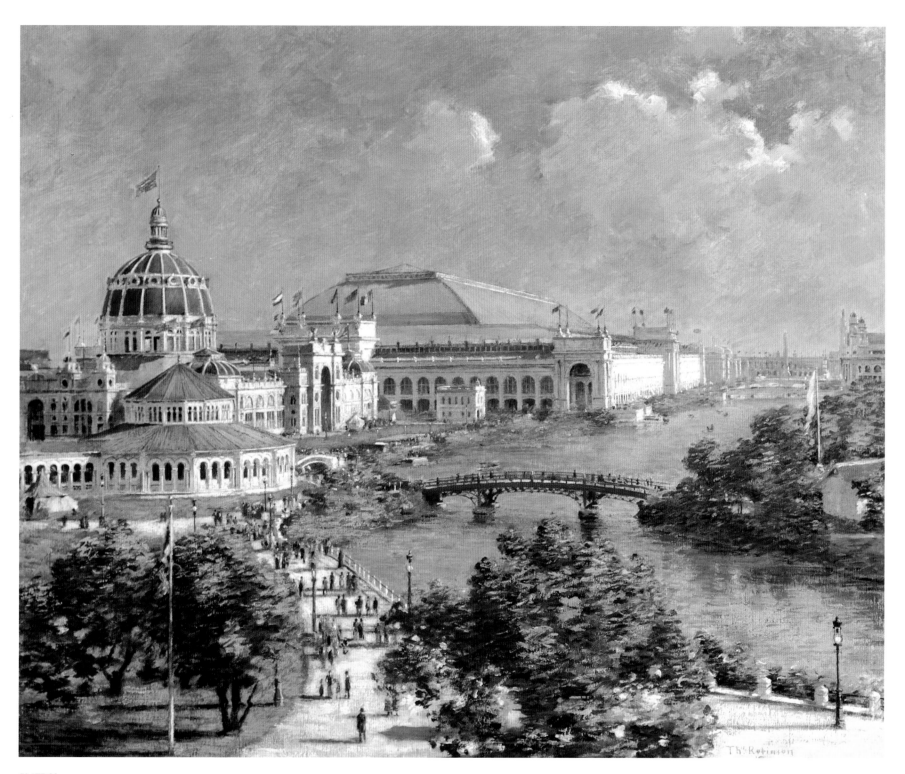

PLATE 21
Theodore Robinson (1852–1896)
World's Columbian Exposition, 1894
Oil on canvas, 25 x 30 inches
Manoogian Collection

Robert Vonnoh (1858–1933)

Born in Hartford, Connecticut, Robert Vonnoh studied at the Massachusetts Normal Art School, graduating in 1879. In 1881 he went to Paris, spending the next two years attending classes in figure painting at the Académie Julian. Returning to Boston, he taught at the newly formed Cowles Art School and the Boston Museum School and established his reputation as a painter of society portraits. A turning point in his development occurred in 1887, when he began making seasonal trips to the village of Grèz-sur-Loing, France, a popular artist haunt located on the edge of the Fontainebleau Forest. It was there that he came into contact with the Irishman Roderic O'Conor, a painter of brilliantly colored landscapes who visited Grèz in 1889. Inspired by O'Conor's work, and by the example of a number of Scandinavian painters who had colonized Grèz during the early 1880s, Vonnoh became an ardent disciple of the "new painting." Applying the fresh, unmixed colors and spontaneous handling of Impressionism to portrayals of local scenery, he went on to paint such sparkling canvases as *Beside the River (Grèz)* (plate 22), a view of the river Loing and the town's ancient stone bridge.

Back in the United States, Vonnoh played a notable role in disseminating Impressionist strategies through his role as a teacher at the Pennsylvania Academy of the Fine Arts (1891–95), where his students included Robert Henri, William Glackens, and Walter Elmer Schofield. A respected figure in the art world, he belonged to the most prestigious clubs and art societies of his day and exhibited his work regularly, and with great success, in New York, Philadelphia, and elsewhere.

In 1899, following the death of his first wife, Grace D. Farrell, Vonnoh married Bessie Potter (1872–1955), a well-known sculptor of mothers and children. After 1906 he began spending summers in Old Lyme, Connecticut, where he painted views of local scenery. He also continued his connection with Grèz, making annual visits there until the outbreak of war and returning permanently, although without his wife, in 1922. Vonnoh's painting output decreased towards the end of his life when his vision began to fail. Remembered today as a pioneering figure in the history of American Impressionism, the artist died in Nice in 1933.

PLATE 22
Robert Vonnoh (1858–1933)
Beside the River (Gréz), 1890
Oil on canvas, 18 x 22 inches
Collection of Walter and Lucille Rubin

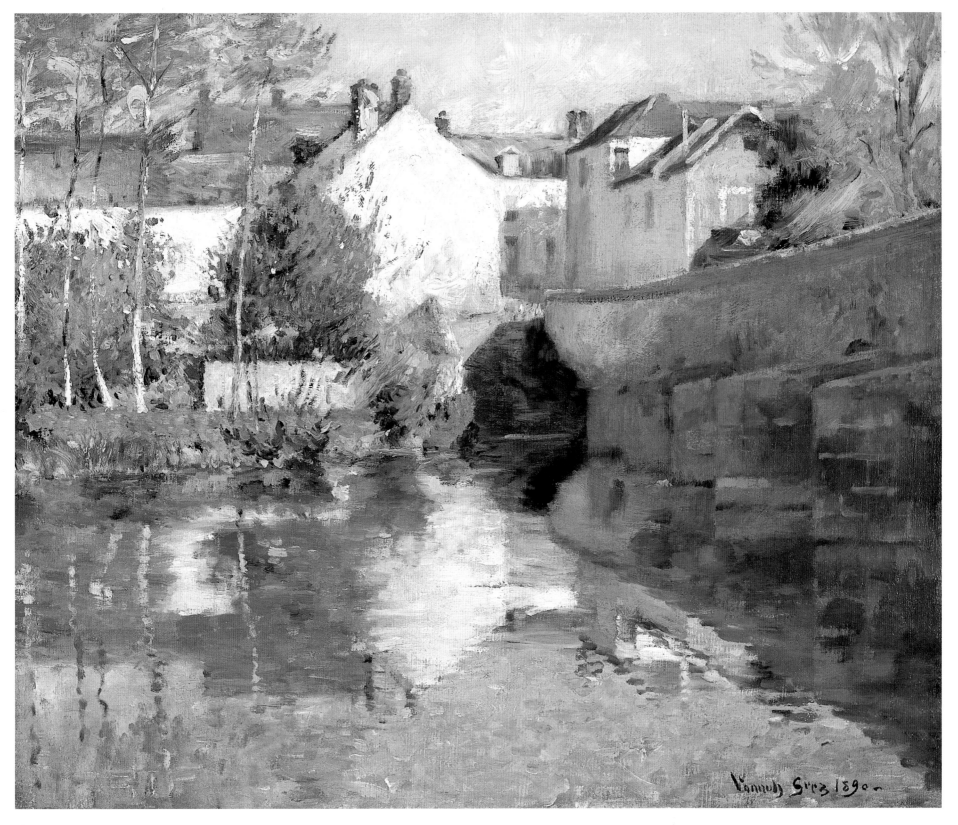

Julian Alden Weir (1852-1919)

Among the first generation of American Impressionists who came to artistic maturity during the 1890s, Julian Alden Weir received a thorough academic training from his father, Robert, a painter who taught drawing classes at the U.S. Military Academy at West Point. During this period Weir studied the art of the Old Masters and painted portraits and views of the Hudson River. His devotion to academic precepts was further enhanced when, from 1870 to 1873, he took further study at the National Academy of Design in New York.

His American training complete, Weir traveled to France in 1873, working under Jean-Léon Gérôme at the prestigious Ecole des Beaux-Arts. He also visited Holland and Spain, where he studied the work of seventeenth-century Baroque masters such as Diego Velázquez and Frans Hals. He likewise became friendly with the popular French painter Jules Bastien-Lepage, whose plein air peasant scenes were very much in vogue.

While in Paris, Weir had the opportunity to see the third Impressionist exhibition, which he declared a "Chamber of Horrors," lamenting that the artists "do not observe drawing or form."[3] Returning to the United States in 1877, Weir settled in New York, supporting himself by teaching, executing portrait commissions, and painting elegant still lifes. Despite his initial rejection of Impressionism as being too radical, he gradually became more sympathetic towards the new aesthetic, especially after he began devoting more of his time to landscape painting and joined the recently-established Society of American Artists, a haven for young European-trained artists with an anti-academic stance. His affinity for modern art was also nurtured by summer trips to Europe in 1880, 1881, and 1883, at which time he acted as an agent for the New York collector Erwin Davis, purchasing two works by the French Impressionist Edouard Manet. By 1890 Weir had become an exponent of native Impressionism, displaying an interest in broken brushwork, a bright palette, and the observation of light that would inform his art for the remainder of his career.

After his marriage in 1883, Weir divided his time between New York City and the Connecticut towns of Branchville and Windham, where he and his wife's family had summer homes. It was at Branchville, in western Connecticut, that he applied the energetic handling and bright chromaticism of Impressionism to landscapes such as *The Laundry, Branchville* (plate 23). The high horizon line, the closely cropped design, and the decorative patterning created by the tree forms indicate the impact of Japanese prints, which Weir, like many of his fellow Impressionists, admired and collected. Eastern design principles—as well as Weir's well-known interest in the theme of industrialization—are also apparent in *The Red Bridge* (plate 24), generally acknowledged as the artist's masterwork. Painted near Windham, this lovely painting depicts the contemporary iron structure that traversed the Shetucket River, replacing an old picturesque covered bridge. Weir's interest in the themes of modern labor and industry are likewise touched upon in *The Building of the Dam* (plate 25), wherein he skillfully incorporates the mechanical equipment with the wooded hills near his Windham home.

Weir was the recipient of many awards and honors throughout his career. He was affiliated with progressive art organizations, including Ten American Painters, and more traditional societies such as the National Academy of Design, where he served as president from 1915 to 1917. He died in New York City in 1919, at the age of sixty-seven.

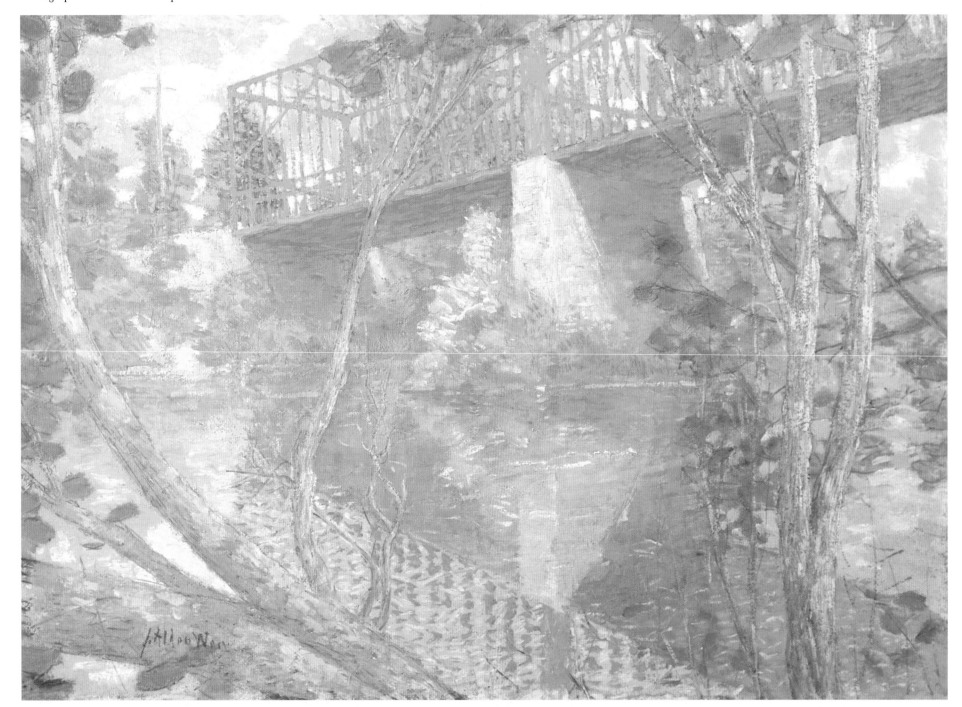

PLATE 25
Julian Alden Weir (1852–1919)
The Building of the Dam, 1908
Oil on canvas, 29⅞ x 40 inches
The Cleveland Museum of Art,
Purchase from the J. H. Wade Fund 1927.171
© The Cleveland Museum of Art, 2002

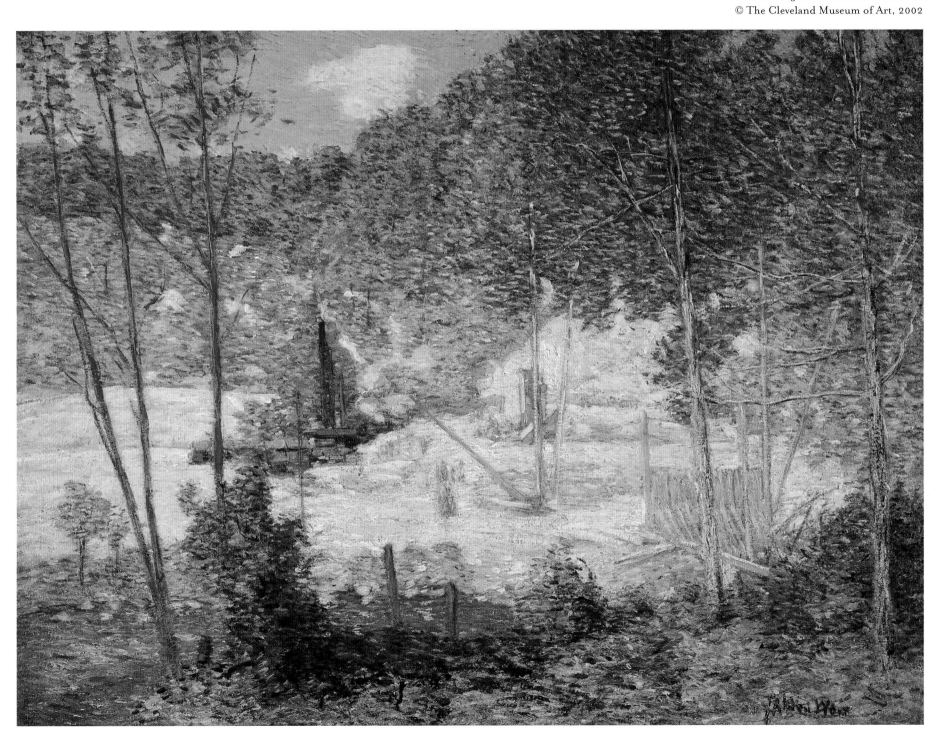

John Henry Twachtman (1853-1902)

John Henry Twachtman was among the principal American exponents of Impressionism during the 1890s. Associated with artistic activity in Connecticut in particular, he evolved a unique style that was at once evocative, yet highly modern.

Twachtman was born in Cincinnati, the Midwestern city that produced a number of well-known painters at the turn of the century. The son of German immigrants, he worked in a decorative window shade factory as a teenager, while attending evening classes at the Ohio Mechanics Institute. In 1871 he enrolled at the McMicken School of Design, where he studied part time for five years. He also attended a night class at the Ohio Mechanics Institute conducted by Frank Duveneck, a Kentucky-born painter who encouraged him to study in Munich, at that time an important gathering place for many young Americans. Twachtman subsequently enrolled at Munich's Royal Academy, where he was taught by Ludwig von Loefftz. Inspired by the example of the contemporary German painter Wilhelm Liebl, in particular, he quickly assimilated the dynamic brushwork and rich, somber palette associated with Munich Modernism.

Twachtman returned to his hometown in 1878 and for several years divided his time between New York City, Cincinnati, and Europe. Desirous of improving his draftsmanship, he attended classes at the Académie Julian in Paris from 1883 to 1885. He also made summer painting trips to the French countryside. By this time Twachtman had abandoned the dark Munich approach. Indeed, influenced by a diversity of sources ranging from Japanese prints, the decorative tonal harmonies of James MacNeill Whistler, the paintings of the Hague School, and the works of plein-air Naturalists such as Jules Bastien-Lepage, he turned to a more progressive manner of painting in which he combined a limited palette of subtle hues—usually greys and greens—and soft brushwork with daring, near-abstract designs and a concern for evoking the quieter moods of nature.

Twachtman returned to America in early 1886. He quickly made a name for himself in the New York art world, winning the Society of American Artists' Webb Prize in 1888 and accepting a teaching position at the Art Students League a year later. Seeking a quiet suburban locale in which to live and raise his family, he purchased a seventeen-acre farm in Greenwich, Connecticut, in 1889. It was there—often working in the company of his good friend, Julia Alden Weir—that he began to paint in the Impressionist mode.

Twachtman's adoption of Impressionism was no doubt influenced by the French Impressionist paintings he had seen in the United States and by the experiments of fellow artists such as Theodore Robinson, but the style he developed was very much his own. Indeed, the artist evolved a lyrical landscape aesthetic characterized by sensuous brushwork, pastel hues, and informal yet very inventive compositions. His paintings stood apart from those of his contemporaries in that they were not just painterly explorations of light and air; they also represented his modernity and his sensitive and highly intuitive response to his environment and to the moods of nature.

Twachtman applied his singular approach to intimate depictions of his farmhouse and property on Round Hill Road, capturing the glories of the floral environment in works such as *Meadow Flowers (Golden Rod and Wild Aster)* (plate 27), painted around 1893. While the artist worked year-round, he was especially fond of painting winter scenes, taking great delight in evoking nuances of sunlight on snow. A fine example of his work in this genre, *Snowbound* (plate 26) features his picturesque farmhouse nestled snugly amidst the high drifts, fronted by an array of leafless trees that imbue the image with a delicate oriental flavor.

When he wasn't depicting his home grounds, Twachtman often frequented the Cos Cob section of Greenwich, where, during the 1890s, he taught summer classes, often alongside Weir. Working from the porch of Holley House—the venerable inn, owned by Edward and Josephine Holley, that provided accommodations for members of the local art colony—he applied his delicate tonal Impressionist style to works such as *October* (plate 28), which affords us a view of the neighboring Brush House, constructed in the late 1700s in the colonial style. Twachtman's evocative aesthetic is also revealed in *From the Holley House, Cos Cob, Connecticut* (plate 29), which presents us with a springtime view along River Road toward the Lower Landing at Cos Cob. Here, Twachtman combines his expressive handling with a dynamic composition.

Twachtman painted the majority of his Impressionist canvases in Connecticut, but he was also active in Gloucester, Massachusetts, Yellowstone National Park, and Niagara Falls. The artist visited the latter locale during the winter of 1893-94, at which time he produced a series of depictions of the Falls, among them *Niagara in Winter* (plate 2), a stunning portrayal of the Horseshoe Falls (on the Canadian side). Notable for its intimate and unusually low vantage point and its cool, luminous palette, the painting was hailed as one of Twachtman's best depictions of Niagara; critics admired the artist's ability to capture the swirling movement of the water and his tendency to conceive Niagara not as a sublime, awe-inspiring icon of the New World but "as a poetic vision."[4]

Notwithstanding his graceful, lyrical style and highly original compositions, Twachtman's work was generally misunderstood by the public. However, he was greatly admired by the more perceptive artists of his day—including his cohorts in the group of Impressionists known as Ten American Painters. Sadly, his career was cut short by his untimely death in Gloucester in 1902, but his legacy as a key exponent of a distinctive brand of native Impressionism lived on. Even when that aesthetic had lost its luster and Modernism had become de rigueur in American art circles, Twachtman continued to be admired by discerning art aficionados; his many admirers included the critic James Gibbons Huneker, who aptly deemed him "the prince of American Impressionists."[5]

PLATE 26
John Henry Twachtman (1853–1902)
Snowbound, ca. 1895–1900
Oil on canvas, 22 x 30 inches
Montclair Art Museum, Montclair, New Jersey
Museum Purchase; Lang Acquisition Fund, 1951.33

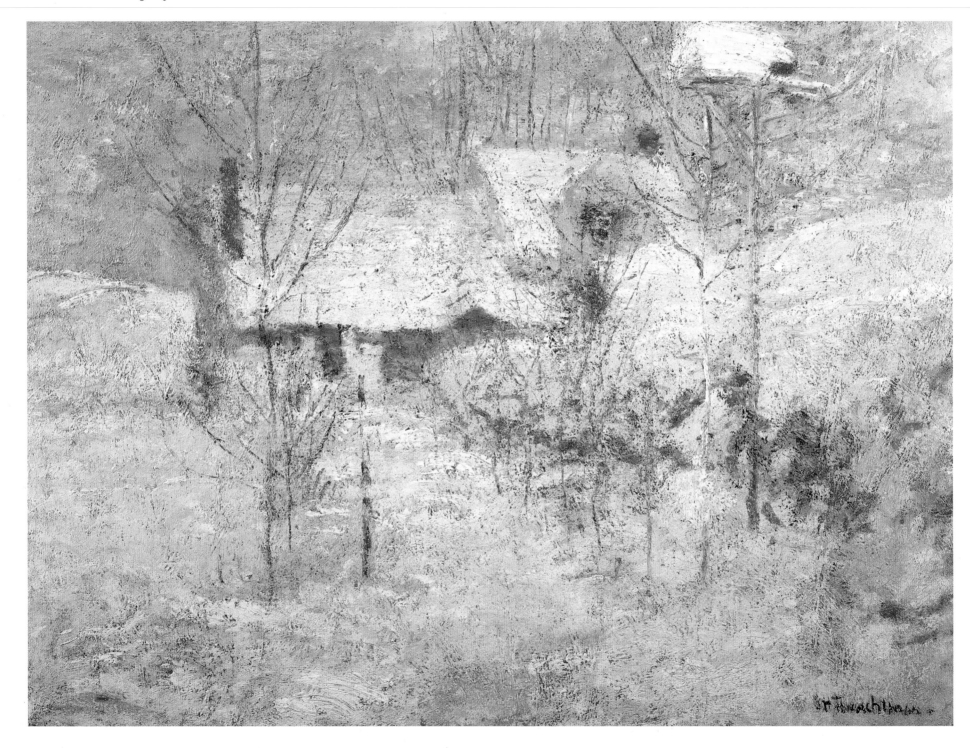

PLATE 27
John Henry Twachtman (1853–1902)
Meadow Flowers
(Golden Rod and Wild Aster), ca. 1893
Oil on canvas, 47 x 36 inches
The Brooklyn Museum of Art,
New York, Caroline H. Polhemus Fund 13.36

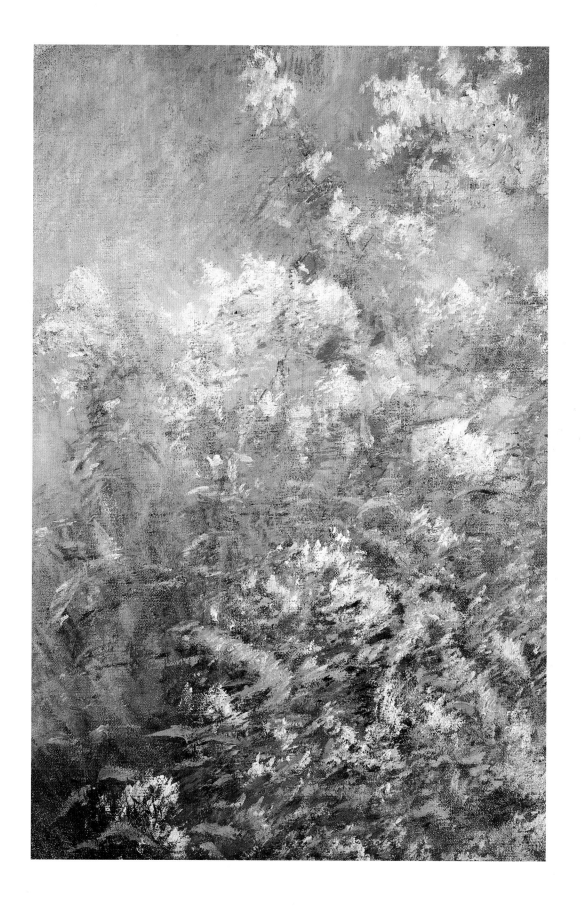

PLATE 28

John Henry Twachtman (1853–1902)
October, ca. 1901
Oil on canvas, 30 x 30 inches
Chrysler Museum of Art,
Norfolk, Virginia
Gift of Walter P. Chrysler, Jr. 71.713

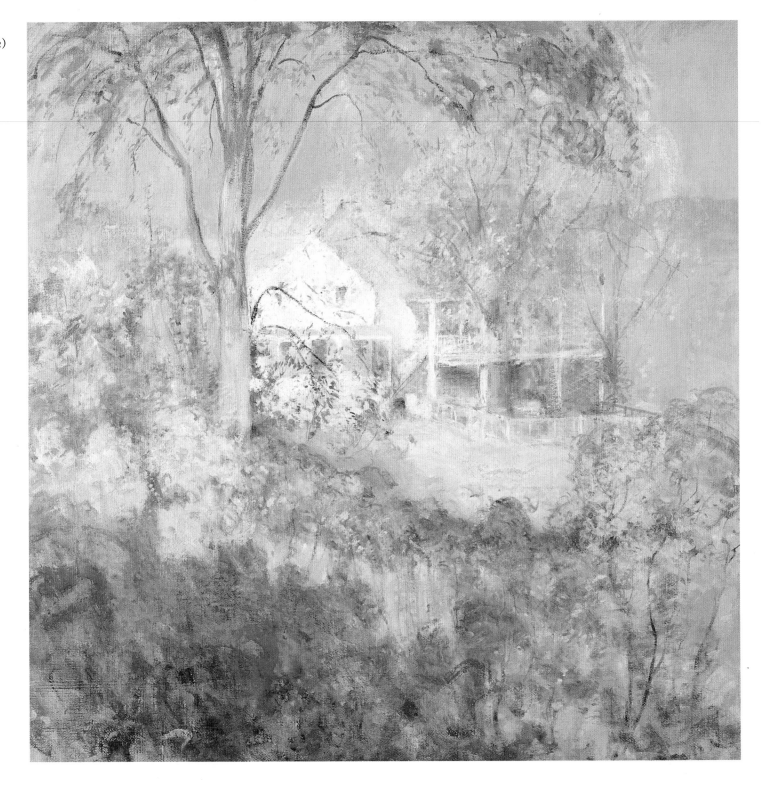

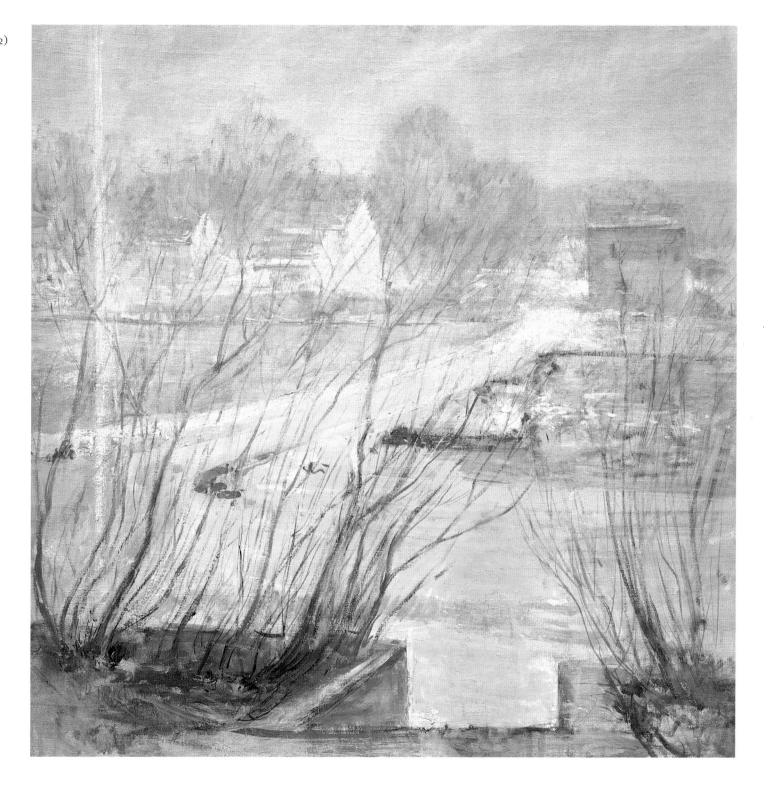

(Frederick) Childe Hassam (1859-1935)

The archetypal American Impressionist, Frederick Childe Hassam was a prolific and highly creative artist whose extensive oeuvre includes landscapes, the floral environment, and figure subjects executed in oil, watercolor, and pastel. He also produced a considerable body of graphic work and was one of the first American painters to explore the aesthetic possibilities of a key Impressionist theme—the modern city.

A native of Dorchester, Massachusetts (now a suburb of Boston), Hassam spent some of his teenage years working in the accounting department of Little, Brown and Company, a Boston publishing firm. At age seventeen he was apprenticed to George E. Johnson, a Boston wood engraver, where he made decorative designs for products such as office stationery. During the late 1870s, he attended evening classes at the Boston Art Club, studied artistic anatomy with William Rimmer at the Lowell Institute, and received private instruction from Ignaz Marcel Gaugengigl, a Munich-trained portrait and figure painter. By the early 1880s he had established his studio in Boston, earning his living by doing illustrations for magazines such as *Scribner's Monthly* and *Harper's New Monthly Magazine.*

In 1883 Hassam made his first visit to England and Europe, where he painted watercolors of urban streetscapes that he exhibited later that year at the Williams and Everett Gallery in Boston. In the ensuing years, he painted atmospheric scenes of Boston's streets and parks seen on rainy, overcast days or at early evening, working in a subdued Tonalist manner. He returned to Europe in the spring of 1886, attending figure classes at the Académie Julian, exhibiting his work in the Salons of 1887 and 1888, and increasing his familiarity with French Impressionism. While abroad, Hassam and his wife spent their summers in Villiers-le-Bel, a small hamlet on the outskirts of Paris. It was there, using his wife and her companion as models, that he painted *After Breakfast* (plate 30), one of his earliest forays into the broken color technique of Impressionism. By showing the women among the flowers, Hassam also links their beauty with that of the colorful blossoms.

Returning to the United States towards the end of 1889, Hassam settled in New York City. An affable man who valued the camaraderie of his fellow artists, he assumed a lively role in local art life, helping found the New York Watercolor Club and Ten American Painters, and exhibiting there and at venues such as the Pastel Society of New York and the Society of American Artists.

While New York remained his home base throughout his career, Hassam was a peripatetic artist who traveled widely in search of motifs. Indeed, he produced some of his finest paintings during trips to his favorite summer haunt—Appledore, the largest among the Isles of Shoals off the coasts of Maine and New Hampshire. Situated about ten miles from Portsmouth and about sixty miles from Boston, Appledore is a small island covered with wild vegetation and bordered by a rocky coastline. It was a thriving fishing port during the seventeenth and eighteenth centuries, but by Hassam's day it had become a popular vacation spot, providing city-dwellers with a lovely, unspoiled setting and clear, salt-tinged air.

For the aesthetically-inclined, there was another reason to summer in Appledore—namely, the presence of the writer and poet Celia Thaxter, who operated an informal salon at Appledore House, her family's hotel. Hassam made his first trip to Appledore in 1884 or 1885, and continued to frequent the island regularly for almost two decades, producing paintings such as *The Sonata* (plate 31), an evocative portrayal of a woman, dressed in white, sitting at the piano in Appledore House. A portion of Cecilia Thaxter's lush flower garden can be glimpsed through the window on the left—a reminder that when she wasn't entertaining artists and literati, Thaxter could be found in her opulent "natural garden" that she cultivated with a devoted and expert hand. As related by one of her contemporaries, "Celia Thaxter's knowledge of flowers was one of her best

known characteristics, and the trouble she took to make her garden on that rocky bed may well encourage some of us in our effort at floriculture."[6] Long familiar with the garden imagery of Claude Monet and stimulated by the beauty of his surroundings, Hassam applied his brush to this subject as well, producing oils such as *Poppies, Isles of Shoals* (plate 1), which features a portion of Thaxter's old-fashioned garden ablaze in dazzling sunlight. As well as demonstrating Hassam's use of lively staccato brushwork and a harmonious palette of pure color, the painting reveals his ability to evoke a sense of place; in viewing the work, one is very much aware that this is indeed the rugged topography of Appledore Island.

Hassam's treks through New England also took him to the venerable fishing port of Gloucester, on Boston's North Shore. Like others who helped establish the town as an important artists' retreat at the turn of the century, Hassam painted views of local landmarks as well as panoramas of the harbor, among them *Gloucester* (plate 32), which shows pleasure boats plying the calm waters on a vivid summer's day. In his slightly earlier and more intimate oil, *The Sparyard, Inner Harbor, Gloucester* (plate 33), the artist explores the theme of work and labor, paying homage to the town's shipbuilding industry, a mainstay of the local economy.

The range and diversity of Hassam's subject matter is also apparent in the paintings he made during seasonal visits to Old Lyme in southern Connecticut. Situated at the mouth of the Connecticut River, this picturesque colonial town was a gathering place for Tonalist and Barbizon painters during the late 1890s and early 1900s. But with Hassam's arrival in the colony in 1903, the aesthetic focus soon shifted to the more modern and popular aesthetic of Impressionism. The style became synonymous with Old Lyme, to the extent that the town eventually acquired a reputation as the "American Giverny." Indeed, Old Lyme provided artists with an array of picturesque motifs in the form of luxurious flower gardens and charming colonial architecture. One of Hassam's

favorite motifs was the old Congregational Church, which he portrayed on numerous occasions between 1903 and 1906. Painted in 1906, *Church at Old Lyme* (plate 34) stands as one of his final images of this beloved landmark—a testament to his direct, observational approach, his reverence for New England's Puritan heritage (from which he had sprung), and his obvious delight with the pictorial offerings of old-time New England. The church was destroyed by fire on 3 July 1907; it was later rebuilt, although Hassam never again recorded its image.

Following his move to Manhattan, Hassam became closely identified with the pictorialization of the "new New York," evidenced by his numerous depictions of the city's streets, parks, and squares shown under different weather conditions. His application of Impressionist precepts to the bustling metropolis is revealed to perfection in his illustrious "Flag" paintings, a series of oils executed during and shortly after the First World War that were intended as visual celebrations of the Allied cause. For Hassam, the flags also provided him with a perfect opportunity to explore an impressionistic concern for light, color, pattern, and movement. *Flags on 57th Street, Winter 1918* (plate 35) was taken from his studio at 130 West Fifty-Seventh Street and features a view looking east towards the intersection of Sixth Avenue. Hassam's much-acclaimed "Flag" series also includes *St. Patrick's Day* (plate 6), wherein pedestrians scurry to and fro beneath the colorful banners on a rainy, overcast day, their figures reflected on the wet, slick surface of the pavement. Like other canvases from the series, this painting's short, rapid brushwork and abruptly cropped design reveals the artist's interest in conveying an impression of the momentary.

Hassam continued to paint cityscapes and landscapes until the end of his career. After 1900, he added the female nude to his repertoire of subjects, and during the mid-1910s, he took up printmaking. After 1917, Hassam spent his summers in East Hampton, on the east end of Long Island, where he died in August of 1935.

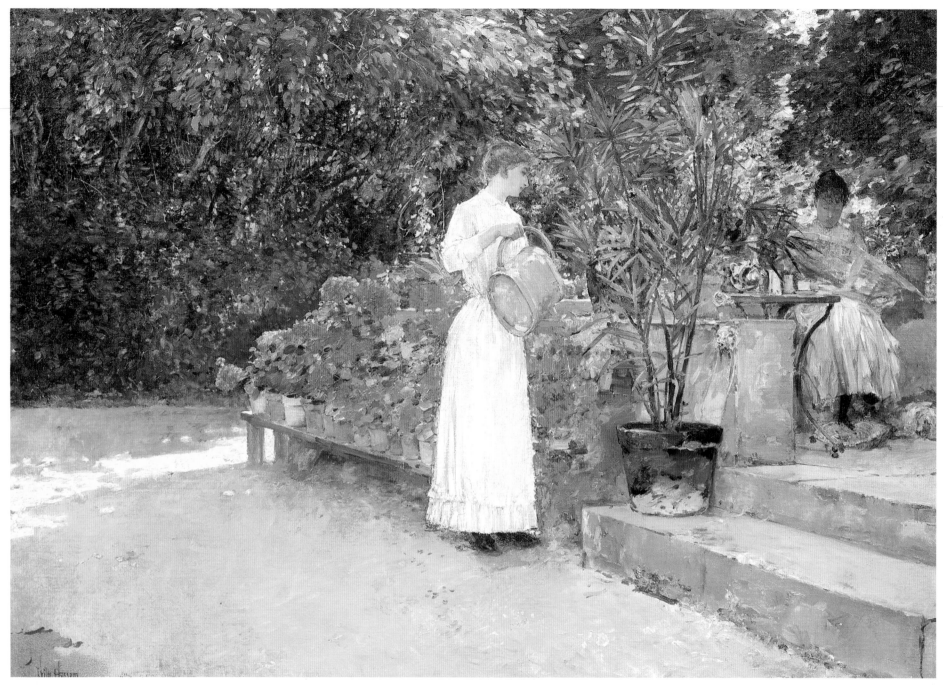

PLATE 30
(Frederick) Childe Hassam (1859–1935)
After Breakfast, 1887
Oil on canvas, 28⅜ x 39⅝ inches
Private Collection

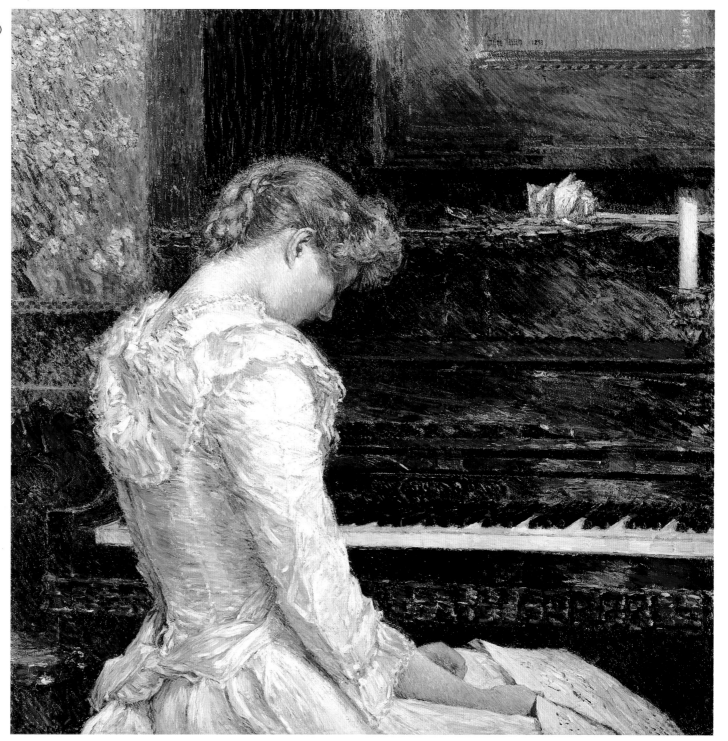

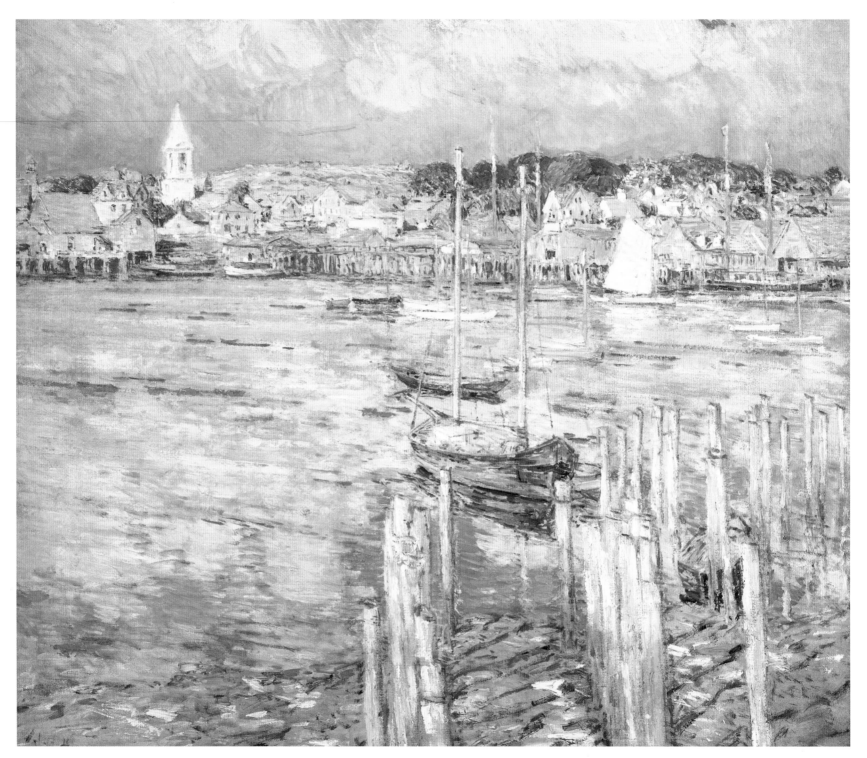

PLATE 32

(Frederick) Childe Hassam (1859-1935)
Gloucester, 1899
Oil on canvas, 32 x 32 inches
Collection of The Newark Museum,
Gift of Mrs. J. Russell Parsons, 1973

PLATE 33
(Frederick) Childe Hassam (1859–1935)
The Sparyard, Inner Harbor, Gloucester, 1895
Oil on canvas, 23 ½ x 19½ inches
Private Collection

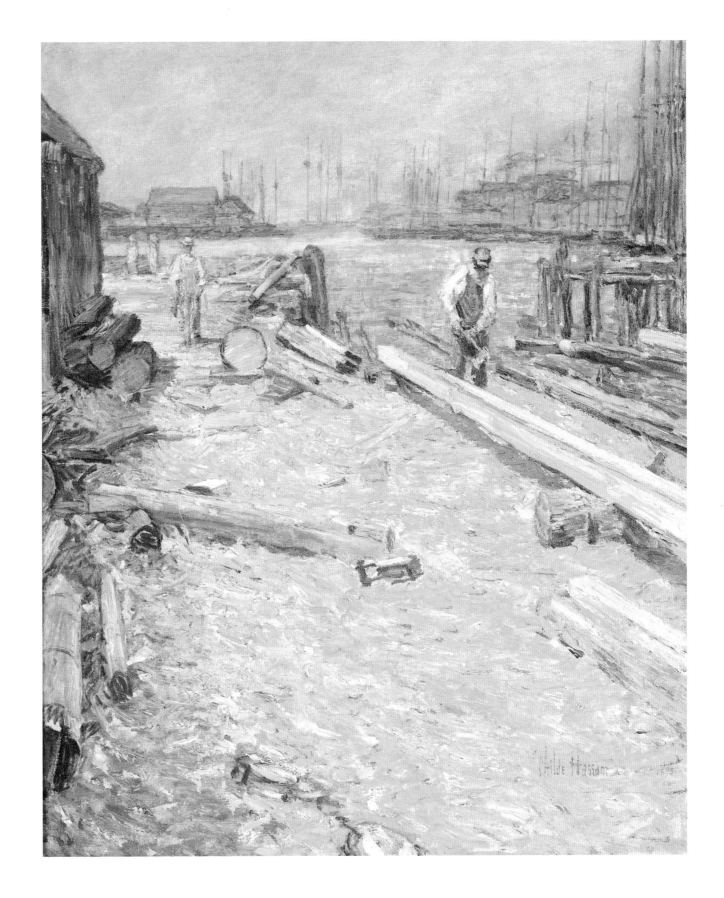

PLATE 34
(Frederick) Childe Hassam (1859-1935)
Church at Old Lyme, 1906
Oil on canvas, 30 ⅛ x 25 ¼ inches
The Parrish Art Museum,
Southampton, New York,
Littlejohn Collection 1961.3.131
Photo credit: Rameshwar Das

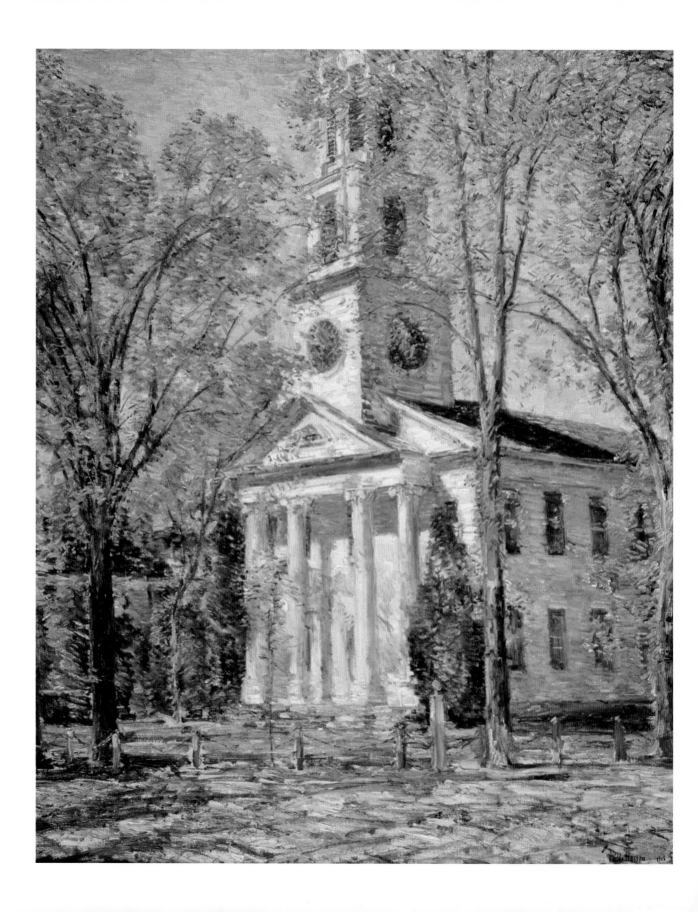

PLATE 35

(Frederick) Childe Hassam
(1859–1935)
Flags on 57th Street,
Winter 1918, 1918
Oil on linen, 37 x 25 inches
Collection of The New-York
Historical Society, 1984.68
Image © Collection of the New-York
Historical Society

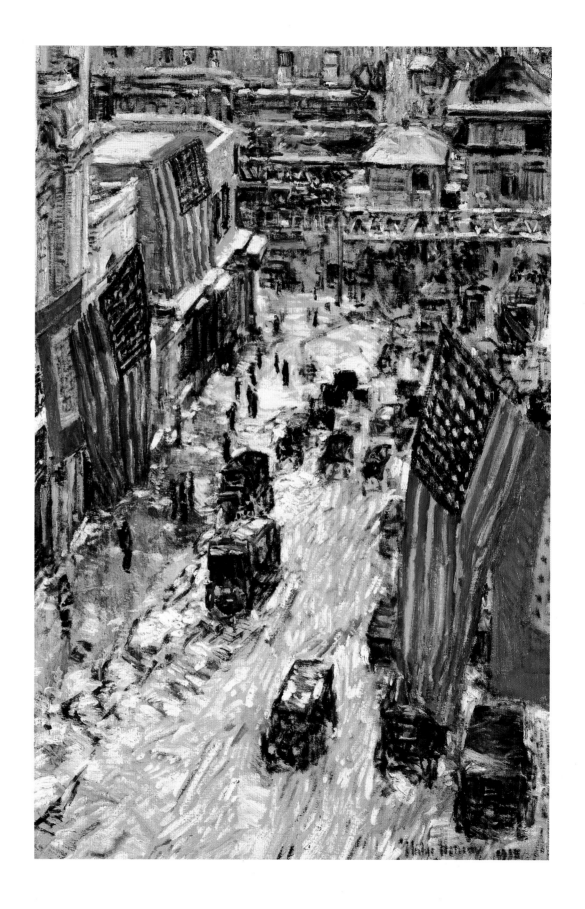

Edward Rook (1870–1960)

A New Yorker by birth, Edward Rook received his artistic training at the Académie Julian in Paris, studying under Jean-Paul Laurens and Benjamin Constant from 1887 to 1888 and 1890 to 1892. With the exception of the occasional visit home, he remained abroad until 1900. After his marriage in 1901, he toured the Pacific Coast and then spent almost a year in Mexico.

Like other American Impressionists of his generation, Edward Rook eventually found his way to the picturesque community of Old Lyme, in southern Connecticut. However, while many of his colleagues visited the town on a seasonal basis only, Rook enjoyed a deep and lasting connection with the country's most famous artists' community. Indeed, after making his first visit to Old Lyme in 1903, he settled there permanently two years later.

Rook directed his creative energies to the portrayal of local landscape motifs, especially the wild laurel—Connecticut's official state flower—that grew so abundantly in the nearby woods. Legend has it that because the blossoms would fade and often lose their color before he completed his canvas, Rook's wife would dye cotton balls pink and affix them to the bushes to retain the fresh effect. As revealed in the delightful *Laurel* (plate 36), Rook's aesthetic approach verged towards the decorative, representing a refined synthesis of Impressionist facture and the structured compositions associated with Post-Impressionism.

Rook exhibited in the national annuals and in several international expositions, winning an array of awards and honors. His work was also familiar to Connecticut audiences through his participation in the exhibitions of the Lyme Art Association. However, financially independent and reluctant to sell his paintings, this unconventional, yet much-admired artist had no desire to promote his work by allying himself with a commercial dealer, much to the disappointment of his fellow colonists, who thought him talented and hard-working, with a vision uniquely his own.

PLATE 36
Edward Rook (1870–1960)
Laurel, ca. 1905–10
Oil on canvas, 40 ½ x 50 ¼ inches
Florence Griswold Museum;
Gift of the Hartford Steam Boiler
Inspection and Insurance Company
2002.1.117

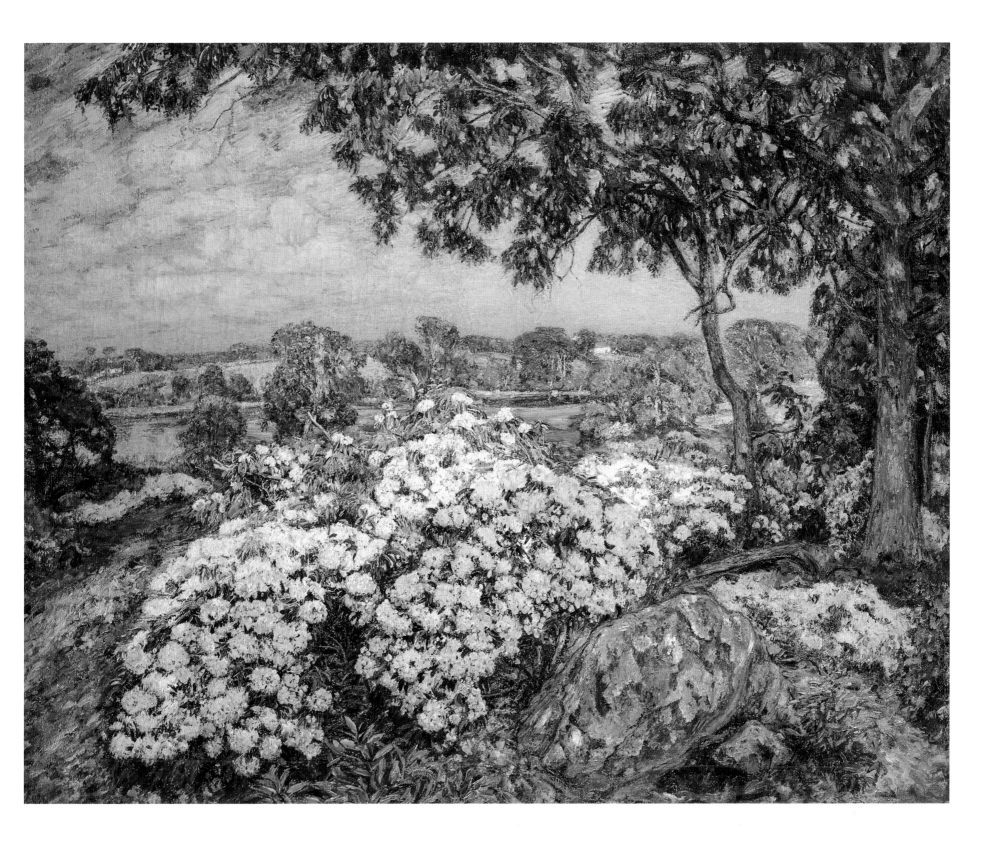

Colin Campbell Cooper (1856-1937)

A native of Philadelphia, Colin Campbell Cooper began his formal studies at the Pennsylvania Academy of the Fine Arts in 1879. In 1886 he went to Paris, honing his skills as a figure painter at the Académie Julian and at the académies Delécluse and Vitti. Beginning in 1895, he taught watercolor painting and architectural rendering at the Drexel Institute in Philadelphia. Three years later he resigned his position and returned to Europe, where he painted and sketched architectural landmarks ranging from Napoleon's Tomb to Lincoln Cathedral. While abroad, Cooper abandoned his former Barbizon style and turned to Impressionism, the aesthetic that would inform his art for the remainder of his career.

Returning to Philadelphia in 1902, Cooper began exploring the pictorial possibilities of the American city, initially drawing inspiration from the tall buildings of his home town. Two years later he moved to New York, where he applied his brush to the soaring skyscrapers of Lower Manhattan. His masterwork, *Broad Street Cañon, New York* (plate 37), underscores his devotion to portraying the urban metropolis and attests to his reputation as a painter who has "shown the modern world that there is beauty, even poetry, in its towering structures of steel."[7]

Cooper traveled often during the 1900s and 1910s, visiting Europe on several occasions and making trips to India and Los Angeles. In 1921 he settled in Santa Barbara, California, serving as Dean of the School of Painting at the Santa Barbara School of Arts during the 1920s. Distanced from the hubbub of Manhattan, he applied the tenets of Impressionism to a range of themes, including landscapes, flower gardens, and California missions. Prior to his death in Santa Barbara, Cooper exhibited his California subjects at the Santa Barbara Art Club, the California Art Club, and at other local and regional venues.

PLATE 37
Colin Campbell Cooper (1856-1937)
Broad Street Cañon, New York, ca. 1904
Oil on canvas, 39 x 56 inches
Stern School of
Business, New York University

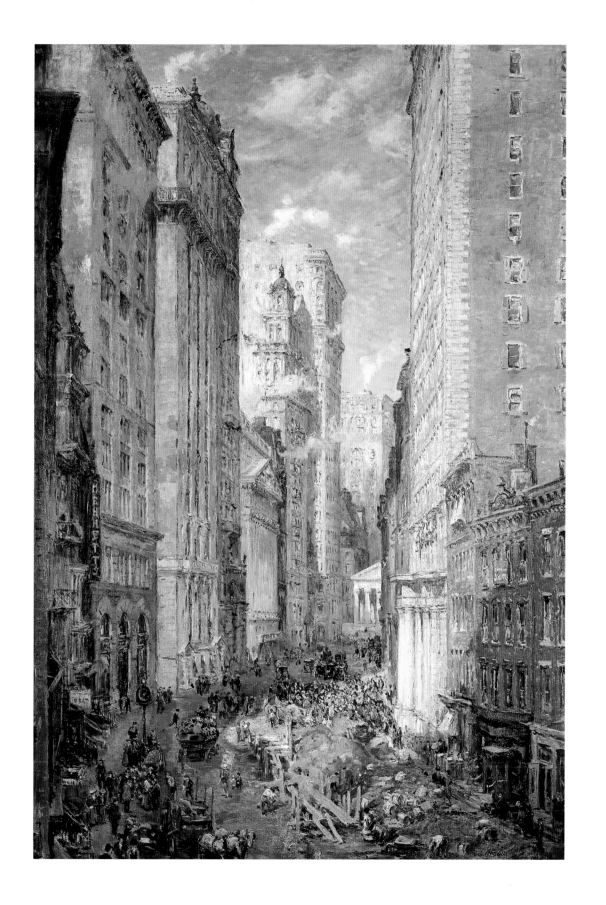

Thomas Wilmer Dewing (1851–1938)

While Thomas Dewing's evocative style had more in common with Tonalism than Impressionism, he shared the American Impressionists' concern for depicting the idealized female form. Indeed, the artist's lyrical renderings of solitary women appeared frequently in the exhibitions of Ten American Painters, the group of celebrated artists who represented the Impressionist vanguard in the United States.

The son of a milliner, Dewing was born in Lower Falls, Massachusetts, where, as a boy, he demonstrated considerable talent in drawing. He began his artistic training as a teenager, studying at the school of the Museum of Fine Arts in Boston. He then served an apprenticeship to a commercial lithographer in Boston before going to Albany, New York, in 1875, where he supported himself by making chalk portraits. A year later he went to Paris, studying figure techniques under Jules Lefebvre and Gustave Boulanger at the Académie Julian.

Dewing returned to Boston in 1878 and took a teaching position at the Museum School. Around 1880 he moved to New York, which remained his home for the rest of his career. In 1881, he married Maria Oakey, a talented flower painter, and embarked on a seven-year teaching stint at the Art Students League. By around 1890, Dewing was well established in New York art circles, exhibiting poetic depictions of beautiful ladies at the annuals of the National Academy of Design and the Society of American Artists.

Although he worked in oil and watercolor, Dewing became particularly fond of pastel, a once-neglected medium that experienced a revival in late nineteenth-century American art circles, especially with the founding of the Society of Painters in Pastel in New York in 1882. Artists of Dewing's generation were drawn to the medium's easy portability, its array of vibrant, jewel-like hues, and its spontaneous, sketchy quality—all of which made it an ideal medium for capturing the immediacy of the moment.

Dewing's tendency to interpret contemporary women as refined, enigmatic beings with somewhat attenuated forms is apparent in his *Lady in Blue, Portrait of Annie Lazarus* (plate 38). While his *Lady in Blue, Portrait of Annie Lazarus* is considered one of the most direct and colorful of his figure subjects, his earlier *Lady in Blue* (plate 7) is more typical of his quietest aesthetic in its muted tonalities, exquisite draftsmanship, and wistful mood. Both examples reveal the artist's preference for minimalist designs executed on brown paper. They also bring to mind the words of the critic Sadakichi Hartman, who described such works as depictions of:

> Mostly mature women of thirty . . . [who] seem to possess large fortunes and no inclination for any professional work. They all seem to live in a Pre-Raphaelite atmosphere, in mysterious gardens . . . or in spacious, empty interiors . . . there they sit and stand, and dream or play the lute or read legends . . . they all have a dream-like tendency, and, though absolutely modern, are something quite different from what we generally understand by modern women.[8]

Dewing's numerous friends and colleagues included the noted architect Stanford White, who designed many of his frames and introduced his work to collectors such as Charles Lang Freer and John Gellatly, who became his most ardent patrons.

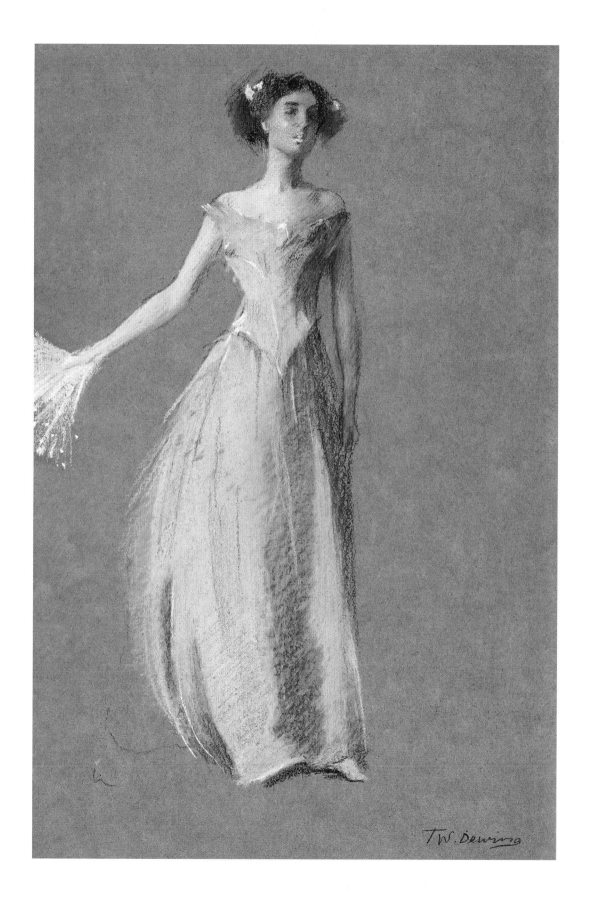

Willard Leroy Metcalf (1858-1925)

A prolific and highly accomplished Impressionist landscape painter, Willard Metcalf produced views of France, as well as portrayals of Italy, North Africa, and Cuba. However, he was first and foremost a painter of New England in all its seasonal glory. In fact, by the time of his death he had established a reputation as the Poet or Painter-Laureate of New England and was, in the words of one contemporary commentator, "unquestionably the finest American painter of the New England countryside."[9]

Metcalf was born in Lowell, Massachusetts, to a working-class family. He began studying art at the age of sixteen, attending classes at the Massachusetts Normal Art School while serving as an apprentice with a Boston wood engraver. In 1875, he received art lessons from the painter George Loring Brown and studied at the Lowell Institute. One year later, Metcalf enrolled at the Boston Museum School, receiving a solid academic training under the tutelage of Otto Grundmann during 1877 and 1878.

In the autumn of 1883, with funds earned by working as an illustrator for New York magazines and through the sale of some of his paintings, Metcalf traveled to France, where he would remain until the end of 1888. While abroad, he studied at the Académie Julian (1883-84) and immersed himself in the rich cultural life of the French capital. Like other young, aspiring painters, he spent his summers experimenting with outdoor painting methods in the rural countryside, working in fashionable artists' retreats such as Pont-Aven and Grèz-sur-Loing, where he painted landscapes and peasant themes in a style influenced by the Barbizon School and the work of French Naturalist painters such as Jules Bastien-Lepage. Metcalf made his first visit to the village of Giverny in 1887 and two years later was among the group of North American painters who founded its famous art colony. During his sojourns in Giverny, Metcalf brightened his palette and loosened his brushwork, inspired by the Impressionist experiments of his fellow artists as much as by the presence of Claude Monet, a resident of the village since 1883.

In 1889 Metcalf returned to Boston and held a solo exhibition of his recent work at the St. Botolph Club, providing local art audiences with an early opportunity to view paintings by the American school of Impressionism. He moved to New York in 1890, working as a teacher and illustrator. In addition to figure subjects, he also produced landscapes such as *Gloucester Harbor* (plate 39), a canvas that reveals his growing preoccupation with natural light. Painted during a trip to Gloucester—an old fishing port and artists' colony on Massachusett's Cape Ann peninsula—with his friend and fellow artist Childe Hassam, the work features an expansive panorama of the town's bustling harbor on a brilliant summer's day. Considered one of his finest excursions into the brilliant colorism of Impressionsm, the painting received the prestigious Webb prize at the annual exhibition of the Society of American Artists in 1896.

Notwithstanding his well-received Gloucester picture and his membership in the group of front-line Impressionists known as Ten American Painters, Metcalf did little painting over the next few years, with the exception of some murals and decorative panels. However, a turning point in his career occurred after spending the summers of 1903 and 1904 with his parents in Clark's Cove, Maine, where, having rediscovered the aesthetic possibilities of native scenery, he made a firm decision to forego figure painting and foreign subjects in favor of the scenic countryside of the northeastern United States; as he put it, he had experienced a "renaissance."

In the years ahead, Metcalf made regular painting trips to Maine, Connecticut, New Hampshire, and Vermont, painting landscapes in which he combined the light and coloristic strategies of Impressionism with a realistic interpretation of his subject. Some of his finest oils were done in Old Lyme, Connecticut, a flourishing art colony that initially attracted painters of the Barbizon and Tonalist persuasions. His first visit to that picturesque colonial town occurred in 1905 and resulted in oils such as *Poppy Garden* (plate 40), an exuberant portrayal of a field of poppies—a theme explored by Monet— with the slow-moving Lieutenant River glimpsed in the background. Indeed, Metcalf's presence in Old Lyme, along with that of Hassam, was largely responsible for transforming the colony from a gathering place for Tonalists to a center of Impressionism: in the ensuing years, Old Lyme came to viewed as the American equivalent of Giverny.

That Metcalf loved to work year-round, under varying climactic conditions, is apparent not only in *Poppy Garden*, but also in his equally striking *Thawing Brook* (plate 8). Painted in 1911 during a honeymoon visit to the artists' colony in Cornish, New Hampshire, this outstanding canvas conveys the tranquil beauty of the rural countryside and reminds us that the artist was a skilled chronicler of seasonal change; here, Metcalf's title, along with pictorial elements such as the melting snow and glowing sunlight, allude to the gradual transition from winter to spring.

Metcalf worked in an Impressionist manner until his death in New York City in 1925—a testament to his devotion to landscape painting and to the longevity of the style itself. Expertly rendered, sharply observed, and pleasing to the eye, his canvases brought him widespread acclaim from critics, who praised the "Americanness" of his work and lauded his ability to capture the specific topography of a place, as well as its spiritual essence.

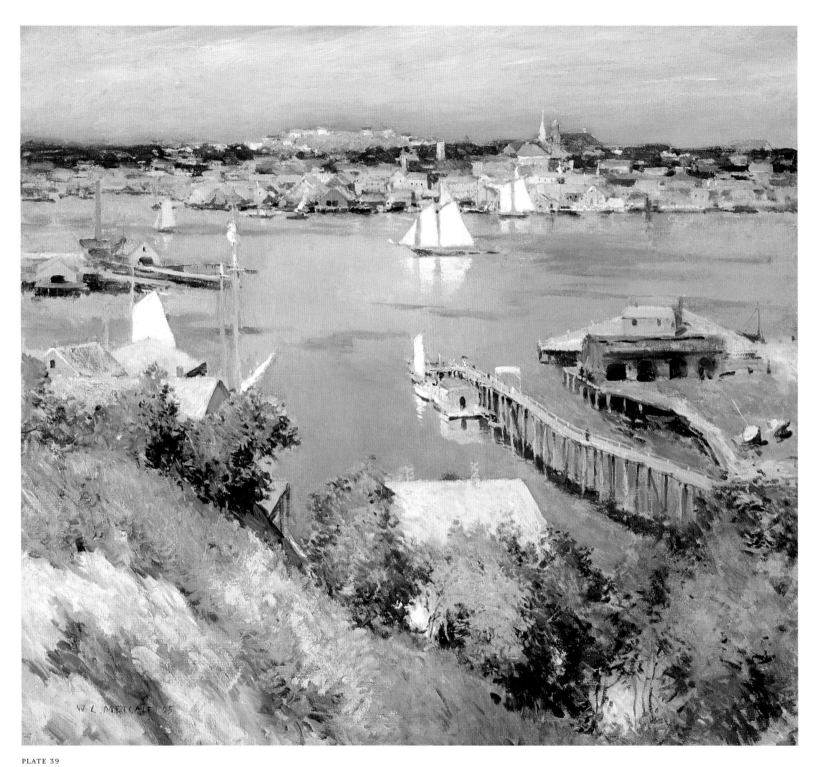

PLATE 39
Willard Leroy Metcalf (1858–1925)
Gloucester Harbor, 1895
Oil on canvas, 26 ⅛ x 29 ¼ inches
Mead Art Museum, Amherst College, Amherst, Massachusetts,
Gift of George D. Pratt, Class of 1893

PLATE 40

Willard Leroy Metcalf
(1858–1925)
Poppy Garden, 1905
Oil on canvas, 24 x 24 inches
Manoogian Collection

Robert Reid (1862-1929)

A highly regarded artist during his day, Robert Reid applied his considerable artistic skills to both mural work and stained glass design. However, he is best remembered for his Impressionist-inspired depictions of elegant young women shown in quiet contemplation in indoor and outdoor settings. Reid shared this thematic concern with Edward Tarbell, Joseph DeCamp, Frank Benson, and Thomas W. Dewing—fellow members of Ten American Painters; however, his work stood apart from that of his colleagues in its modern decorative qualities. His personal take on Impressionism is readily apparent in *The White Parasol* (plate 41); painted in Medfield, Massachusetts, in the summer of 1907. This striking canvas underscores the hallmarks of Reid's style, revealing his fondness for bright colors, feathery brushwork, and flattened, two-dimensional space, as well as his love of pairing idealized women with flowers.

Reid was born in Stockbridge, Massachusetts, the son of a headmaster of a boy's school. After periods of instruction at the Boston Museum School and the Art Students League of New York during the early-to-mid 1880s, he studied figure painting at the Académie Julian in Paris and made seasonal painting trips to the Normandy countryside. In 1889 he returned to New York and established a reputation as a genre painter working in a conventional academic style. The exact date of his conversion to Impressionism remains unclear, but by the late 1890s he was painting images of lovely women in which he melded vivid hues, spirited brushwork, and strong patterning, with an academic handling of the figure. Displayed at the exhibitions of the Ten and at the leading national annuals, his work in this vein earned him critical accolades and a reputation as a "decorative Impressionist."[10]

Reid's mural commissions included designs for the World's Columbian Exposition in Chicago (1893), the Library of Congress, and numerous hotels and public buildings in Manhattan. He remained an active member of the New York art scene until around 1920, when he moved to Colorado Springs to teach at the recently established Broadmoor Academy. During the 1920s, he turned increasingly to portraiture. When a stroke suffered in 1927 left him partially paralyzed, Reid taught himself to paint with his left hand. He spent the last two years of his life in a sanatorium in Clifton Springs, New York.

PLATE 41
Robert Reid (1862-1929)
The White Parasol, 1907
Oil on canvas, 36 x 30 inches
Smithsonian American Art Museum,
Gift of William T. Evans

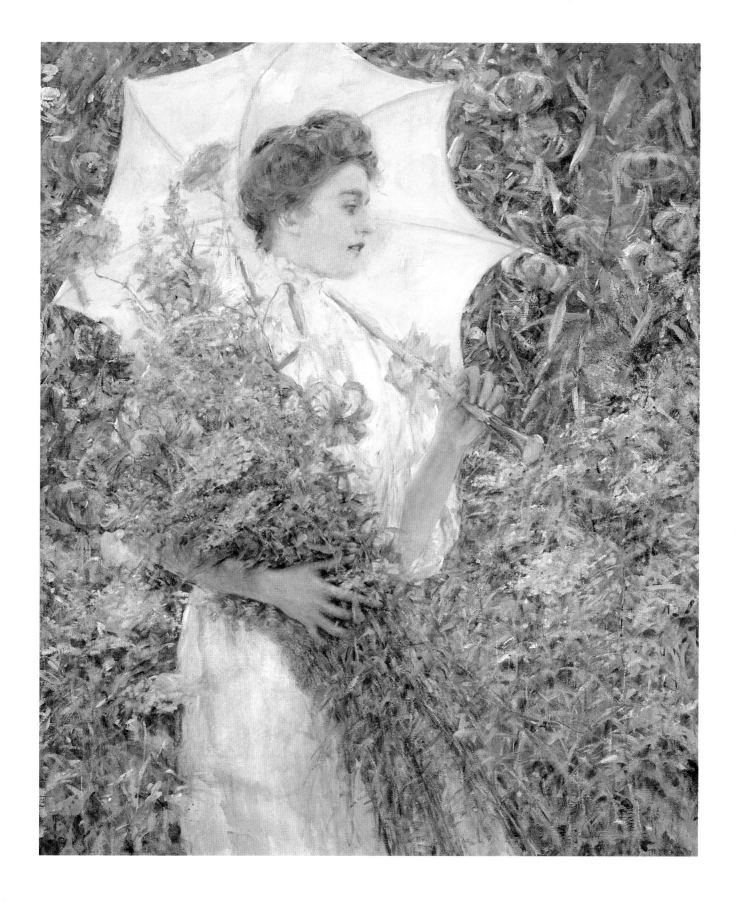

Frank Weston Benson (1862-1951)

One of the most venerated Impressionists working in turn-of-the-century Boston, Frank Benson was an exceptional painter who investigated a variety of motifs, ranging from sporting subjects and landscapes to still lifes and marines. However, he was first and foremost an interpreter of the female figure. Indeed, Benson was renowned for his depictions of young women and children in sun-dappled settings, portrayed with the luminous palette and flickering brushwork of Impressionism. His sparkling canvases were lauded by contemporary critics who praised his ability to render the figure in relation to modern precepts of light and atmosphere, among them a writer for the *Boston Transcript*, who declared: "His pictures of children and youth, in the open, bathed in sunlight and fresh air, are among the best ever painted, and their chief beauty is in their purely individual styles, blending brilliancy with delicacy."[11]

Born to a prosperous family in Salem, Massachusetts, Benson decided to pursue an artistic career at age sixteen. He received a sound academic training at the Boston Museum School, which he attended from 1880 to 1883. Accompanied by his friend and fellow painter Edmund Tarbell, he supplemented his American instruction by taking further study at the Académie Julian in Paris from 1883 to 1885. Returning home, he began exhibiting his work in Boston and New York, and secured a teaching position at the Portland School of Art in Maine. In 1888, while sharing a Boston studio with Tarbell, he married Ellen Peirson.

During the early 1890s, Benson painted colorful plein air landscapes during summer visits to New Hampshire. At this point in his career, he was chiefly a studio painter who focused on images of refined young women in interiors illuminated by artificial light. However, by the end of the decade, he was painting figures in idyllic outdoor settings, first in New Hampshire and later on the island of North Haven, Maine.

Like other artists of the Boston School—one thinks especially of Tarbell—Benson used members of his immediate family as his models. To be sure, the majority of his plein air paintings feature his wife, their son George, and their three daughters, Eleanor, Elisabeth, and Sylvia, who were willing to "pose again and again for the father" whom they adored.[12]

Considered Benson's earliest fully realized work in the Impressionist vein, *The Sisters* (plate 42) features Elisabeth and Sylvia in an idyllic coastal setting. The artist's active brushwork imbues the image with the spontaneity associated with Impressionism, while his prismatic palette evokes the myriad effects of flickering summer sunlight. The Impressionist spirit—and Benson's obvious affection for his offspring—is also very much in evidence in his *Girls in the Garden* (plate 9), which provides us with a stunning glimpse of his daughters, all dressed in virginal white, enjoying the pleasures of the family's sun-dappled garden.

Benson exhibited his figure paintings in the annual exhibitions of Ten American Painters, the group of artists that came to epitomize mainstream American Impressionism. He enjoyed a long and illustrious career as a painter of oils and watercolors, an etcher, and as a teacher at the Museum School from 1893 to 1912. Much revered by critics, the public, and his fellow artists, he died in Salem in 1951.

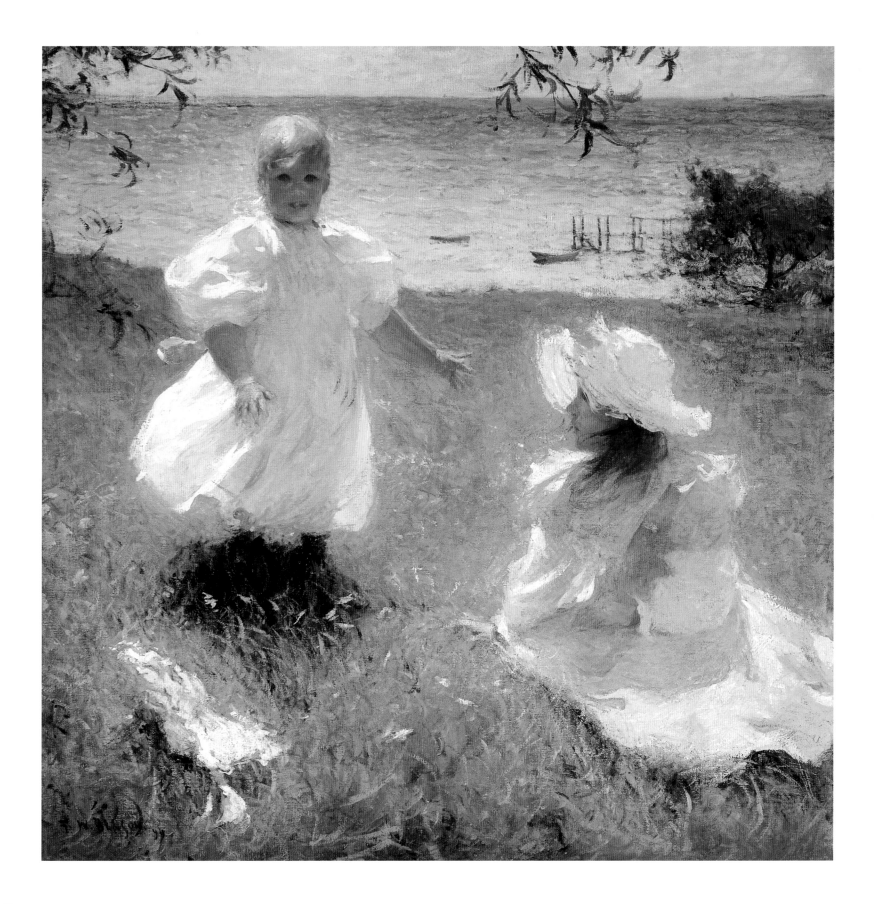

Joseph DeCamp (1858-1923)

Joseph DeCamp was born in Cincinnati, Ohio, a city that produced a number of leading Impressionists. Primarily a portrait and figure painter, he first studied art in his hometown, attending classes at the McMicken School of Design and the Ohio Mechanics Institute. In 1878 he went to Munich, studying at the Royal Academy and working in Florence and Venice with the Kentucky-born painter Frank Duveneck. DeCamp returned to Cincinnati around 1883 but left for the East soon after, settling in Boston in 1884.

A firm believer in academic principles of careful draftsmanship and well-crafted designs, DeCamp became an important teacher, initially at Wellesley College, and then at the Boston Museum School and the Cowles Art School. In 1903 he joined the faculty at the Massachusetts Normal Art School, where he taught painting and portraiture classes for two decades.

When he wasn't executing official portrait commissions of celebrated people from the worlds of commerce, education, and politics, DeCamp was engaged in figure painting. Like many of his Boston cohorts, he followed the example of Edmund Tarbell, portraying well-dressed women in stylish domestic settings bathed in a muted, Vermeerian light. He explored Impressionism more fully in his outdoor figural themes, investigating the effects of glittering sunshine in works such as *June Sunshine* (plate 43). Believed to have been painted in 1902 in Gloucester, Massachusetts, the popular art colony on the Cape Ann Peninsula, this intimate oil features the artist's wife, Edith, reading to their daughter Sally, their forms profiled against the scenic beauty of Wonson's Cove.

Although he continued to execute figural works, most of DeCamp's later years were devoted to important portrait commissions, which included painting the likenesses of delegates to the Peace Conference in Versailles in 1918. The artist died in Boca Grande, Florida, in 1923 while convalescing from an operation. Sadly, studio fires in Boston and Maine destroyed hundreds of DeCamp's paintings.

PLATE 43
Joseph DeCamp (1858-1923)
June Sunshine, 1902
Oil on canvas, 30 x 25 inches
Private Collection

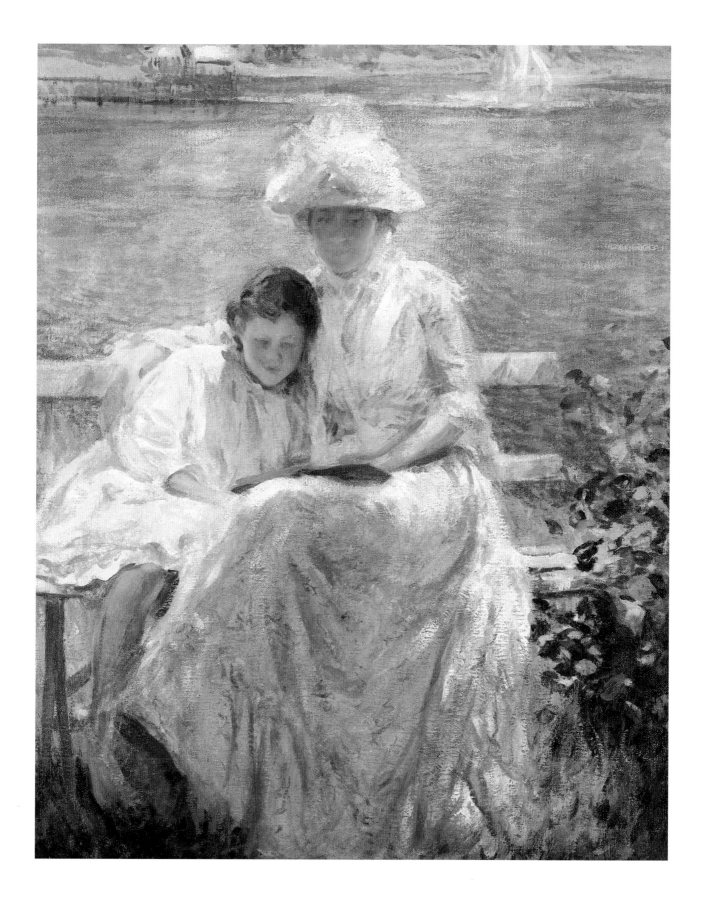

Edmund Tarbell (1862-1938)

The leader of the Boston School of Impressionism, Edmund Tarbell won national acclaim for his figure paintings, ranging from outdoor subjects to images of upper-class women in subtly lit interiors. Born in West Groton, Massachusetts, Tarbell developed an interest in art at an early age, studying drawing at the Massachusetts Normal Art School while still attending grammar school. In 1879 he enrolled at the Boston Museum School, where he received a thorough grounding in traditional precepts of solid draftsmanship and carefully articulated compositions from his teachers, Otto Grundmann and Frederick Crowninshield. Four years later, Tarbell went to Paris, resuming his training at the Académie Julian and traveling throughout France, England, and Germany. In 1886 he returned home and established a flourishing portrait practice. Three years later he secured a position at the Museum School, where he was a popular and influential teacher until his resignation in 1912.

By around 1890, Tarbell was incorporating Impressionist precepts into his work, painting colorful, light-filled portrayals of figures engaged in outdoor leisure activity, often using members of his family as models. He continued to explore this theme exclusively until the late 1890s, when he began painting elegant, well-appointed interiors populated by lovely young women shown in quiet contemplation or engaged in pleasant domestic tasks such as sewing. Inspired by the work of the seventeenth-century Dutch painter Jan Vermeer, he bathed his subjects in a softly diffused luminosity, manipulating the intensity of his light through devices such as diaphanous curtains or Venetian blinds. Painted in 1907, *Girls Reading* (plate 44) is an excellent example of his academic Impressionist manner, in which he blended modern concerns relative to light with a traditional rendering of the figure and an enduring concern for beauty and sound craftsmanship—qualities that came to represent the aesthetic stance of both Tarbell and the Boston School in general.

After 1909, Tarbell devoted part of his time to formal portraiture. Praised for his ability to "make it like," he became one of the most sought-after portraitists of his day, attracting a coterie of famous sitters that included presidents Herbert Hoover and Woodrow Wilson, and the French military commander Marshal Ferdinand Foch. In 1918, he was appointed director of the Corcoran School of Art in Washington, D.C. From then on he divided his time between the capitol and his summer house in New Castle, New Hampshire. After his retirement in 1926 he settled permanently in New Castle, where he continued to paint. By the time of his death in 1938, he was known as the "Dean of American Impressionists."

PLATE 44
Edmund Tarbell (1862-1938)
Girls Reading, 1907
Oil on canvas, 25 x 30 inches
Shein Collection

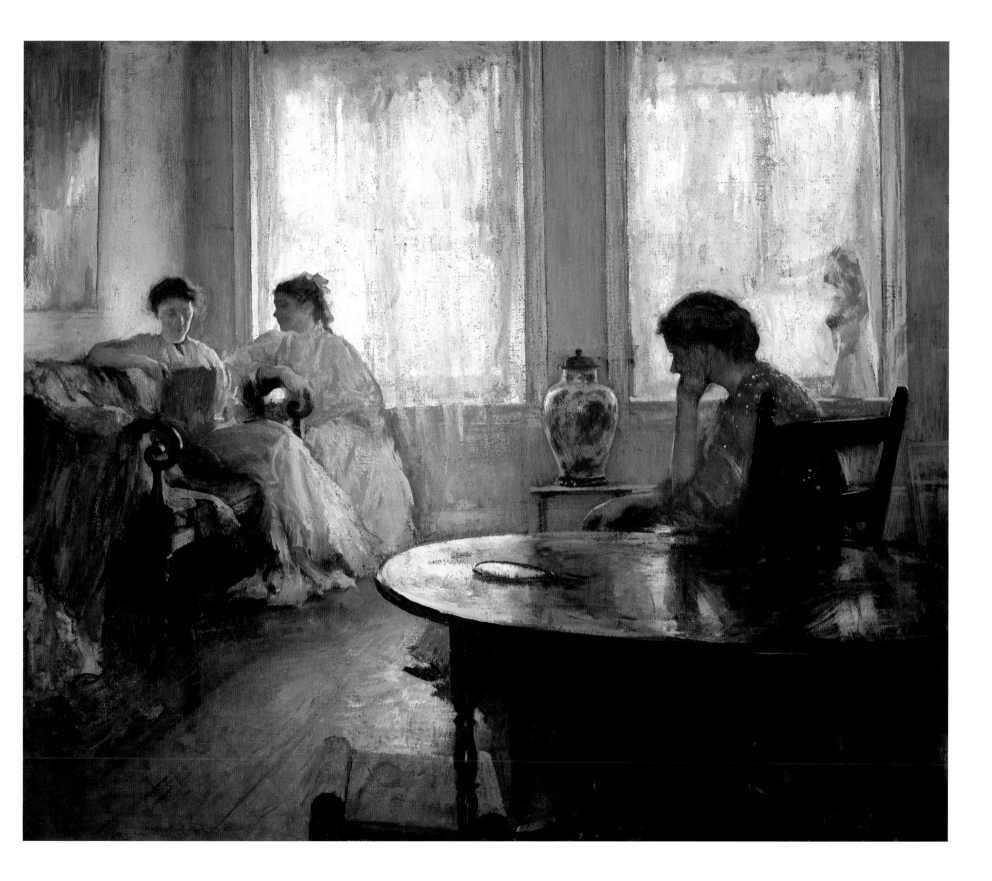

Daniel Garber (1880-1958)

Among the most renowned of the Pennsylvania Impressionists, Daniel Garber focused his creative energies on depicting the scenery in and around the town of New Hope, in Buck's County. However, Garber did not restrict himself to landscape themes; he also achieved success in the realm of figure painting, garnering widespread acclaim for his depictions of his wife and children in sunlit outdoor settings and quiet interiors.

Garber was born into a family of Mennonites in North Manchester, Indiana. After attending classes at the Art Academy of Cincinnati during 1897-98, he spent two summers at the Darby Art School in Fort Washington, Pennsylvania, studying outdoor painting techniques under the guidance of Hugh Breckenridge and Thomas Anshutz, artists who encouraged their students to experiment with new and different techniques. In 1899, Garber enrolled at the Pennsylvania Academy of the Fine Arts, where he was taught by a coterie of talented painters that included William Merritt Chase and Cecilia Beaux. Upon winning the Academy's Cresson Fellowship in 1905, Garber made his first trip to Europe, where he had the opportunity to see examples of French Impressionist painting firsthand.

Returning to America in 1907, Garber divided his time between Philadelphia and his country house in the Cuttalossa Glen, near Lumberville, located a few miles from New Hope. He quickly emerged as one of the most prominent members of the New Hope art colony, attracting critical acclaim for his portrayals of the towns, mills, and quarries of the Delaware River Valley. A view of the distant Jersey cliffs seen from the banks of the Delaware River, *Wilderness* (plate 45) is a fine example of his style, in which he united Impressionist strategies of light and color with an overall decorative treatment of form.

Garber taught at the Philadelphia School of Design for Women (now the Moore College of Art) until 1909, when he joined the faculty at the Pennsylvania Academy of the Fine Arts. He was an influential teacher at that institution until his retirement in 1950.

PLATE 45
Daniel Garber (1880-1958)
Wilderness, 1912
Oil on canvas, 50 x 60 inches
Private Collection of Jim's Antiques
Fine Arts Gallery, Lambertville, New Jersey

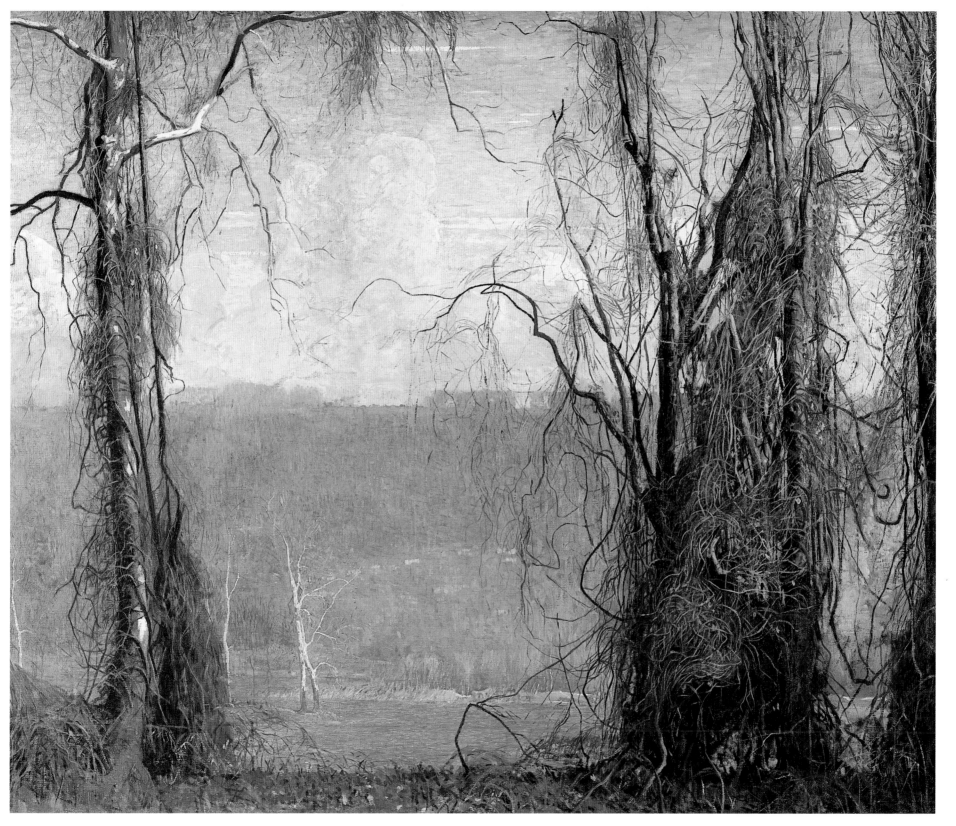

Robert Spencer (1879–1931)

An important member of the colony of Impressionist landscape painters working in New Hope, Pennsylvania, during the early twentieth century, Robert Spencer eschewed the picturesque scenery of the Delaware River countryside in favor of the region's architecture, ranging from dilapidated houses and tenements to rural factories and mills. *Five O'Clock, June* (plate 46) is a characteristic example of his mature work, revealing his penchant for depicting working-class themes as well as his personal Impressionist style, in which he conjoined carefully articulated compositions with a stitch-like divisionist technique and a cool palette.

The son of a Swedenborgian clergyman and his wife, Spencer was born in Harvard, Nebraska. He initiated his formal training at the National Academy of Design in New York, studying under academicians such as Francis Coates Jones and Edwin Blashfield, among others. Following this he attended classes at the New York School of Art, where he was taught by the Impressionist William Merritt Chase and the urban Realist painter Robert Henri. After spending the summer of 1909 studying with the Impressionist landscape painter Daniel Garber in Lumberville, Pennsylvania, Spencer settled in nearby New Hope and became part of a colony of artists that included Edward Redfield, Walter Schofield, and Charles Rosen. Probably taking his cue from the example of Henri, who advocated that artists paint the grittier aspects of modern life, Spencer turned his attention to depictions of local industrial sites and ramshackle houses, usually adding a few figures—such as factory workers, farmers, and laundresses—as a humanizing element. He was quick to make his mark on the national art scene, winning numerous awards at the major annuals in New York, Philadelphia, and elsewhere, and acquiring a reputation as an astute interpreter of the "time-scarred factories and mills of New Hope."[13]

Throughout the 1920s, Spencer painted views of the Delaware River and extended his repertoire of subjects to include genre scenes, portraiture, and depictions of Europe. During these years, the artist suffered a succession of nervous breakdowns that led to his tragic suicide at the age of fifty-two.

PLATE 46
Robert Spencer (1879–1931)
Five O'Clock, June, 1913
Oil on canvas, 36 x 30 inches
Richard and Mary Radcliffe

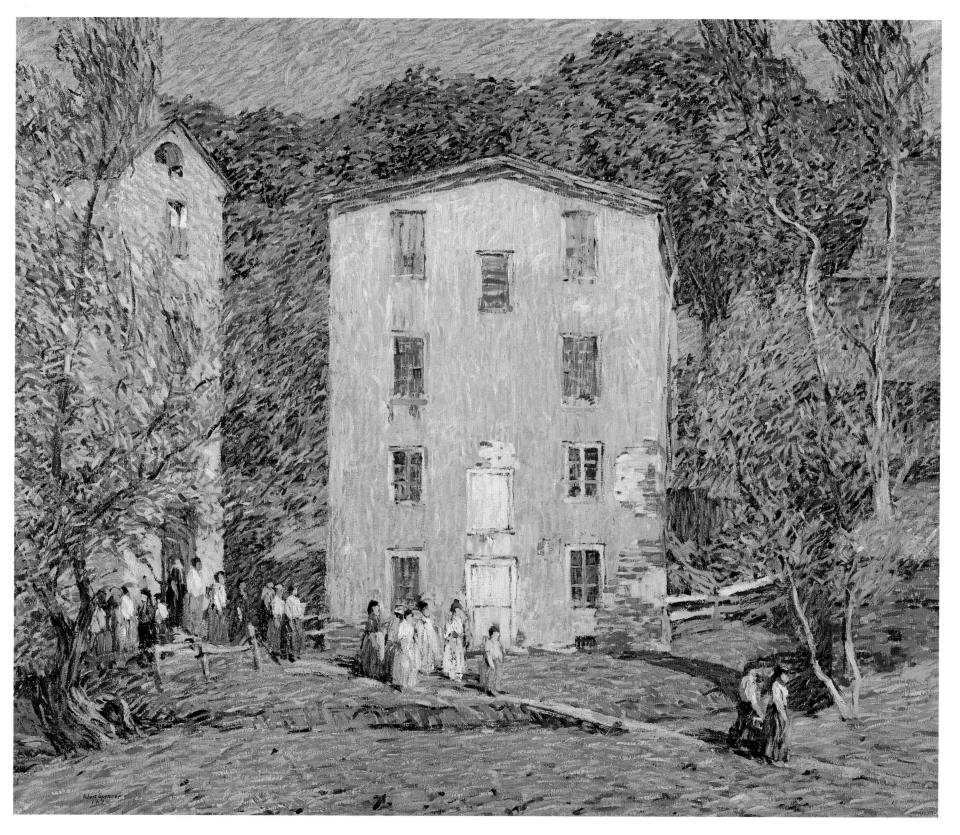

Helen M. Turner (1858-1958)

Recognized as one of the most celebrated women artists working in the United States during the early twentieth century, Helen M. Turner enjoyed a long and productive career as a painter of Impressionist-inspired figure subjects. She was associated with the art life of New York City and New Orleans, but produced some of her most important work in the village of Cragsmoor, New York, a popular artists' colony in the Shawangunk Mountains, where she spent her summers from 1906 to 1941.

Born into an affluent family in Louisville, Kentucky, Turner grew up in New Orleans and it was there, around 1880, that she began to paint. During the early 1890s she attended classes at the Artists' Association of New Orleans, after which time she taught art at a girls' school in Texas. In 1895, she moved to New York, undertaking further study at the Art Students League (1895-99), the Women's Art School at Cooper Union (1898-1901; 1904-05), and Columbia University Teacher's College (1899-1904), in addition to attending William Merritt Chase's art classes in Europe (1904, 1905, 1911).

Turner initially specialized in miniature portraits, pastels, and watercolors. Responding to the lure of Impressionism, she eventually turned to oil, developing a distinctive aesthetic characterized by glowing hues and thick brushstrokes, which she applied to depictions of genteel female types in domestic interiors, lush flower gardens, or ensconced on sun-dappled porches, as revealed in her delightful *Girl with Lantern* (plate 47).

Turner exhibited widely throughout the United States, winning numerous awards and honors and attracting a host of influential patrons that included such notables as Duncan Phillips. She returned to New Orleans in 1926 but continued to visit and work in New York, producing figurative work as well as portraits. Although she began suffering vision problems during the 1930s—a result of cataracts—she continued to paint well into the following decade. Turner died in New Orleans in 1958.

PLATE 47
Helen Maria Turner (1858-1958)
Girl with Lantern, 1904
Oil on canvas, 44 x 34 inches
Greenville County Museum of Art, Museum purchase with funds donated by The Friends of Helen Turner: Dorothy Hipp Gunter; Mr. and Mrs. R. Glenn Hilliard; Mr. and Mrs. William W. Kehl; Dr. and Mrs. Jeffrey G. Lawson; Mr. and Mrs. E. Erwin Maddrey II; Mr. and Mrs. Charles C. Mickel; Mr.and Mrs. G. Franklin Mims; Mr. and Mrs. Lawrence J. Nachman; Mary M. Pearce; Mr. and Mrs. John D. Pellett, Jr.; Mr. and Mrs. Thomas A. Roe; Mr. and Mrs. Robert Small; W. Thomas Smith; Mr. and Mrs. Thomas H. Suitt, Jr.; Mr. and Mrs. Robert T. Thompson, Jr.; Mr. and Mrs. Barton Tuck; Mr. and Mrs. Richard F. Watson, Jr.; Mr. and Mrs. Wilson C. Wearn; Mr. and Mrs. Irvine T. Welling III; anonymous donor

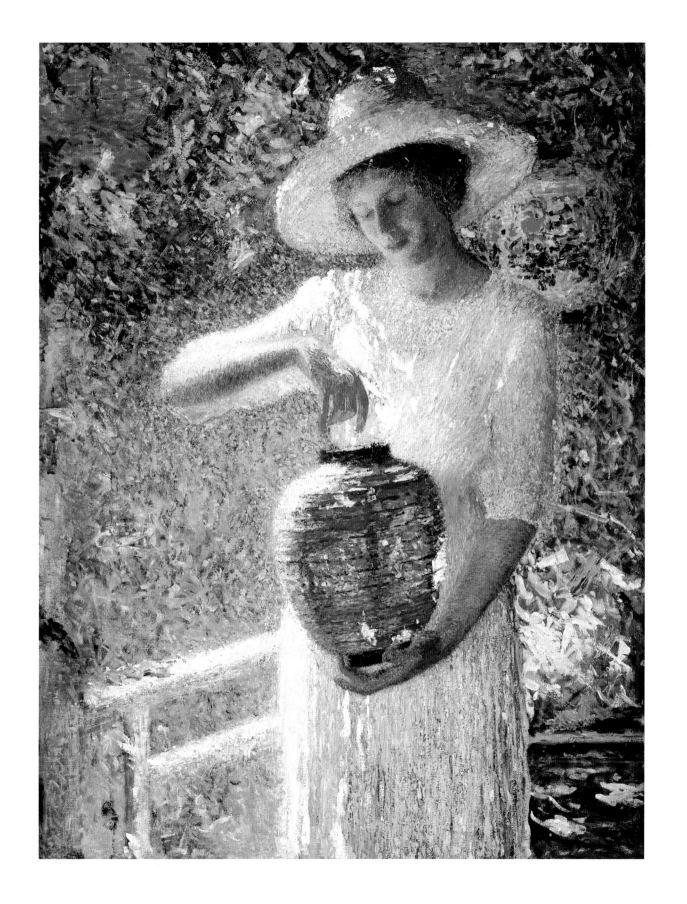

(Julius) Gari Melchers (1860–1932)

Gari Melchers spent much of his career in Holland where, around the turn of the century, he began incorporating the stylistic precepts of Impressionism into his work. Following his repatriation in 1915, he made significant contributions to the Impressionist tradition in the South.

The son of a sculptor, Melchers was born and raised in Detroit. After receiving art lessons from his father, he went on to study at the Royal Academy in Düsseldorf, Germany, and at the Académie Julian and the Ecole des Beaux Arts in Paris. In December of 1884 he settled in the Dutch fishing town of Egmond-aan-Zee, where he resided for over two decades. He initially painted depictions of devout Dutch peasants and mothers with children, working in an academic realist style. However, he eventually turned to the heightened colorism and loose handling of Impressionism, painting interiors with figures as well as highly decorative depictions of fields of flowers.

With the outbreak of war, Melchers returned to the United States and thenceforth divided his time between New York and Belmont, the eighteenth-century Georgian home near Fredericksburg, Virginia, which he purchased in 1916. Inspired by the topography and people of the South, he turned his attention to his immediate environment, painting landscapes, genre scenes, and portraits of African-Americans. He also applied the brilliant hues and scintillating brushwork of Impressionism to views of small-town life, as is apparent in this engaging portrayal of *St. George's Church* (plate 48).

A high-profile figure in national art life, Melchers belonged to the leading art organizations in New York, including the National Academy of Design, the National Arts Club, and the Century Club. He also chaired the federal commission to establish a National Gallery of Art (1923) and served on the boards of both the Corcoran Gallery of Art and the Virginia Arts Commission. He died in Falmouth, Virginia, in 1932. In 1955, the artist's wife, Corinne, deeded Belmont and its art collection to the state of Virginia in memory of her husband.

PLATE 48
Gari Melchers (1860–1932)
St. George's Church, ca. 1920
Oil on canvas, 33 x 32 ½ inches
Belmont, The Gari Melchers Estate and
Memorial Gallery, Mary Washington College,
Fredericksburg, VA

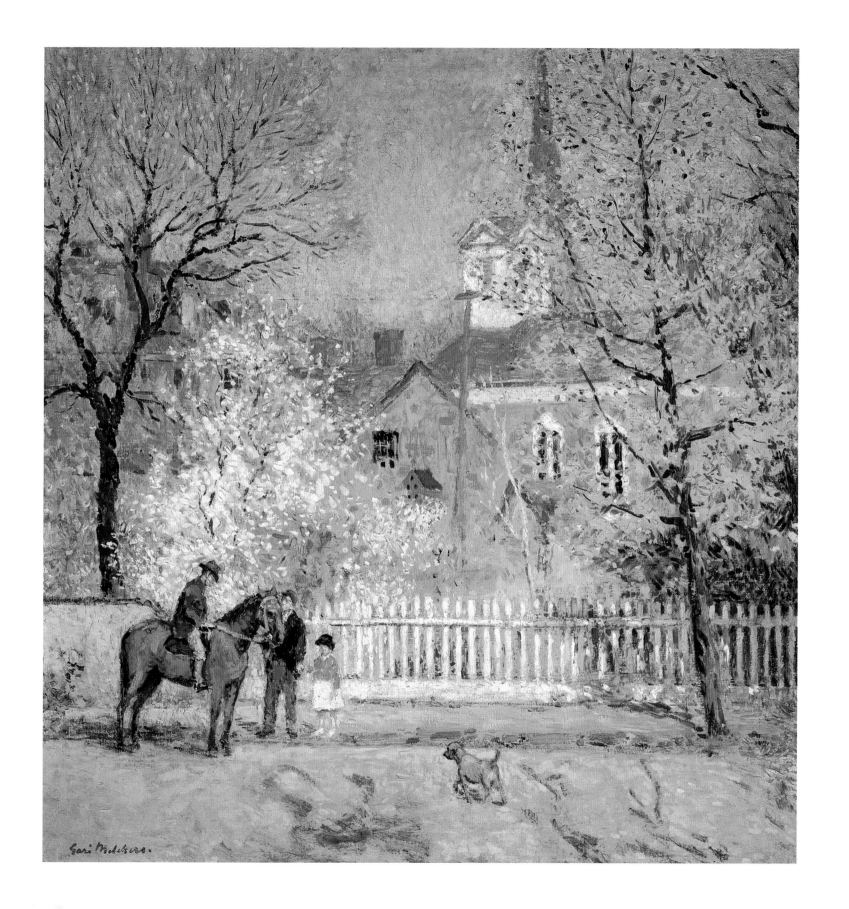

Theodore Steele (1847-1926)

A painter associated with the tradition of Impressionism in the Midwest, Theodore Steele was born near Gosport, in Owen County, Indiana, in 1847. After studying art in Chicago and Cincinnati, he spent three years working as a portraitist in Battle Creek, Michigan. In 1873 he moved to Indianapolis, where, along with some fellow artists, he organized the short-lived Indianapolis Art Association. Steele also acquired a patron named Herman Lieber who provided him with funding for further training abroad. He subsequently went to Munich, continuing his education at the Royal Academy under Ludwig Loefftz and others. He also studied at Schleissheim with the American expatriate painter J. Frank Currier. During this period, Steele painted portraits, peasant subjects, and landscapes in the dark, sketchy style associated with Munich Realism.

Steele returned to the United States in 1885. While most of his contemporaries settled in eastern art centers such as New York or Boston, the artist sought out his home grounds, re-settling in Indianapolis. Foregoing portraiture and figural work in favor of landscape subjects, Steele began painting in the local countryside, eventually turning to the formal strategies of Impressionism as a means of capturing the spirit of regional scenery. In 1893 he exhibited several of his Impressionist paintings at the 1893 World's Columbian Exposition in Chicago, where they were lauded by writers and critics such as Hamlin Garland. Steele often worked in Brookville, in the Whitewater Valley, where he shared a home and studio with the painter John Ottis Adams. It was there that he painted expansive landscapes such as *November Morning* (plate 49), which helped earn him a reputation as one of the foremost members of the Hoosier School, a group of Impressionists that included Adams, William Forsyth, and Otto Stark.

After 1907, Steele was active in Brown County, Indiana, the most popular artists' colony in the Midwest, where he built a residence called the "House of the Singing Winds," and devoted his time to painting views of the surrounding hills and valleys. A major proselytizer for Impressionism in the Midwest, Steele was also an influential teacher, serving as an art professor at the University of Indiana from 1918 until his death in Brown County in 1926.

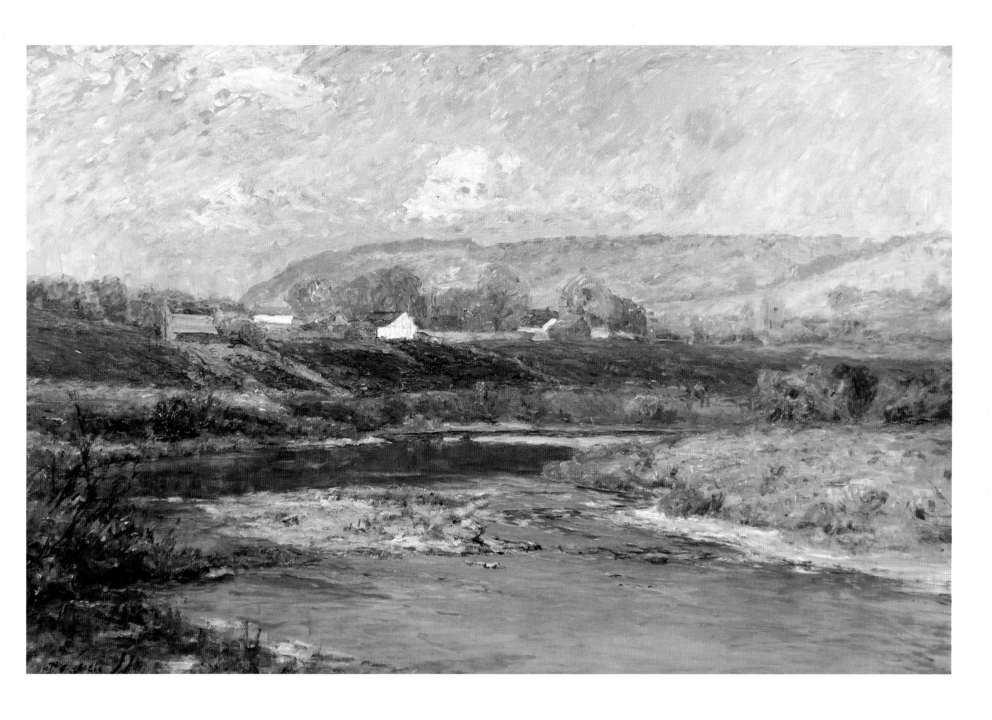

Guy Rose (1867–1925)

Guy Rose occupies a significant position in the history of American Impressionism. During his years in France, he was associated with the legendary Anglo-American artists' colony in Giverny, where he made his earliest forays into modern strategies of light and color. Later, as a resident of Southern California, Rose applied Impressionist precepts to his depictions of the regional landscape, and in so doing played a critical role in the dissemination of that aesthetic throughout his home state.

The son of a prosperous rancher and California senator, Rose was born in San Gabriel, California. His interest in art began during his boyhood and continued into his high school years, leading to his eventual enrollment at the California School of Design in San Francisco in 1885. Three years later he went to Paris, becoming one of the first Californians to study art abroad. After completing his studies at the Académie Julian in 1889, he remained in France, painting peasant scenes inspired by contemporary French Naturalists such as Jules Bastien-Lepage. It was during this period that Rose made his first to trip to Giverny, where he painted a number of plein-air landscapes.

Rose moved to New York in 1892 and became a successful illustrator and an instructor at the Pratt Institute. He returned to France in 1899, making Paris his home base. In 1904, he settled year-round in Giverny, joining a cadre of American Impressionists that included Frederick Frieseke and Richard Miller, and abandoning his former academic realist approach in favor of a full commitment to the brilliant hues and fluid brushwork of Impressionism. In 1910, he exhibited with the so-called "Giverny Group" at New York's Madison Gallery.

Rose settled in Pasadena, California, in the autumn of 1914 and subsequently emerged as one of the state's leading painters. Thereafter, he worked in and around Pasadena, applying flickering brushwork and a prismatic palette to his renderings of the Sierra mountains and the Mojave desert region, as in his remarkable *Sunset Glow (Sunset in the High Sierras)* (plate 50). From 1918 to 1920, the artist also made summer excursions to the Monterey Peninsula in Northern California, where, in response to the crystalline light, he produced intensely colored oils such as *Point Lobos* (plate 10).

Rose did much to promote Impressionism in Southern California, participating in local and regional exhibitions and serving as an instructor (1915-18), and later director (1918-21), at the Stickney Memorial School of Art in Pasadena. He stopped painting in 1921, after suffering a stroke, and died in Pasadena four years later.

PLATE 50
Guy Rose (1867–1925)
Sunset Glow (Sunset in the High Sierras), before 1921
Oil on canvas, 29 x 24 inches
Mark and Donna Salzberg Collection

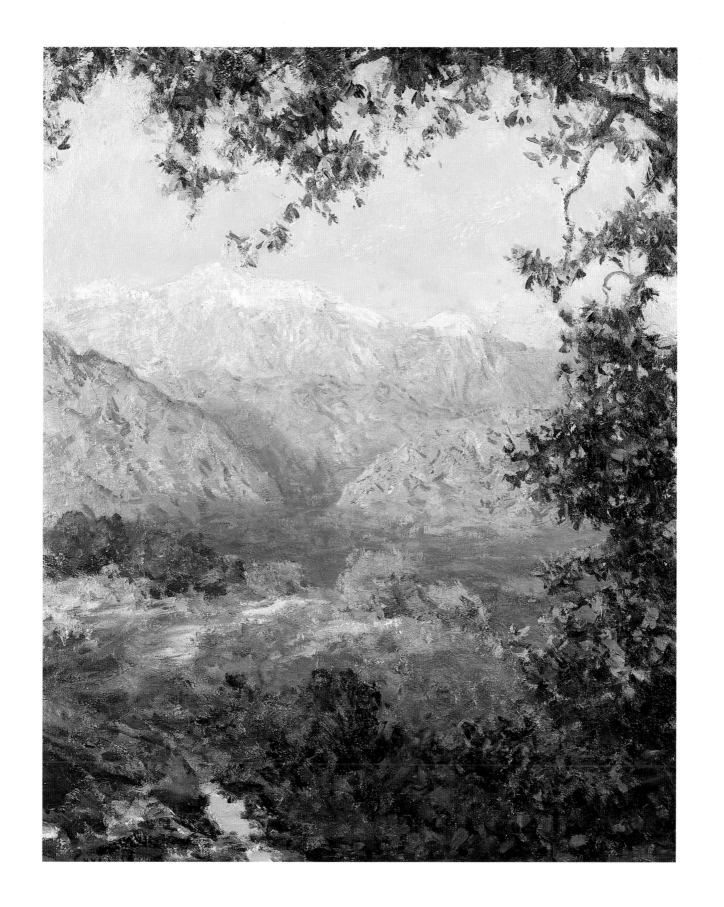

Ernest Bruce Nelson (1888-1952)

Among the talented painters who contributed to the Impressionist tradition in Northern California, Ernest Bruce Nelson enjoyed a brief but fruitful association with the Carmel-Monterey art colony. Responding to the scenic beauty of the region, he painted richly colored landscapes and spirited coastal scenes in a dynamic, decorative Impressionist mode. A key example from this period, *Pacific Grove Shoreline* (plate 51) reflects his proclivity for bold designs, simplified forms, and vigorous, divisionist brushwork.

Born in Santa Clara, California, Nelson studied civil engineering and architecture at Stanford University. Upon graduating he found employment with a San Francisco architectural firm, but left soon after to study art. Moving to New York City, he took classes at the Art Students League and attended the League's summer school in Woodstock, New York, developing his skills as a pleinairist under the direction of the Tonalist landscape painters Birge Harrison and John F. Carlson.

Returning to San Francisco in 1912, Nelson had his first one-man show at the galleries of Helgesen & Marshall, an event that brought him to the attention of local critics, who admired his perceptive colorism and his ability to convey fluctuations of light and atmosphere. One year later, he established his studio in Pacific Grove, where he depicted local scenery and taught outdoor painting classes.

Nelson went on to have successful solo exhibitions in San Francisco, Los Angeles and Oakland. He was also a silver medalist at the Panama-Pacific International Exposition held in San Francisco in 1915. However, his link with the California art scene was all too brief; indeed, after serving in the United States Army during the First World War, the artist settled in Cooperstown, New York. Little is known of his later career. He appears to have abandoned painting at some point in the mid-1920s, possibly after moving back to New York City, where he died in 1952.

PLATE 51
Ernest Bruce Nelson (1888-1952)
Pacific Grove Shoreline, ca. 1915
Oil on canvas, 24 x 30 inches
Private collection of Mr. and
Mrs. John Dilks, Carmel, CA

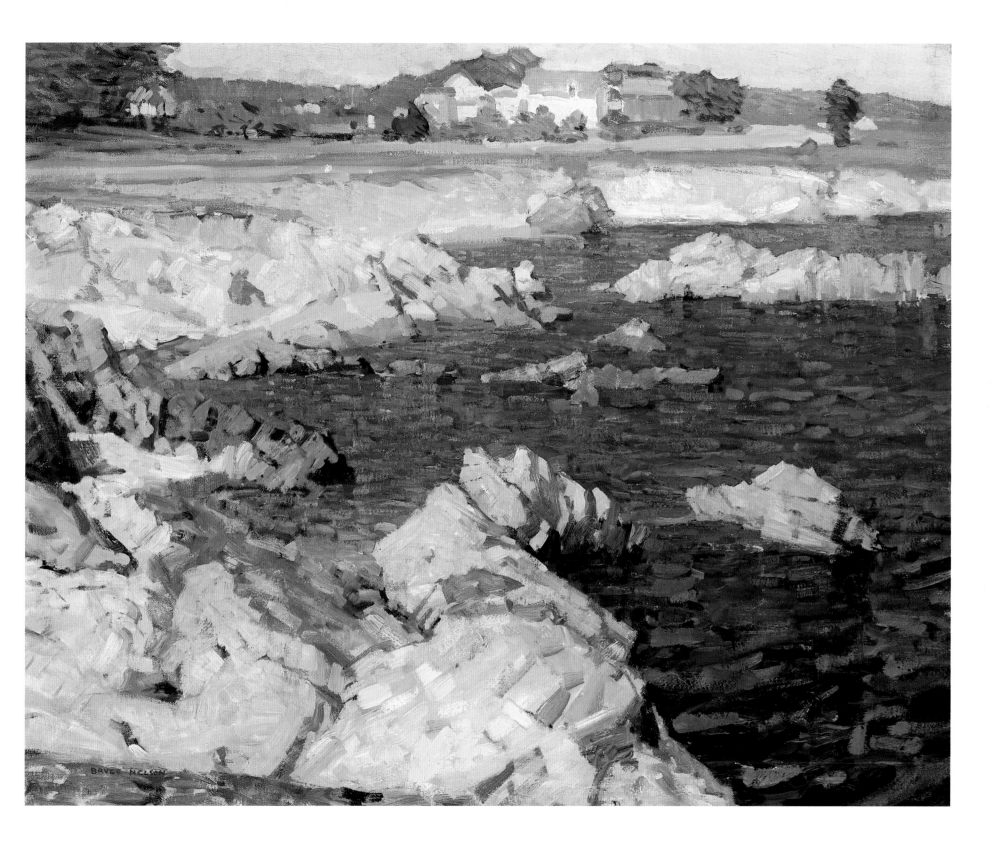

Frederick Frieseke (1874-1939)

One of the most popular of the American Impressionists, Frederick Frieseke won international acclaim for his portrayals of lovely young women in sunlit flower gardens. By 1932, his reputation was such that a writer for *Art Digest* called him "America's best known contemporary painter . . . [and] one of the best represented . . . Even the smallest of the public galleries is . . . sure to have a Frieseke."[14]

Born in Owosso, Michigan, Frieseke studied at the school of the Art Institute of Chicago and at the Art Students League of New York during the early-to-mid 1890s. In 1897 he went to Paris, attending classes at the Académie Julian and studying briefly with the American expatriate painter James McNeill Whistler at the Académie Carmen. He also absorbed the latest tends in contemporary French art, ranging from the figure paintings of Impressionists such as Pierre-Auguste Renoir to the decorative interiors of the Nabis painters Edouard Vuillard and Pierre Bonnard.

Frieseke's early Parisian work consisted of renderings of genteel women in interiors, painted with muted colors and soft brushwork that reflected the influence of Whistler. However, soon after moving to Giverny, the famous Impressionist art colony on the Seine about forty miles northwest of Paris, in 1906, the artist abandoned his former Tonalist style and took up the colorful hues and broken brushwork of Impressionism.

In contrast to the first generation of American Givernois, Frieseke had little interest in painting views of local scenery. Instead, he continued to direct his attention to the figure. Although he often posed his models indoors, many of his finest canvases were painted in his garden, where he could combine his interest in depicting the female form with his concurrent concern for vibrating light. As he told an interviewer, "It is sunshine, flowers in sunshine, girls in sunshine . . . which I have been principally interested in . . . My one idea is to . . . produce the effect of vibration."[15] Frieseke achieves these goals in *Hollyhocks* (plate 52), which exemplifies his passion for sunlight as well as his concern for lively patterning—an aspect of his work that links him with the Post-Impressionist tradition.

Frieseke remained in Giverny until 1920, when he moved permanently to Le Mesnil-sur-Blangy, the French village that remained his home until his death in 1939. During his later years he concentrated on portraiture.

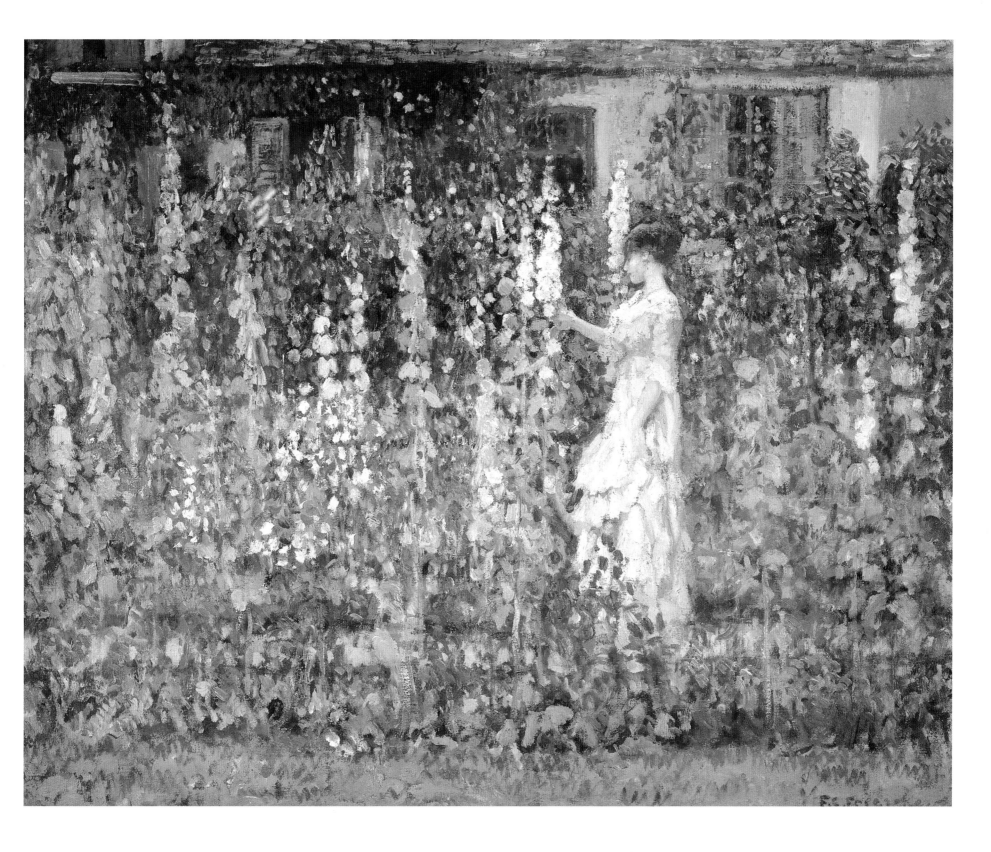

Richard Emil Miller (1875-1943)

Richard Miller first studied art in his native St. Louis, attending classes at the Saint Louis School of Fine Arts during the mid-1890s. From there he went to Paris, studying figure painting techniques at the Académie Julian during 1898-99. Upon completing his training Miller remained in the French capital, teaching at the Académie Colarossi and painting images of contemporary women in cafés and domestic interiors with muted colors and soft brushwork that reflected the impact of the American painter James McNeill Whistler.

Around 1907 Miller began making seasonal visits to the Giverny art colony, where he formed part of a circle of gifted American Impressionist figure painters that included Frederick Frieseke. Although he continued to situate his models in interiors, by 1910 Miller was also posing them in idyllic outdoor settings, including Frieseke's garden, which is probably where he painted *A Gray Day* (plate 53). In addition to demonstrating Miller's penchant for depicting comely women, this canvas indicates his predilection for combining an impressionistic treatment of the landscape elements with a more conventional, academic handling of the figure. Miller painted images such as this not only in Giverny but also in the Breton village of Saint-Jean-du-Doigt, where he taught summer classes beginning in 1911. Not surprisingly, they were well received by both critics and the public, especially in Europe, where they graced the walls of museums in France, Italy, Belgium, and elsewhere.

Miller returned to America in 1914. In 1916 he moved to Pasadena, California, where he taught at the Stickney Memorial School of Art and influenced the development of Impressionism in Southern California. By the fall of 1917 he had settled in Provincetown, Massachusetts, where he continued to paint images of women in domestic surroundings. Miller died in Saint Augustine, Florida, in 1943.

PLATE 53
Richard Emil Miller (1875-1943)
A Gray Day, 1910-11
Oil on canvas, 39 ¼ x 31 ⅝ inches
National Academy of Design, New York 870-P

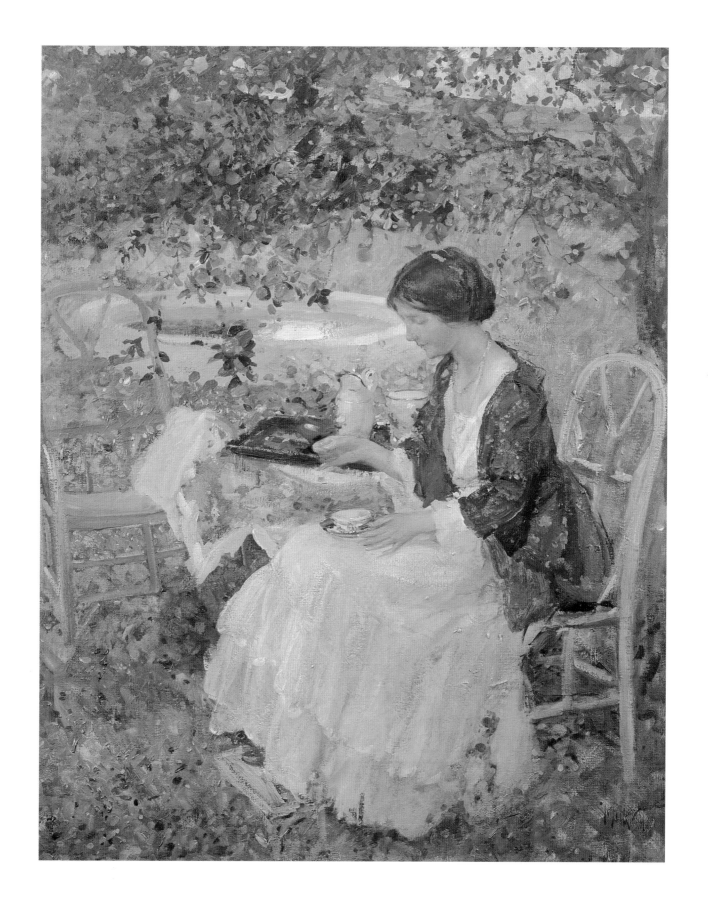

Joseph Raphael (1869–1950)

One of the most innovative of Northern California's Impressionists, Joseph Raphael painted landscapes and garden scenes in a progressive style that fused elements of Impressionism and Post-Impressionism. Indeed, while the majority of his American contemporaries worked in a modified Impressionist manner characterized by carefully articulated compositions and delicate, harmonious palettes, Raphael evolved a more vigorous aesthetic that set an important example for other plein air painters in the Bay area. According to William Clapp, a fellow artist and museum director, he was "practically idolized by the younger generation of painters."[16]

Raphael studied at the California School of Design in San Francisco from 1887 to 1897, receiving instruction from Arthur Mathews and Douglas Tilden. In 1902 he went to Paris, attending figure classes at the Académie Julian. After completing his training he settled in Laren, Holland, where he concentrated on figure subjects painted in a dark, academic manner. In 1912 he moved to Uccle, Belgium, a suburb on the southern edge of Brussels in the vicinity of the Soignes Forest. It was around this time, inspired by the contemporary art he had seen in European art centers—including the work of Dutch and Belgian Post-Impressionists such as Vincent van Gogh and Théo van Rysselberghe—Raphael discarded his old-fashioned tonal style in favor of modern strategies of color and light. Turning from the figure to popular Impressionist landscape themes such as meadows, orchards, and flower gardens, he evolved a bold, Pointillist technique, applying his high-keyed pigments with individual daubs and dashes in such a way as to imbue his canvases with lively Post-Impressionist patterning, as evidenced in works such as *The Garden* (plate 54).

Although he led an expatriate lifestyle for much of his career, Raphael maintained a vital presence in San Francisco art circles by contributing his work to local and regional exhibitions. In fact, he was visiting California when hostilities broke out in Europe in 1939. Prevented from returning to Belgium, he remained permanently in San Francisco, establishing his studio on Sutter Street. Thereafter, he applied his brush to local motifs, ranging from the playgrounds of Chinatown to the tea garden in Golden Gate Park. His later work became increasingly expressionistic.

PLATE 54
Joseph Raphael (1869–1950)
The Garden, 1913
Oil on canvas, 28 x 30 inches
Garzoli Gallery, San Rafael, CA

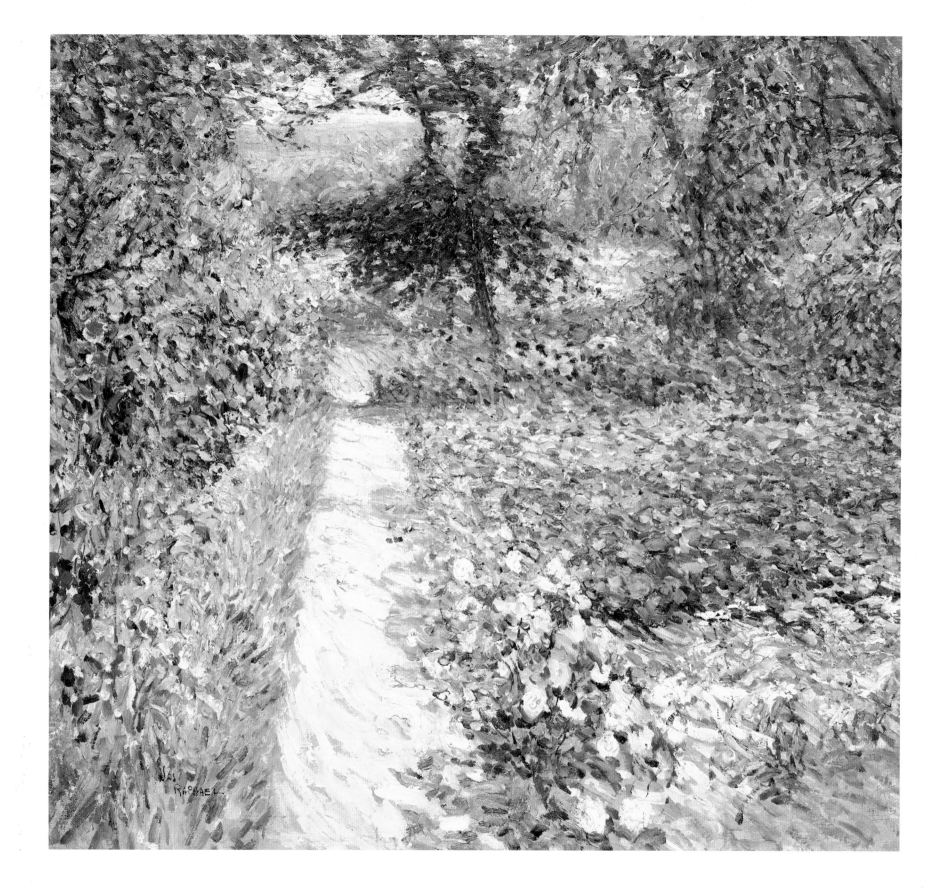

Maurice Prendergast (1858-1924)

A progressive-minded artist who played a seminal role in the history of American Modernism, Maurice Prendergast loved to depict leisure activity at beaches and resorts, a recurrent theme in his work throughout the course of his career.

Born in St. John's, Newfoundland, and raised in Boston, Prendergast went to Paris in 1891, studying at the académies Colarossi and Julian. More vital to his development, however, was his friendship with the Canadian Impressionist James Wilson Morrice, who took him to coastal resorts such as Dieppe and Saint-Malo, where he made small-scale sketches, or pochades, of fashionable beach-goers. While abroad, Prendergast assimilated the latest artistic trends, including the work of Symbolists such as Paul Gauguin and the Nabis painters Pierre Bonnard and Edouard Vuillard.

Prendergast returned to Boston in 1895. In the ensuing years, he painted festive oils, watercolors, and monotypes featuring adults and children strolling through parks, gardens, and city streets or enjoying an outing at the shore. This type of subject was popular among French and American Impressionists alike, but Prendergast handled it in his own singular way. Probably painted at Boston's Revere Beach or at Nantasket, *Ladies with Parasols* (plate 55) exemplifies his lyrical Impressionist style, with its delicate yet highly spontaneous handling.

In the years ahead, Prendergast made additional trips to Europe, increasing his familiarity with modern art, including the oeuvre of painters such as the Post-Impressionist Paul Cézanne and the Fauvist Henri Matisse. In his later work, he continued to investigate Impressionist leisure subjects but his style became increasingly advanced in its use of intense colors, simplified, near-abstract forms, and strong, rhythmic patterning. Indeed, Prendergast's artistic individuality set him apart from the artistic mainstream; it was for this reason that he became affiliated with the Eight, the group of anti-establishment artists who exhibited together at the Macbeth Gallery in New York in 1908. A pioneering Modernist who combined the technical innovations of Post-Impressionism with his personal response to his surroundings, his paintings were championed by some of the more forward-thinking collectors of his day, among them Lillie P. Bliss, Albert C. Barnes, and Duncan Phillips.

Prendergast lived in Boston until 1914, when, in response to that city's growing artistic conservatism, he moved to New York, remaining there until his death at age sixty-five.

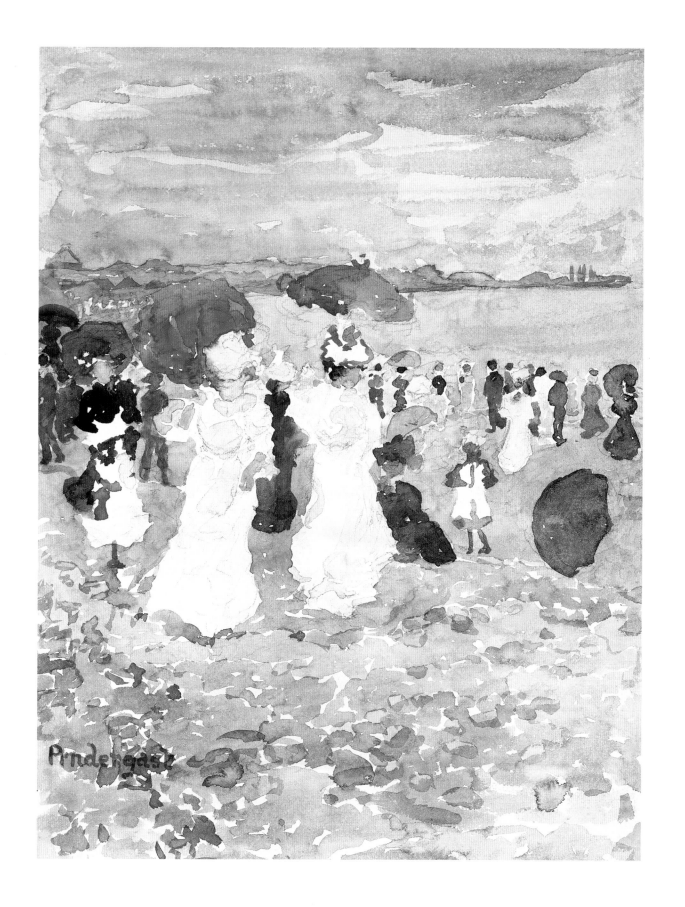

Ernest Lawson (1873-1939)

Born in Halifax, Nova Scotia, Ernest Lawson studied at the Kansas City Art Institute and the Academias Naçionale de San Carlos in Mexico City during the late 1880s. In 1891 he moved to New York, enrolling in classes at the Art Students League under John Henry Twachtman. He also spent a summer attending Twachtman and J. Alden Weir's outdoor painting classes in Cos Cob, Connecticut, at which time he was especially inspired by Twachtman's poetic Impressionist style, with its painterly handling, muted colors, and sumptuous application of pigment.

In 1893 Lawson went to Paris, studying at the Académie Julian and sharing a studio with the author Somerset Maugham. He continued to paint en plein air, working in small French villages such as Moret-sur-Loing, where he met and was influenced by the French Impressionist Alfred Sisley. Over the next few years he led a peripatetic existence, with periods of activity in France; Connecticut; Kingston, Ontario; Toronto; and Columbus, Georgia.

In 1898, Lawson moved to Washington Heights, at that time a rather isolated locale situated at the northern tip of Manhattan. Inspired by his surroundings he painted views of the bridges, docks, train tracks, boathouses, and shanties along the Hudson, Harlem, and East Rivers, evolving a form of Impressionism that was decidedly robust. Part landscape, part urban scene, *Harlem River* (plate 56) underscores Lawson's ability to evoke natural phenomena by means of a vigorous paint handling, lush impastoed effects, and iridescent hues—the hallmarks of his mature Impressionist style. Indeed, during his day Lawson's evocative paintings caught the eye of many discerning patrons, among them Duncan Phillips, who, captivated by the artist's subtle chromaticism, declared: "Ernest Lawson's impressionistic method of using color is not only his contribution to the art of painting, but also his right to a place among the romantic poets."[17]

During the early 1900s Lawson became friendly with New York Realists such as Robert Henri and John Sloan, who shared his interest in depicting the less picturesque aspects of the urban environment. He went on to participate in the landmark exhibition of The Eight, organized by Sloan and held at the Macbeth Gallery in New York in 1908.

Lawson ultimately moved to Greenwich Village, but he continued to paint views of Upper Manhattan, often portraying the same scene under diverse seasonal and atmospheric conditions; like Twachtman, he became especially adept at winter subjects. During the mid-1910s the artist modified his style, putting a greater emphasis on structured compositions and expressive brushwork, and adopting a more intense, almost Post-Impressionist palette as a means of conveying his inner emotions. In the late teens and twenties he painted landscapes in a variety of locales—including New Hampshire, Nova Scotia, and Newfoundland—and taught at the Broadmoor Art Academy in Colorado Springs and at the Kansas City Art Institute. In 1931 he began making winter visits to Coral Gables, Florida, seeking refuge from an array of personal and financial troubles that plagued him throughout the decade. He settled there permanently five years later. Lawson died on a beach near Miami, possibly from a heart attack, in December of 1939.

LENDERS TO THE EXHIBITION

Adelson Galleries, Inc., New York City

Belmont, The Gari Melchers Estate and Memorial Gallery,
 Mary Washington College, Fredericksburg, Virginia

The Brooklyn Museum of Art, Brooklyn, New York

Rhoda and David Chase

Chrysler Museum of Art, Norfolk, Virginia

Cincinnati Art Museum, Cincinnati, Ohio

The Cleveland Museum of Art, Cleveland, Ohio

Mr. and Mrs. John Dilks, Carmel, California

Fogg Art Museum, Harvard University Art Museums,
 Cambridge, Massachusetts

Garzoli Gallery, San Rafael, California

Greenville County Museum of Art, Greenville, South Carolina

Florence Griswold Museum, Old Lyme, Connecticut

Marie and Hugh Halff

Eugene and Mary L. Henderson

Margaret and Raymond Horowitz

Mr. and Mrs. Meredith J. Long

Manoogian Collection

Mead Art Museum, Amherst College, Amherst, Massachusetts

The Metropolitan Museum of Art, New York City

Alan Mirken Collection

The Montclair Art Museum, Montclair, New Jersey

Museum of Fine Arts, Boston, Massachusetts

National Academy of Design, New York City

National Gallery of Art, Washington DC

The Nelson-Atkins Museum of Art, Kansas City, Missouri

New Britain Museum of American Art, New Britain, Connecticut

The New-York Historical Society, New York City

The Newark Museum, Newark, New Jersey

The Parrish Art Museum, Southampton, New York

Private Collection, Courtesy of The Irvine Museum, Irvine, California

Private Collection, Courtesy of Spanierman Gallery LLC, New York City

Private Collection of Jim's Antiques Fine Arts Gallery,
 Lambertville, New Jersey

Private Collections

Richard and Mary Radcliffe

Walter and Lucille Rubin

Fayez Sarofim

Mark and Donna Salzberg Collection

Scripps College, Claremont, California

Shein Collection

Smithsonian American Art Museum, Washington DC

Stern School of Business, New York University

Terra Foundation for the Arts, Chicago, Illinois

Weir Farm Trust, Wilton, Connecticut

NOTES

1. Arthur Hoeber, "Famous American Women Painters," *Mentor* 2 (16 March 1914): 2.

2. See John I.H. Baur, *Theodore Robinson, 1852-1896*, exhibition catalogue (New York: Brooklyn Museum, 1946), 35.

3. Dorothy Weir Young, *The Life and Letters of J. Alden Weir* (New Haven, Connecticut: Yale University Press, 1960), 123.

4. John Cournos, "John H. Twachtman," *Forum* 52 (August 1914): 246.

5. James Gibbons Huneker, "The Seven Arts," *Puck* 75 (23 May 1914), 21.

6. See Cecila Thaxter, et al., *The Heavenly Guest, with other unpublished writings,* edited by Oscar Laighton (Andover, 1935), 119-20. For Thaxter's garden and Hassam's pictorialization of it, see also William H. Gerdts, *Down Garden Paths: The Floral Environment in American Art* (Rutherford, New Jersey: Fairleigh Dickinson University Press, 1983).

7. "Among Our Contributors," *Century* 100 (October 1920): vii.

8. Sadakichi Hartman, *A History of American Art*, vol. 1 (Boston: L.C. Page and Co., 1902): 301-02.

9. Bernard Teevan, "A Painter's Renaissance," *International Studio* 82 (October 1925): 10.

10. See Christian Brinton, "Robert Reid, Decorative Impressionist," *Arts and Decoration* 2 (November 1911): 13-15, 34.

11. *Boston Evening Transcript,* 11 January 1910, p. 13.

12. Anna Seaton-Schmidt, "Frank W. Benson," *American Magazine of Art* 12 (November 1921): 366.

13. See *An Exhibition of Paintings, Drawings and Sketches by Maurice Sterne and An Exhibition of Paintings by Robert Spencer*, exhibition catalogue (St. Louis: City Art Museum, 1917).

14. "Frieseke, at 68, Turns to Landscape," *Art Digest* 6 (15 March 1932): 12.

15. Clara T. MacChesney, "Frieseke Tells Some of the Secrets of His Art," *New York Times*, 7 June 1914, sec. 6, p. 7.

16. [William Clapp], "Joe Raphael," undated manuscript, Archives of California Art, Oakland Museum.

17. Duncan Phillips, "Ernest Lawson," *American Magazine of Art* 8 (May 1917): 262-63.

SELECT BIBLIOGRAPHY

GENERAL BOOKS

American Painters on the French Scene, 1874-1914, exhibition catalogue. New York: Beacon Hill Fine Art, 1996.

An American Tradition: The Pennsylvania Impressionists, exhibition catalogue. New York: Beacon Hill Fine Art, 1995.

Becker, Jack, and William H. Gerdts. *The California Impressionists at Laguna*, exhibition catalogue. Old Lyme, Connecticut: Florence Griswold Museum, 2000.

Gerdts, William H. *American Impressionism*, Second Edition. New York: Abbeville Press, 2001.

_____. *American Impressionism*, exhibition catalogue. Seattle: University of Washington, Henry Art Gallery, 1980.

_____. *Down Garden Paths*, exhibition catalogue. Montclair, New Jersey: Montclair Art Museum, 1983.

_____. *The Hoosier Group: Five American Painters*, exhibition catalogue. Indianapolis: Eckert Publications, 1985.

_____. *Art across America: Two Centuries of Regional Painting, 1710-1920*. 3 vols. New York: Abbeville Press, 1990.

_____. *Lasting Impressions: American Painters in France, 1865-1915*, exhibition catalogue. Giverny, France: Musée Américain, 1992.

_____. *Monet's Giverny: An Impressionist Colony*. New York: Abbeville Press, 1993.

_____. *Impressionist New York*. New York: Abbeville Press, 1994.

Gerdts, William H., et al. *Ten American Painters*, exhibition catalogue. New York: Spanierman Gallery, 1990.

Gerdts, William H., et al. *All Things Bright and Beautiful: California Impressionist Paintings from the Irvine Museum*, exhibition catalogue. Irvine, California: Irvine Museum, 1998.

Gerdts, William H., and Will South. *California Impressionism*. New York: Abbeville Press, 1998.

Hiesinger, Ulrich W. *Impressionism in America: The Ten American Painters*. Munich: Prestel Verlag, 1991.

Hoopes, Donelson F. *The American Impressionists*. New York: Watson Guptill Publications, 1972.

Keyes, Donald D. *Impressionism and the South*, exhibition catalogue. Greenville, South Carolina: Greenville County Museum of Art, 1988.

Larkin, Susan G. *The Cos Cob Art Colony: Impressionism on the Connecticut Shore*. New York: National Academy of Design; New Haven, Conn.: Yale University Press, 2001.

The Painters in Grez-sur-Loing, exhibition catalogue. Tokyo: The Japan Association of Art Museums, 2000.

Peterson, Brian, editor. *Pennsylvania Impressionism*. James A. Michener Art Museum, Philadelphia: University of Pennsylvania Press, 2002.

Peterson, Brian. *Up the River: The Pennsylvania Impressionists and Modernists*, exhibition catalogue. Princeton, New Jersey: Gallery at Bristol-Myers Squibb, 2001.

Prelinger, Elizabeth. *American Impressionism: Treasures from the Smithsonian American Art Museum. National Museum of American Art*. New York: Watson-Guptill Publications, 2000.

Solon, Deborah. *In and Out of California: Travels of American Impressionists*, exhibition catalogue. Laguna Beach, California: Laguna Art Museum, 2002.

Stern, Jean, and William H. Gerdts. *Masters of Light. Plein-Air Painting in California 1890-1930*, exhibition catalogue. Irvine, California: Irvine Museum, 2002.

Weber, Bruce. *The Giverny Luminists: Frieseke, Miller and Their Circle*, exhibition catalogue. New York: Berry-Hill Galleries, 1995.

Weinberg, H. Barbara, et al. *American Impressionism and Realism: The Painting of Modern Life, 1885-1915*, exhibition catalogue. New York: The Metropolitan Museum of Art, 1994.

ARTISTS

FRANK W. BENSON

Bedford, Faith Andrews. *Frank W. Benson: American Impressionist*. New York: Rizzoli, 1994.

Wilmerding, John, Sheila Dugan, and William H. Gerdts. *Frank W. Benson: The Impressionist Years*, exhibition catalogue. New York: Spanierman Gallery, 1988.

DENNIS MILLER BUNKER

Hirshler, Erica E. *Dennis Miller Bunker: American Impressionist*, exhibition catalogue. Boston: Museum of Fine Arts, 1994.

Hirshler, Erica E. *Dennis Miller Bunker and His Circle*, exhibition catalogue. Boston: Isabella Stewart Gardner Museum, 1995.

MARY CASSATT

Barter, Judith, et al. *Mary Cassatt*, exhibition catalogue. Chicago: Art Institute of Chicago; New York: Harry N. Abrams, 1998.

Bullard, E. John. *Mary Cassatt, Oils and Pastels*. New York: Watson-Guptill Publications, 1972.

Constantino, Maria. *Mary Cassatt*. New York: Barnes & Noble Books, 1995.

Rosen, Marc and Susan Pinsky. *Mary Cassatt Prints and Drawings from the Artist's Studio*, exhibition catalogue. Princeton, New Jersey: Princeton University Press, 2000.

WILLIAM MERRITT CHASE

Gallati, Barbara Dayer. *William Merritt Chase*. New York: Harry N. Abrams, Inc. in association with the National Museum of American Art, Smithsonian Institution, Washington, D.C., 1995.

Pisano, Ronald G. *William Merritt Chase*. New York: Watson-Guptill Publications, 1979.

_____. *William Merritt Chase in the Company of Friends*. Southampton, New York: Parrish Art Museum, 1979.

_____. *Summer Afternoons: Landscape Paintings of William Merritt Chase*. Boston: Little, Brown, 1993.

JOSEPH DECAMP

Buckley, Laurene. *Joseph DeCamp: Master Painter of the Boston School*. New York: Prestel Verlag, 1995.

THOMAS WILMER DEWING

Hobbs, Susan. *The Art of Thomas Wilmer Dewing: Beauty Reconfigured,* exhibition catalogue. Brooklyn, New York: Brooklyn Museum in association with Smithsonian Institution Press, Washington, D.C., 1996.

FREDERICK FRIESEKE

Kilmer, Nicholas, et al. *Frederick Carl Frieseke: The Evolution of an American Impressionist,* exhibition catalogue. Savannah: Telfair Museum of Art in association with Princeton University Press, 2001.

DANIEL GARBER

Foster, Kathleen A. *Daniel Garber 1880-1958,* exhibition catalogue. Philadelphia: Pennsylvania Academy of the Fine Arts, 1980.

CHILDE HASSAM

Adelson, Warren, Jay E. Cantor and William H. Gerdts. *Childe Hassam, Impressionist.* New York: Abbeville Press, 1999.

Fort, Ilene Susan. *Childe Hassam's New York.* San Francisco: Pomegranate Artbooks, 1993.

Hiesinger, Ulrich W. *Childe Hassam: American Impressionist.* New York: Prestel-Verlag, 1994.

Hoopes, Donelson F. *Childe Hassam.* New York: Watson-Guptill Publications, 1979.

ERNEST LAWSON

Leeds, Valerie Ann. *Ernest Lawson,* exhibition catalogue. New York: Gerald Peters Gallery, 2000.

GARI MELCHERS

Dreiss, Joseph G. *Gari Melchers: His Works in the Belmont Collection.* Charlottesville: University Press of Virginia, 1984.

WILLARD METCALF

Boyle, Richard, Bruce Chambers and William H. Gerdts. *Willard Metcalf,* exhibition catalogue. New York: Spanierman Gallery, 2003.

De Veer, Elizabeth and Richard J. Boyle. *Sunlight and Shadow: The Life and Art of Willard L. Metcalf.* New York: Abbeville Press, 1987.

RICHARD E. MILLER

Kane, Marie Louise. *A Bright Oasis: The Paintings of Richard E. Miller.* New York: Jordan-Volpe Gallery, 1997.

MAURICE PRENDERGAST

Ivinski, Ivinski, and Nancy Mowll Mathews. *Maurice Prendergast: Paintings of America.* New York: Adelson Galleries, 2003.

Wattenmaker, Richard J. *Maurice Prendergast.* New York: Harry N. Abrams in association with The National Museum of American Art, Smithsonian Institution, Washington, D.C., 1994.

JOSEPH RAPHAEL

Gerdts, William H. *Joseph Raphael.* New York: Spanierman Gallery, 2003.

Lilienthal, Theodre M. *An Exhibition of Rediscovery: Joseph Raphael, 1872-1950,* exhibition catalogue. Berkeley, California: Judah L. Magnes Memorial Museum, 1975.

ROBERT REID

Weinberg, Helene Barbara. "Robert Reid: Academic Impressionist." *Archives of American Art Journal* 15, no. 1 (1975): 2-11.

THEODORE ROBINSON

Theodore Robinson: Exhibition of Paintings, exhibition catalogue. New York: Owen Gallery, 2000.

William H. Gerdts. *Theodore Robinson. West River Valley, Vermont.* New York: Owen Gallery, 2001.

GUY ROSE

South, Will. *Guy Rose: American Impressionist,* exhibition catalogue. Introduction by William H. Gerdts; essay by Jean Stern. Oakland, California: Oakland Museum; Irvine, California: Irvine Museum, 1995.

JOHN SINGER SARGENT

Kilmurray, Elaine, and Richard Ormond. *Sargent e l'Italia,* exhibition catalogue. Ferrara, Italy: Palazzo del Diamanti, 2002.

Ratcliff, Carter. *John Singer Sargent.* New York: Abbeville Press, 1982.

Robertson, Bruce, editor. *Sargent and Italy,* exhibition catalogue. Los Angeles, California: Los Angeles County Museum of Art, 2003.

Weinberg, H. Barbara. *John Singer Sargent.* New York: Rizzoli International, 1994.

ROBERT SPENCER

Folk, Thomas. *Robert Spencer: Impressionist of Working Class Life,* exhibition catalogue. Trenton, New Jersey: New Jersey State Museum, 1983.

THEODORE STEELE

Steele, Selma N., Theodore L. Steele, and Wilbur D. Peat. *The House of the Singing Winds: The Life and Work of T. C. Steele.* Indianapolis: Indiana Historical Society, 1966.

EDMUND TARBELL

Buckley, Laurene. *Edmund C. Tarbell: Poet of Domesticity.* New York: Hudson Hills Press, 2001.

Docherty, Linda J., editor, et al. *Impressionism Transformed: The Paintings of Edmund C. Tarbell,* exhibition catalogue. Manchester, New Hampshire: Currier Gallery of Art, 2001.

HELEN MARIA TURNER

Rabbage, Lewis Hoyer. *Helen M. Turner, NA (1858-1958): A Retrospective Exhibition,* exhibition catalogue. Cragsmoor, New York: Cragsmoor Free Library, 1983.

JOHN TWACHTMAN

Boyle, Richard J. *John Twachtman.* New York: Watson-Guptill Publications, 1979.

Chotner, Deborah, Lisa N. Peters, and Kathleen A. Pyne. *John Twachtman: Connecticut Landscapes,* exhibition catalogue. Washington, D.C.: National Gallery of Art, 1989.

Hale, John Douglass, Richard Boyle, and William H. Gerdts. *Twachtman in Gloucester: His Last Years, 1900-1902,* exhibition catalogue. New York: Spanierman Gallery, 1987.

JULIAN ALDEN WEIR

Cikovsky, Nicolai, Jr., et al. *A Connecticut Place: Weir Farm: An American Painter's Rural Retreat,* exhibition catalogue. Wilton, Connecticut: Weir Farm Trust, 2000.

Young, Dorothy Weir. *The Life and Letters of J. Alden Weir.* New Haven: Yale University Press, 1960.

INDEX